A BRIEF HISTORY OF

PAINTING

A BRIEF HISTORY OF

PAINTING

Roy Bolton

Introductory essay by
Matthew Collings

MAGPIE BOOKS, LONDON

Constable & Robinson Ltd
3 The Lanchesters
162 Fulham Palace Road
London W6 9ER

This edition published by Magpie Books,
an imprint of Constable & Robinson Ltd 2006
www.constablerobinson.com

First published in the UK by Robinson,
an imprint of Constable & Robinson Ltd 2004

A copy of the British Library Cataloguing in
Publication Data is available from the British Library

ISBN-10: 1-84529-453-X
ISBN-13: 978-1-84529-453-3

Printed and bound in China

1 3 5 7 9 10 8 6 4 2

To my parents, and to George and Caroline

Contents

How to Use this Book

A Brief History of Painting is a new way of seeing some of the world's most important artists and paintings. This chronological story covers 150 pivotal and representative paintings in an authoritative historical overview. The book can be read from cover to cover for an introduction to the history of painting, and it can be used to look up individual paintings and artists.

Following the introductory essay by Matthew Collings, 'The Inner Life of Painting', there are eight chapters, beginning with the ancient world and ending with Modernism and contemporary art. Each chapter begins with a summary of the most influential artists belonging to the period and important historical events that influenced their art. The paintings selected for individual entries are each accompanied by a guide to the painting and a short biography of the artist. Art terms and art movements are highlighted and explained in a glossary on pages 289-93. A timeline on pages 280-5 locates artists and art movements in relation to one another in time. Finally, there are recommended books for further reading on pages 286-8.

The Inner Life of Painting
An introductory essay
Matthew Collings

This book is an introduction to the history of painting. The mood is light. You can use the book in two ways – as a reminder of the changes in painting throughout our history, or (and the two ways are not mutually exclusive) as a sort of jumping-off point for learning about art. I would not wish to give an impression that there is something marvellous about painting that can be summoned more or less like a genie, where you waft your hands and a fantastic experience starts. That isn't how I think that painting or writing works. This kind of accessibility is okay for a beginning, but I think you have to put a bit of work in before real appreciation begins.

You get more out of art the more you're willing to put in. And I find the more you've got out of it, the more particular and finicky you tend to become on all sorts of levels. You will find you become very discriminating about paint. You categorize it – you see it as flatter or more disturbed, or sheer or transparent or spread out, or lumped-up or glutinous or coagulated or whatever – and you have mental frameworks for all these effects. You can read them. You don't like everything in the same way, and maybe there's a lot you never like at all.

I could never like anything by the Surrealist, Yves Tanguy, for example, but I find his contemporary, Salvador Dalí, to be full of magnificence, even if it's wildly inconsistent and always on a jokey level. He is magnificent in the way that certain comedians are magnificent. Dalí and Tanguy share a generalized, horrible, paint-killing technique, but within the ghastliness Dalí often manages to come up with surprises of colour, space and form. Of course the overall wackiness of imagery is

what Dalí is known for, and this is indeed where his power lies. But the difference between the Dalí of the classic Surrealist period, the 1920s (which is also Magritte's great decade; and he's another murderer of oil paint) and his later paintings is really a difference of psychological tone, where the superior believability of the earlier work is due to a more intuitive and thus more nuanced, dramatic and less routine handling of materials.

So what I'm saying here is that within a visually rather low-grade mode, which is what Surrealism is, there can still be a hierarchy of good and bad. And if you've got any curiosity or enthusiasm or natural thinking power, and you've found yourself somehow in the world of painting, you'll be surprised by how important these kinds of intuitive or instinctive judgements soon become. You'll realize that being interested in art and being able to think about it – and maybe even communicate your thoughts, or put your thoughts into action if you want to be a painter yourself – is its own reward. You don't get into it for reasons of snobbery or wanting to gain the power to intimidate people with a lot of weird terms or jargon you've just learned. Instead the attraction is something more inward. There is an inner yearning that painting answers.

In any case there are certain things that paint does that you may come across in your first encounters with the tradition and be impressed by, and the pull of this initial attraction may always remain with you. You might realize later in life that your interest is actually rather narrow. Perhaps it's that certain way (and you want to see it again and again) that Monet and Tintoretto have of dragging an undiluted bit of oily matter across a more thinly laid-in area. For the rest of your life liking and disliking certain things will connect to this original attraction. In this way painting is trans-historical, but as we saw with the earlier examples from Surrealism, it also kind of rises above categories generally. It is its own category. Then there's the way that taste develops through experience. You learn to see more, so a famous painting you always knew becomes slightly different in stages, and eventually you realize it's become quite amazingly different to how you originally saw it. Remember we're only talking about the paint here – we haven't even mentioned what might be going on in the representation or in the story of the artist's life or what was going on in society at the time. To find this level of painting fascinating, namely the way the paint works, is to be a kind of connoisseur.

You will probably find that you start to apply discrimination to art writing as well. On the whole, you will want the language that is used to describe and evaluate

painting, to convey a sense of the dignity of the tradition and discipline of the medium, to be lucid and super-informed, to be inspired in a certain way, to feel as if it were born for this task and no other. When it's different to that you know it's a type of writing for someone else, not for you. You've already found that kind of thing not quite as vibrant and flexible and observant and thoughtful as you need writing on art to be. But maybe you remember when you were moved by whatever you could find, maybe sometimes more moved then than you are capable of being now, if that's not too sentimental.

From personal experience I know that the starting point for getting interested in the history of painting is pretty arbitrary. Painting is like a stream, where you can step in at any point. For me it was a few little basic well-intentioned primers that told me what Impressionism or Paul Klee was supposed to be. I had no idea what I was reading. I looked at the reproductions and read the text and found them equally odd but not equally attractive. I definitely thought the pictures had the edge. Art writing is a peculiar thing. It's not self-sustaining. It's not like novels. The greatest art writers are just not that interesting if you're not already interested in the subject. Paint and painting speak for themselves but art writing never does – it follows where art leads. On the other hand you can't have such a thing as art appreciation unless you've read a few books about art. It's not really appreciation otherwise, it's a hobby or a distraction, or a bit of nonsense. In other words I think painting is serious and it calls for a high seriousness on the part of its audience and on the part of those who want to be its champions and leaders and explainers. But you can acquire that seriousness via all sorts of diverse and even dubious routes.

Is the painting we have today, that we see in exhibitions and in the Turner Prize for example, connected to the past in any real way? I think the answer is no. The stuff we have now (and have done for about fifteen years) is really a new kind of ideas-art, connected to the type of art that is fashionable now. Painting today defines itself not according to its own tradition but according to this new tradition, which is profoundly non-visual. Its look comes from photography and film when it's most visual, but its main look is just a kind of convenience – whatever visual arrangement is the most convenient and clear for getting the idea over, whatever it is. Consequently painting today is mostly visually boring. In its weird obstinate incompetence, its refusal to mature, its insistence on remaining at an arrested adolescence stage, it makes painting-puppies of an earlier era, such as Salvador Dalí, seem genuinely like Velázquez (rather than a gagster who often referred to Velázquez).

But again as with Dalí there is still a hierarchy of good and bad. For example, Damien Hirst's spin-paintings offer little visual pleasure. They just have arbitrary runnings-together of different colours. Their interest is really 'performative' – they are records of a certain kind of theatre. It's a spectacle that involves a lot of the materials we associate with painting, but it doesn't have the same aesthetic aims as the high tradition of painting. It's a kind of skewed comment on Jackson Pollock. At the time when Pollock still lived there was an English painter who enjoyed a bit of success, who used to ride a bicycle over a paint-spattered canvas. He really didn't seem to understand that Pollock was a supreme artist of composition and placement, of transforming space, of creating space through mark making; he thought Pollock was a bit of theatre. And the English public laughed when they saw this guy on TV in a documentary about painting. In a way Hirst's spin-paintings re-do that moment, but instead of remaining on a slightly pathetic philistine level, they make the moment into something glamorous and memorable. There is a zero-level aesthetic aspect to his spin-paintings, but on all the other levels – sociological, fashionable, humorous, punky, witty, and so on – they represent a high achievement.

Yet Hirst's spot-paintings, where you might imagine the colour effect to be just as arbitrary, often have a level of visual rightness to them. The reason seems to be the whiteness round the spots. Maybe it's the proportion of white to colour. I don't know. I do know that there is something similar in Bridget Riley, who otherwise is a very different kind of artist – she really is interested in the art of the past and has a deep knowledge of it. But in Riley's work, up till the mid 1970s, you generally find very small amounts of colour surrounded by much larger amounts of white, and the graphic balance somehow makes the colour seem exciting. Whereas when she puts larger and larger bands of colour next to each other, so that what used to be a mark now becomes an area, the results often seem out of control, almost bilious.

I often find myself liking Hirst's spot-paintings, and wondering if the only reason some are less successful is simply because he occasionally does something fiddly with the canvas shape, or he cuts a row of spots off in the middle, or otherwise de-regularizes the layout in some such way. But Hirst's spin-paintings have no positive effect on me whatsoever, although I see why people find them striking. The art world is fascinated by populism now, by attracting to itself an enormous audience that doesn't have any real interest in art but is willing to pause for a moment if there's a shock or scandal or a bit of depravity on offer. The hated thing now is to think of painting as involved with aesthetic pleasure. The loved thing is anything extreme –

extreme emotion, extreme states of being, extreme difference. And to make a painting in such an evidently silly way as these spin-paintings are made is extreme.

To resort for a brief moment to anecdote, I found myself in the Beaux-Arts Gallery in London's Cork Street the other day, where there was a retrospective of the work of the Scottish expressionist John Bellany, the guy who had to have a liver transplant because his drinking was so extreme. I overheard the dealer telling someone that Damien Hirst had just bought three early Bellanys. I supposed it was because of Bellany's slightly religious content. I looked at all the paintings. The good things were an impression of spontaneity and a sense that he meant it. I thought the basic mode was illustration – maybe the most competent thing was illustrative drawing. The bad things were out-of-control colour, corny symbols and too many different types of contrasts. Bellany filled-in spaces and then seemed to think the painting was finished when there was no emptiness left to fill. But the effect was always visually banal. The corny symbolism would be all right if there wasn't the problem of too many visual differences (different types of drawing, colour, shapes, handling – all jangling against each other in chaos). Although a catalogue essay stated that Rembrandt was an influence, the Australian painter of the 1950s and 1960s, Sidney Nolan, in fact seems closer. Nolan's virtue is minimalism – paring back, so the dubious symbolism he goes in for doesn't seem so grating. The point of this anecdote is that when you get seriously interested in art you learn to think for yourself, and not just believe a lot of easy clichés that art writers tend to go in for, and even many artists tend to believe in too.

To remain with Hirst for a bit longer (which is okay, I think, since he's become a barometer of taste), it's the Hirst idea of Francis Bacon that we're now encouraged to take seriously – that Bacon's writhing blob-monsters are actually expressive of something. I find these screaming monsters tedious and idiotic. I think it's the Matisse-like backgrounds that make Bacon stand out. He handles flat areas of colour impressively. Maybe this sounds disappointing. Surely art should be about something more mind-blowing than this? Compared to the thrill of monsters, mere 'colour' seems anticlimactic. That's the problem when taste gets so corrupted.

How do you negotiate connoisseurship? The point is that you don't – at least not the positive, democratic kind that I am trying to explain here. The other kind, where you do an art history course for several years and learn to bray about identity politics and so on, is pretty deathly unless you've really got personality problems. But the kind of which I speak is about liveliness and enthusiasm, and living up to the quality of feeling that is painting's true content.

When did we last find that quality of feeling in painting generally? The painting tradition that began with the early Renaissance ran down in the 1950s. Its last gasp was American colour field painting of the 1960s, and its last heyday was American Abstract Expressionism. The highpoint of the heyday, as it were, is Jackson Pollock, Mark Rothko and Barnett Newman at exactly mid-twentieth century. Throughout the 1950s Abstract Expressionist painting, having established itself as the international dominant style, settled in as a mannerism, so that by the middle of the decade it was already routine. When the Abstract Expressionist look was defeated in the early 1960s, first by Pop art and then by the immediate offshoots of Pop – Minimal art and Conceptual art (and all their various nutty offshoots too, performance and video art, and so on) – it was not a tragedy but merely a case of something being knocked out that had hung around too long.

What continued from Abstract Expressionism into the Pop and geometric art of the 1960s, and can be seen throughout the five hundred-year-old western tradition, going as far back as Italian painting of the fifteenth century, is the will to find a pattern, to create abstract loveliness and order, to find a design and create a dynamic, satisfying flatness – and all this in the process of painting, whether the starting point is a scene out there in the world or just the blank canvas. But what was almost immediately lost was a sense that this might be enough for painting. From the 1960s on, a general idea takes hold within the art world and within the audience for art that these visual qualities, so essential to the culture of painting before, are now a bit trivial. The whole idea of painting possessing an 'inner life', an existence and a reason for being that doesn't care about imagery and subject matter or history or outside reality, seems an oddity to this new mind-set, which is the mind-set we have now. This is the idea of art that is celebrated now by Tate Modern and the Turner prize, and so on. These new institutions are big public signs of art's 'success', its recent movement from the margins to the centre of social life.

What we have now as far as painting is concerned – at least fashionable, centre-stage painting – is weak. Of course as a critic I see a hierarchy of good and bad within our present set-up. But I see the whole set-up as weak compared to the old tradition, both the tradition of Modernism and of the Old Masters. The weakness is caused by distraction – painting is distracted by irrelevancies. Think of painting as a culture, not as paintings but 'painting'. There are loads of paintings being done today, but painting as a culture or a discipline isn't considered to be viable contemporary art. Viable art is videos and installations, a photo-based vision of the world, or mass

media-based vision. Contemporary painting tries to incorporate this mass media vision in order to keep up with it, in order to be popular and successful (since these are the aims of the mass media), instead of defining itself by being different to this vision, and thereby risking being unpopular but being successful on its own terms. (That is, painting falls over itself trying to be popular.)

In the twentieth century the great paintings up to the 1950s – with abstract painting of that time being the last great phase of modern painting – were about self-definition. The result was a certain kind of simplification, with broader colour, simple forms, and less going on in terms of story and imagery. We don't seem to be able to tolerate this any more. Instead of liking the qualities that are liberated through this simplification, the visual richness of abstract art of a 1950s kind (Jackson Pollock and so on), we perceive only a loss – the lack of the buzz of instant contemporaneity that turns us on, or that we believe turns us on, like drugs turn on people who have something that makes them anxious which they want to avoid. The pseudo-profundity and titillating freak-show shocks of contemporary art are our drugs, and what we want to avoid is humanity, seriousness, depth and feeling.

It's from the Old Masters and from the recently defunct tradition of Modernism that painting can learn to be itself again. I don't mean that new painting should look more like old art in a literal way – that would be absurd. Also, I don't think 'Old-Master-ness' as such, any more than Modernism as such, is what contemporary painting lacks, so much as 'genuine-ness', a sense of integrity. It might seem odd to deplore painting's separation from its own tradition when the trendy painting of nowadays seems to be full of references to the past. But to refer to something isn't the same as being connected on a profound level to it. The typical successful painting of today will often quote from the tradition of painting, but the reference is always deliberately shallow and trivial. It's really about pointing up in a spirit of black humour or despairing glee our modern difference from the past, not our connection to it.

The quote – a bit of imagery or a bit of handling that has the look of a style or mannerism from the past (but also of course that might be a direct quote from the imagery of the past) – will be deliberately enigmatic. We don't know why it's there, whereas we know why Picasso quotes El Greco or Manet quotes Goya. We know it is to invoke something wholeheartedly, to connect back to something, even if the new thing being made out of the old might appear initially to be a bit staggeringly different to anything the quoted artist would recognize as 'art'. But the motivation for trendy painters of nowadays to quote from the past isn't to connect to the past's achievements

but to insincerely drag in the past in the same way that the present is dragged in. Both are seen as popular, flat and ironic, like ads. This new type of painting is fascinated by futility and impotence, these anti-qualities seem wonderfully glamorous to trendies. Art culture generally is about fast, empty stimulation now. This culture forces painting to be a kind of illustrative demonstration of the pointlessness of anyone taking painting seriously. (So if anyone does take it seriously they will seem marooned on an island of sincerity, a pathetic position.)

An optimistic view might be that as it continues to hover around the history of painting, or at least keeps coming back via one route or another to this history (however corrupt or crass the conscious connection might be), new painting might start to become more like old painting, if only by accident. I personally think that's too passive and depressing an attitude. I think we need to see more clearly what we've become in order to change our state positively. We have to know ourselves. Obsessed to the point of illness by anti-elitism, art culture has become silly and shallow. Its products are often amusing but never genuinely playful, or genuinely free, and consequently never really serious – only either trivial or solemn or both. We now ask art to turn us on with shocks. This is our corruption as a society. But the history of painting mapped out through the illustrations in this book gives the reader or browser a set of shocks of a different kind. In these reproductions we see a culture of humanity and beauty that is shockingly different to today's mainstream painting, or the kind of painting that makes it into the Turner Prize and exhibitions at the Saatchi Gallery.

Of course the same tortures and murders and nastiness, and the same buffoonery and human weakness, and the same emptiness and blankness and tedium are there in the old as in the new. (Ironically perhaps, this is especially true if we think of the Old Masters rather than Modernism compared with the present.) But whereas in the Turner Prize these things are literal and graspable, part of an amusement park or freak-show type of experience, where you are confronted with something amusingly disagreeable (appalling or disgusting) or temporarily compelling (like an adolescent's display of emotion in order to get attention), in the great tradition of painting they are all only one aspect of the art experience. They are the hallucinatory surface aspect of something that has other more substantial and powerful aspects. Sometimes these less easily definable or more abstract contents are tuned in to the hallucinatory content, and sometimes they seem indifferent to them, with the two just running alongside each other as if in connected but separate corridors. Sometimes they even seem antipathetic or opposite.

The Inner Life of Painting

What I'm doing is pointing out the difference between the inner life of painting and painting's subject matter, and also the difference between painting's inner life and the personal biography of the artist. I think this inner life becomes more available and see-able through being examined again and again in every context conceivable – which includes the historical and social meanings, the artist's life, ideas and thoughts, and relationship to the times generally and to patrons and bosses. But I also believe in what Modernism teaches us, that the use the painting has in the end, if the painting is important, is to do with its identity as a painting, and not the surrogate it offers through imagery, history, documentation and recording and so on, of various other experiences.

How do you look at the paintings of the distant past? How else but with your own eyes, with your own experience and thoughts? But you need frameworks of ideas as well, within which your intuitive perceptions can deepen. Sometimes the Old Masters have a strongly moral dimension. Bruegel and Bosch, for example, are moralists. But their moralizing goes along with a high formalism. Both of these painters are astounding organizers and colourists, as well as amazingly convincing observers of objective forms (of nature) and inspired concoctors of fantasy forms. In the case of other Old Masters sometimes the moral is there but we're not convinced the artist really means it – as often happens with Titian and Tintoretto. Here the moral story is a framework for something else that the artist feels more urgently. But just as Titian and Tintoretto combine form at its most heightened and powerful (broad, dramatic, expressive) with colour and handling each pitched to an exquisite highpoint (it's actually quite rare for painting to have such a combination), so they convey moral content precisely through the very thing that we might think would oppose it or diffuse it – visceral, delicious, almost physical pleasure. The pleasure is the feeling we get from a scintillating, breathing and infinitely tender paint surface, from passages of different thicknesses and thinnesses of paint.

Sometimes art from the past is pious and monumental, like the High Renaissance painting of Raphael, or pious and monumental but also explosive and dynamic, like the Baroque painting of Rubens and Caravaggio. Sometimes it's moving because of simplicity, sometimes because of complexity. Or conversely, again as in Baroque art, the complexity is initially off-putting. We feel we want Masaccio not Rubens. Rubens is all fireworks, it seems, all show – where's the feeling? Then we see the distressed surfaces of Masaccio, the way he comes up with visual equivalents for walls and skies, the folds and planes of tunics and cloaks and the heavy graceful contours of the

profiles and backs of the saints. Being drawn into those abstract qualities we start to see how abstract Masaccio is, and how abstract too is Rubens. He is really offering a variation on the feeling in Masaccio, rather than a departure from feeling or dilution of it. Masaccio seems noble, monumental and quiet, inward, contemplative, massive and deep, while Rubens seems frothy and noisy, steamy, panting, violent, stirring up feeling for the sake of feeling.

The old idea in art history, which goes back to the eighteenth century when art history began to be established as a discipline, was that Masaccio stands for a type of organization where details are as convincing as the whole, while Rubens stands for a type where only the whole is truly coherent; the parts are always in the process of forming and melting. But Masaccio and Rubens are both deep, both monumental, and both offer a kind of experience that is more inward and arresting and profoundly human (in the sense of individuals being capable of sympathy and empathy for other individuals) than we are used to being offered by the art culture of the present moment.

The difference between the past and the present is not stylistic as it is between Rubens and Masaccio, but moral – one has depth, while the other deliberately doesn't. Rubens and Masaccio's depth unites them and separates both of them equally from what we now have as art. Our shallowness, which new institutions like the Turner Prize, the Saatchi Gallery and Tate Modern celebrate, is connected to the desire we have for meaning in art to be literal. The audiences of the past might have been moved by the literal meanings on offer – 'that crucifixion looks real'; 'those saints are pious'. But the meanings these works have now are only partly to do with literalism. We're often not really in touch with this level of meaning, for one thing. And in any case even if we were we might find it repellent. For example, Bruegel is generous and humane in the richness of his artistic vision, but his attitude toward the peasants whose daily existence he portrayed is not generous but patronizing. He's mocking them.

The humanity in Bruegel is not in the peasants but in the painting, and to understand this you have to think about how the painting is put together, what the shapes are doing, how the rhythms are working, how one set of patterns opposes another and then subtly unites with it. The richness of this visual experience is what gives life to the other kind of 'life', which is the painting's narrative content – everyday life in the early seventeenth century. And this same expressive richness changes Bruegel's original motivation (to fulfil a brief to amuse his patron with a

condescending image of low existence) into an experience that can't be pinned down and that remains truly deep.

I think the reproductions of the world's great art in this book speak for themselves. If you stick with the subject of painting and its histories, having read the book, you will find that painting never stands still. You only have to look at individual paintings for a short time, but if they're good you can come back to them again and again, and they'll always have something new to say. If this is your first encounter with some of these images then it will be a moment you'll look back on in the future and feel moved by.

The Rise and Fall of the Ancient World:

Egypt, Greece, Rome, China and the European Dark Ages

The history of painting is the history of humanity's struggle to come to terms with its predicament. The reasons why we are interested in art are the same as the reasons why we are interested in religion, philosophy or science. This is why great art is never only about beauty; it is also about the recognizably valuable human experience that it transfers from one person to another. Differences in time or culture can be reduced away by these expressions of eternal concerns and questions. The great classical and religious texts, like the Bible, the Koran or Plato's *Discourses*, have influenced the thought of different civilizations for thousands of years. But it is the ever changing art form of painting that has left us with a trail of individual testimonies to humanity's perennial obsessions.

Painting really begins about 20,000 years ago in the Ice Age caves of France and Spain. What began as scratchings on cave walls had developed into forceful and dynamic animal paintings by 15,000 BC. The bison and horses painted by the cavemen in Lascaux were not just decorations. They were serving that magical or religious part of mankind that has propelled the arts through most ages. Painting the beasts of the kill was probably their way of magically trapping them. Completely lost from view until the late nineteenth century, they were so sophisticated that they were thought to be hoaxes until as late as the 1940s.

This may be where it all started, but it is not where our linear art history begins. The interrelated story of painting, where everything is connected to what has come before, starts in Egypt in the Nile valley. Four thousand years ago, amongst the

building sites of the pyramids, artists were painting and sculpting those who were powerful enough to justify the privilege. Over 3,000 years of Egyptian culture has left a rich legacy of religious wall painting. The Egyptians used a different pictorial language from ours today, and painted to strict formulas, which can look stiff and alien to us now. It was not a time of artistic development – artists strove to replicate, not innovate – and the art was static, like that of the early Middle Eastern and Mediterranean cultures, which relied on geometric patterns and formulaic representations. But the example set by the Egyptians was to spark off a revolution.

Finally, thousands of years of emulating the past began to give way to new forms. The Greeks were taking risks; they questioned ideas of philosophy, democracy, art and science in what looks like a very modern way to us now. They had learnt from the Egyptians, but they took what they needed from them and founded western civilization with their new ideas. For the first time painting emerged where scenes were painted with something like reality in mind, not unquestioned tradition. The Greeks didn't achieve full perspective in painting, but they did discover how to shorten angles and give the impression of three-dimensionality, called foreshortening; now in Greece a human face could be painted from the side angle without the device of the eye being painted in a bovine fashion, as though it were being viewed from the front. This may seem a small change, but it was nothing less than a revolution – the beginning of art as we know it. Out went the slavish reproduction of handed-down models and in flooded questioning, invention and progress. These Greek painters (and their Roman followers who carried on their work) attained incredible levels of skill, which were unsurpassed anywhere until the Renaissance. But when the Roman Empire split in two in AD 395 and was dissolved in AD 476, the advancements of its arts were lost throughout Europe. Invading tribes destroyed what they could, and the civilization that created and appreciated the incredible statues and paintings of the period simply fell apart. To a small extent perspective, shading and other particularly Greco-Roman advances were held onto in some religious manuscripts of the new Latin and Greek Churches. The religious constraints on imagery in the Greek church meant that Byzantine art never came out of this phase of atrophy. It still continues to produce icons that have changed little since the days of Emperor Constantine in the fourth century. Like the earlier Middle Eastern and Egyptian cultures, it slipped into reverence for replicating the past. But in the same way that the Egyptians inspired the Greeks to greatness, the art of the Byzantines was the starting point for the Renaissance in the Latin Church in Italy.

While Rome was flourishing and Christ was causing trouble for the established pagans, 5,000 miles to the east the Chinese were painting their tombs in a similar way to the old Egyptians. They had comparable beliefs in the afterlife and painted similarly formulaic wall paintings, though in a more organic, curvaceous style. Not many early Chinese paintings have survived but like their close followers, the Japanese, they developed a rather different approach to painting from that of the Romanized West. Calligraphy was as prized as painting, even more so at times, so the painting traditions that grew up relied on well-defined ink outlines. The purpose of painting was very different too. It was less dominated by religious imagery, and was practised for a small, educated elite of nobles and bureaucrats. In landscape painting, it was tied to meditation.

Religious practices were a heavy influence on what the powerful Islamic world would represent in art. Artists were not encouraged to paint figures, so the human body was rarely used in art. Calligraphy and interlacing designs, or *arabesques*, were painted instead. This skill at pattern-making shows itself in the Islamic art of Persia and later in the Indian Mughal dynasty.

During this vast period Egyptian culture collapsed. China's institutionalized traditions continued developing but stylistically they found a form that they kept to for 2,000 years. The world of Islam focused less on painting than on mathematics and calligraphy, while the South American, Indian and South East Asian cultures left no significant painted artifacts amongst their breathtaking temples. Meanwhile Greece and Rome peaked and were then sacked by invading tribes, bringing the arts of the West to their highest level in history before they were almost totally forgotten until the thirteenth century.

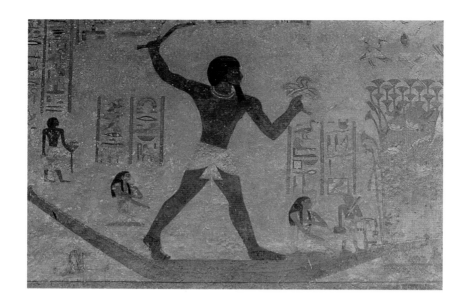

Egyptian Wall Painting

Wall painting from the Tomb of Khnumhotep II, c.1,900 BC
Beni Hasan, Egypt

THE PAINTING From this painting we can see that hunting in the marshes of the Nile was Prince Khnumhotep's favourite pastime. Finished nearly 4,000 years ago it was there to help him in the afterlife, like everything else in his tomb. The idea is as distant to us now as the picture may seem. The Ancient Egyptians believed that the soul contained three parts, two of which stayed with the dead body. If the body was not preserved and accompanied by the trappings of life, it could not have a good afterlife. So Egyptian tomb art had the important role of imitating real life, both accurately and symbolically. This is why Prince Khnumhotep's wives and son, at his feet, are so small. Hierarchy was crucial. If they were bigger than Khnumhotep then they would have been seen as more important.

THE ARTIST Egyptian painters had to follow strict rules, which dictated that everything had to be recognizable. Nothing could be left to chance because it might not transfer to the afterlife. So the torso is always viewed from the front, the head looks as it does in profile, and the feet are viewed from the side. To us it might look stiff and unnatural, but this approach served an important purpose, and continued to do so for 2,000 years. However, across the Mediterranean the Greeks did not have such religious constraints. They learnt to copy Egyptian art and then, seemingly out of nowhere, set it free from its shackles.

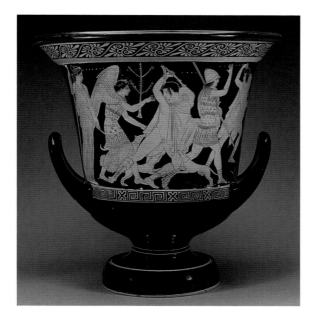

Attributed to **The Dinos Painter**

The Death of Aktaion, c.430–420 BC
Attic Red-Figured Calyx-Krater
49.2 cm (19½ in) high
Private Collection

THE PAINTING As punishment for watching the naked goddess Artemis bathing, Aktaion is transformed into a stag. His own hunting dogs rip him apart. This classic myth of sex and violence was later adopted by the Romans, and endlessly re-created in later European art. The painter is partly thinking like Ancient Egyptian artists, with each face still in recognizable profile, but everything else is in naturalistic action. The strict rules of representation have been broken and something totally new has been created. Aktaion's feet are seen from the front, not the side. The ability to draw in perspective and the invention of foreshortening were groundbreaking developments in art. The idea of painting things as they actually looked, rather than the way they would best be recognized, had taken over. The history of art as we know it begins here.

THE ARTIST The rugged inlets of the Greek peninsula were perfect hiding places for pirates. As these bands of hardy individuals grew richer and more established, their embattled ports and hilltops became the kingdoms of Greece. We can attribute certain paintings to large important workshops, but instead of any major remains there are just pots like this one. Ancient Greeks like the Dinos Painter applied their independent spirit and inventiveness to Egyptian traditions and carried art to its highest levels. Previously, artists had adhered to a rigid sequence of rules and formulas. The Greeks revolutionized art by questioning it, beginning a continuous process that rages to this day.

Roman Wall Painting

Hercules discovering Telephus, C.AD 70
Removed from the 'Basilica' at Herculaneum
Museo Archeologico Nazionale, Naples

THE PAINTING In the classic Greek stories of Hercules, we learn that he had a son, Telephus, by a woman who was sworn to chastity. For her crime Telephus was sent to die in the wilderness. Nursed by a lioness, he survived and was found by Hercules. Here he is feeding at the teat of a doe. This was a more acceptable scene for Roman eyes, who were used to seeing the legendary founders of their city, Romulus and Remus, suckling at a wolf. A lion – Hercules' symbol of strength – sits passively in the corner. After his ascent to Olympus to become a god, Hercules married his half-sister Hebe, the goddess of youth. She looks on, wearing delicate drapery, with attendants by her side. The eagle, their father's symbol, is perched between them. The picture is full of activity but is perfectly balanced. Although old, Hercules is still a god and has supple flesh, darkened by his twelve labours. The luminous skin tones, the drapery, the anatomically perfect figures and the advanced composition show how far Classical art had progressed. It is amazingly sophisticated, especially as it is just a wall decoration from a house in a provincial town. Renaissance artists strove to paint like this, but unfortunately all the skills they required disappeared when the Roman Empire crumbled in the fifth century.

THE ARTIST In AD 79 the Roman statesman and scholar Pliny rowed across the Bay of Naples to inspect the explosion of Vesuvius. Like all the inhabitants of Pompeii and Herculaneum, he was buried under the volcanic ash. Trapped and preserved, the bodies of residents and animals can still be seen here. Since the eighteenth century excavations have uncovered paintings like this. The quality of this one in particular shows just how far painting had advanced in the 500 years since the Dinos Painter's vase. It took another 1,400 years for anyone to come close to it again (further north, in fifteenth-century Florence). By the first century Rome had outstripped the Greek world and was busy buying up and copying Greek art treasures. The names of the greatest Greek and Roman artists are known from texts, like the fourth-century BC Greek painter Apelles, who was as legendary then as Michelangelo or Raphael are now. The great artist who created this painting, however, is as anonymous as the town's dead.

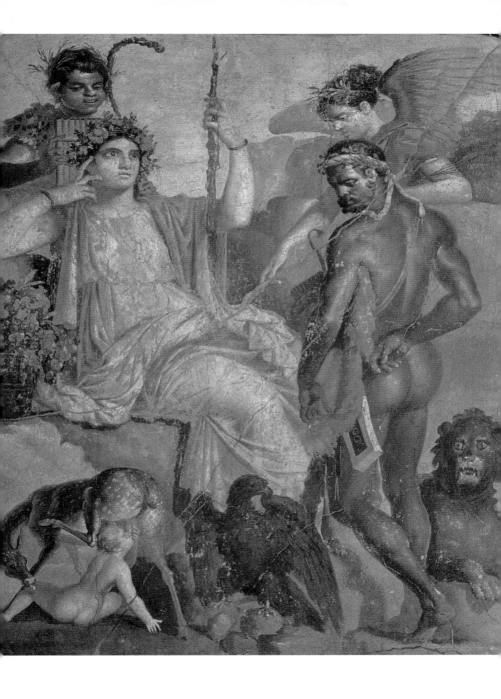

Egyptian School, Roman Period

Portrait of a Man, C.AD 80–140
Panel
38.8 cm (15¼ in) high
Private Collection

THE PAINTING This is the portrait of a mummified man, embalmed 1,900 years ago in Egypt. He has nothing to do with the ancient artistic traditions that accompanied dead pharaohs of 2,000 years earlier. He has been painted as his friends knew him. Affable and lively, he looks at us engagingly. Silhouetted against a pale green background, he is lit from one source, above his head on the left. It brightens his forehead and casts shadows under his chin. This technique was lost to western art until fifteenth-century Florence. The throws of his white robes look casual, painted in thick lively strokes. Free handling of paint like this did not appear again until sixteenth-century Venice. His pose, with body turned and his face looking directly at us, is another Renaissance rediscovery. Probably still in his twenties, his groomed beard and moustache are finely picked out. Far from being still and characterless, like previous Egyptian paintings of figures, this young man has all the sensitivity and humanity that we would recognize in a good portrait now. It feels very modern. Painted for religious beliefs in rebirth, based on an accurate image of the dead, it was placed over the face of the mummified man and buried with him. Yet the reasons seem immaterial now. They were essential to understanding earlier Egyptian art, but this painting is of a very real man, someone we could know. The reasons why it was painted are less important, as we naturally relate to this painting.

THE ARTIST The portrait was painted by an unknown artist, living somewhere in the Fayum area southwest of Cairo. Egypt had been part of the Greco-Roman world for 170 years by the time this was painted, and old Egyptian art would have looked as foreign then as it does to us now. Even to the artist, the old tried and tested ways of painting the dead would have long been forgotten. The demand was for Greco-Roman inspired art, and the strict regime that suited 3,000 years of pharaohs and grandees was swept away along with Egyptian independence. Egypt's cultural and political strength came to an end as the power of the pharaohs declined and the power of the priests increased. Alexander the Great took Egypt in 332 BC. From this time until the twentieth century the country was ruled by successive foreigners, her first native culture dead.

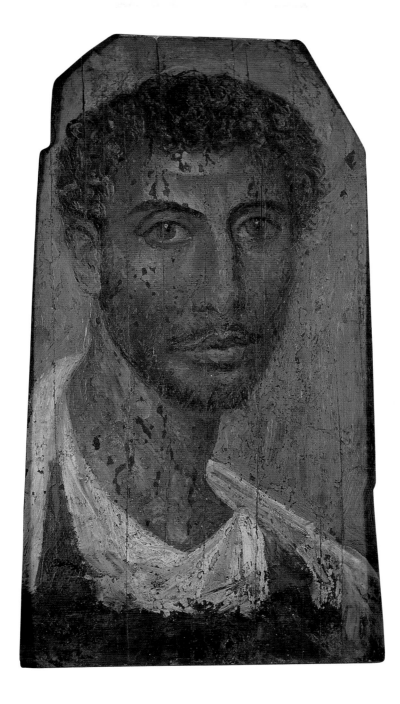

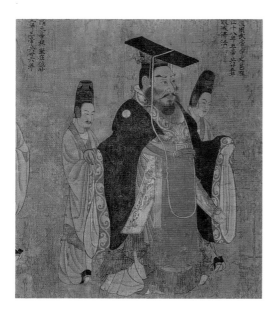

Attributed to **Yan Liben**

b. China c.AD 600; d. China AD 673
Emperor Wudi of Northern Zhou Dynasty,
from the 'Thirteen Emperors' scroll, 7th century
Ink and colour on silk
51 x 531 cm (20 x 209 in) – total size
Museum of Fine Arts, Boston
Denman Waldo Ross Collection

THE PAINTING Most ancient Chinese painting, like that of the Ancient Greeks, has vanished without trace. This rare painting, a detail from a massive scroll, shows Emperor Wudi with his attendant eunuchs. Just as in Egyptian pictures, the eunuchs are smaller to show that they are less important. Amazingly, despite working within these artistic constraints, the Chinese made the same innovative leap that the Greeks did. Liben put the eunuchs behind Wudi, creating a naturalistic painting as well as increasing the grandeur of the Emperor. Chinese art has always been about drawing with ink, and Liben was one of its great masters. Here we get the impression of a round, solid Emperor, just from the outline. Drawing directly on to the silk scroll with pen and ink, Liben gave volume to the sleeves and body by very simple lines, and added colour later.

THE ARTIST Liben forced Chinese attitudes toward art to change forever with his intensely realistic drawing. Like artists of the European Renaissance 900 years later, he transformed the practice of a painter into the notion of an artist. He was the first in a long line of Chinese artists who were also scholars and important civil servants, and he helped to elevate painting, like calligraphy, to be considered one of the highest intellectual and spiritual attainments. Liben worked in a culture vastly different from one we would recognize, but here he has managed to capture an individual of dignified majesty who could belong anywhere.

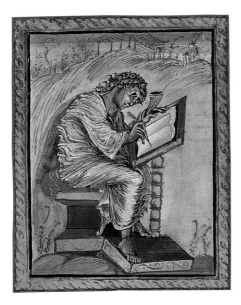

French School

St Matthew
From the Ebbo Gospels, painted at Reims, C.AD 816–23
Vellum
25.4 x 20.3 cm (10 x 8 in)
Bibliothèque Municipale, Epernay

THE PAINTING St Matthew sits awkwardly over his lectern, his face and eyes screwed up in obedient but terrified concentration. God is channelling His gospels through Matthew, who anxiously gets them down on paper. His wild hair and the electric folds of his robes tremble with the power of his calling. The fast flicks of gold paint in the landscape mirror the intensity of emotion; the immediate strokes reflect Matthew's frantic writing. The painter believes in the excitement of this moment – it is in every brushstroke. It was a painting created by the faithful for the faithful, in a time of belief. From the end of the Roman Empire until the beginning of the Renaissance, art was simple communication with paint. The painter copied the image from an old Roman original, but instead of blindly mimicking it he made an original and vivid painting full of movement and immediacy.

THE ARTIST Christianity was only 800 years old. It was battling with paganism and, at the borders in Spain, with Islam. The first Holy Roman Emperor, Charlemagne, had died only two years before the Bishop of Reims commissioned this gospel, and the future of the Christian world inhabited by our nameless artist-monk was very unsure. Devoted to God and to the spreading of His word, painting would have been one way to express his faith. We cannot imagine the deep religious reverence of a man living in these conditions, but we can certainly appreciate the fervour he left us in paint.

Attributed to **Xu Xi**

b. China *c.*1020; d. China *c.*1090
Travellers in the Autumn Mountains, 11th century
Ink on silk
141 x 96.5 cm (55^1/$_2$ x 38 in)
Private Collection

THE PAINTING We can look at this painting and simply see it as an evocative landscape, without ever worrying about the reasons why it was made. It is a beautiful mountain landscape, with gnarled trees jutting out on rocks receding through mists, a temple near the top, a stream running down to a lake and a horizon of endless mountains off to the left. We don't know if the mountain carries on up, and it doesn't matter, as everything we need in a landscape is here. To western eyes it might look odd as we are used to long landscapes with a focus in the foreground, whereas here everything is in the middle and higher. And it's colourless. For thousands of years Chinese painting has been based on fine outlines of ink, and colour in this kind of painting would distract from its purpose. It wasn't painted just to be a pretty picture, like a western landscape – looking at this was an act of meditation, bringing the viewer to a spiritual state closer to Buddha. The Chan sect of Buddhism, the largest at the time of this painting, said that rituals and religious study were a waste of time. Buddha existed in everyone, and could be reached by meditating. In the highest state of meditation you could see the 'Absolute Principle' of all life. Meditating on nature, or art that represented the unity of nature, was a way to do this. There were many ways to judge how well a painter was helping you to attain this high spiritual state, and the best at it were hugely important figures. Acting as a sort of spiritual guide, Chinese landscape painters were more important and more venerated than other artists anywhere in the world.

THE ARTIST In Xu Xi's *Advice on Landscape Painting*, he wrote about the need for paintings like this so that everyone could satisfy their spiritual need for wholeness between themselves and nature. By everyone, he meant the artistic and spiritual elite who could understand the principles of high art and meditation; the peasant masses didn't come into it. Not every wealthy court official and city dweller was lucky enough to have time to contemplate nature, and so Xu Xi's help by painting these scenes was well rewarded. He was a member of the Sung Dynasty's Imperial Academy for sixty years, and is regarded as one of China's greatest landscape artists.

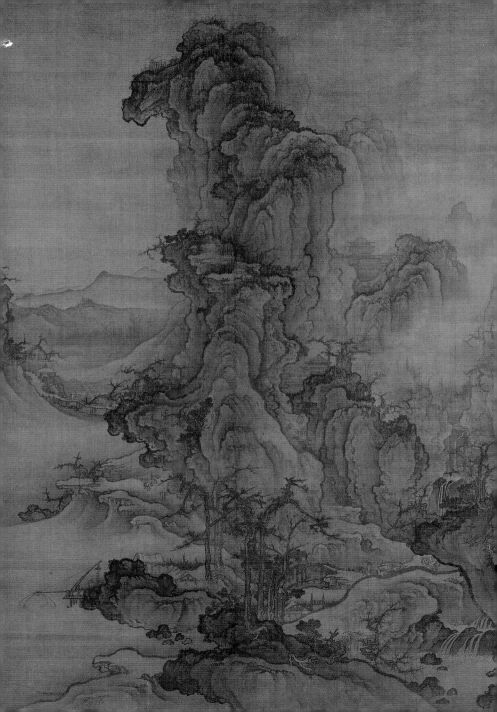

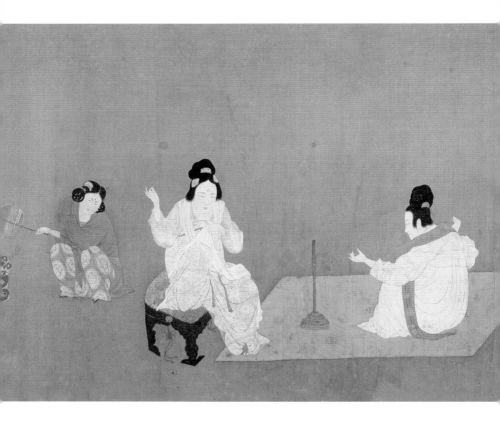

Attributed to **Emperor Huizong**

b. Gansu Province 1082; d. Heilongjiang Province 1135
Court Ladies Preparing Silk (detail)
Ink, colour and gold on silk
37 x 145 cm (14¹/₂ x 57 in) – total size
Museum of Fine Arts, Boston

THE PAINTING This is just one detail from a four feet long silk scroll. It was painted to be slowly unfurled, for private viewing. Its bright colours make it very different from the meditative, monochrome landscapes of Xu Xi. It is also very unlike painting in the West, which at that time was for public display. In this scene the elegant court ladies are beating the newly woven silk. They stand very close together, and although there are no shadows or other more western methods of defining solidity, somehow they still seem to be standing in real space. Yan Liben's advances in outline drawing had been fully mastered by this time. The ladies are busy in a moment of concentration, and it is this sort of intimacy that gives Chinese art its sense of informality. However, this is a highly considered informality. The academic traditions in China were much stricter than those in Europe 600 years later. In academic reverence to a master of the past, the Emperor copied this from an earlier painting by Zhang Xuan. We know

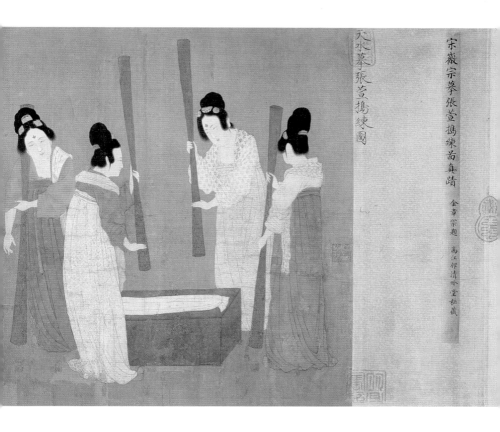

this because his grandson, Emperor Zhangzong, wrote this information on the scroll eighty years later, imitating Huizong's own calligraphy.

THE ARTIST In China it has never been rare for emperors to paint, but Huizong took it so seriously that the entire Northern Song Dynasty is thought to have fallen because of it. He was from a long line of artistic emperors, who added to the Imperial collections and held discussions about painting, calligraphy and art collecting. Collecting for Huizong was easy – if he wanted a painting, the owner would have to hand it over. When he inherited the throne, aged nineteen, it was expected that he would continue his ancestors' enlightened royal patronage. This he did, but spent so much of the next twenty-five years immersed in art and religion that he ignored his official duties. Xu Xi influenced his landscapes, but Huizong's style was pretty individual. Because of his position his painting was officially considered to be a work of genius. Early art historians called him 'divine' so it's difficult to know exactly how important he was to Chinese painting. In China it was considered an honour, not a forgery, to sign an artwork with the name of a great master, so there are more paintings around with his name attached to them than he had a hand in actually making.

Persian School

Temujin proclaiming himself Genghis Kahn, 14th century
Ink and gouache on vellum
Bibliothèque Nationale, Paris

THE PAINTING The warrior Temujin celebrated his uniting of the Mongols, in 1206, by crowning himself Genghis Khan. Meaning 'ruler of all', this ambitious title was earned by conquering and enslaving every nationality from Eastern Europe to China. This simple picture, painted in thick watercolour known as gouache, commemorates his triumph. He sits in his tent at the centre of the scene, surrounded by the soldiers and officials that made his vast and bloody empire run so mercilessly well. Above, the deep blue sky is filled with trailing flowers and branches, which are strangely missing from the ground. This is deliberate, as it mimics a Muslim prayer mat. Flowers replace the intricate patterns of eastern carpets, while the tent stands in for the kneeling area that always points to Mecca. The picture draws on a curious and subtle intertwining of secular art and religious undercurrents, and shows interdependence with the ancient Oriental cultures. The calligraphy plays its part too, both for its decorative finesse and for the explanation it gives. The art of calligraphy was thought of as highly as it was in the Chinese and Japanese traditions.

THE ARTIST Islam's founder Mohammed (d. 632) did not encourage painting as a form of religious expression. It was not banned, it just didn't have a place in the Koran. This explains why painting in the otherwise highly developed Islamic world did not advance as it did elsewhere, and why the painter of this image had to rely on a prayer mat for inspiration. Like Egyptian, Chinese and European cultures, the arts of the Muslims were formed by their religious beliefs. Mohammed considered architecture to be wasteful, and lived in a hut for most of his life to prove his piety. The making of religious figurative images was an abomination to him, and so his followers turned their backs on what they saw as unholy or wasteful practices of producing art. While architecture and other forms of art with geometric patterns nevertheless flourished, like at the Palace of Alhambra in Mohammedan Spain, this artist probably wasn't encouraged much as a figurative painter. He is likely to have gained more employment as a calligrapher. Though Persian artists couldn't paint many pictures like this, they did go on to have a huge effect on the Islamic art of the Mughal Empire in India.

حکایت

فوریلتای بزرگ جنگیزخان نوبتی سیله ... بایه بضب فرمود و لتبته جنگیزخان بوه مقذر
کث و عزیمت اوجنگ بوبرون بازشاه بگر ... امان و کونتن بر روزن ده بدر را جون سیارکی و فرخی بارس سال که سال بوزباشده بوانق
سال رجب سنه سین و سته بعه بهجری در آنرم در ذا آمد با فضل بارجنگیزخان فرمود مانوفی ده بایه سیه ربای کرده نده معینی کرده ... باعطت
فوریلتای بزرگ لبب بزرگ جنگیزخان بروی معزز کردنه و سیارکی و بخته نشت

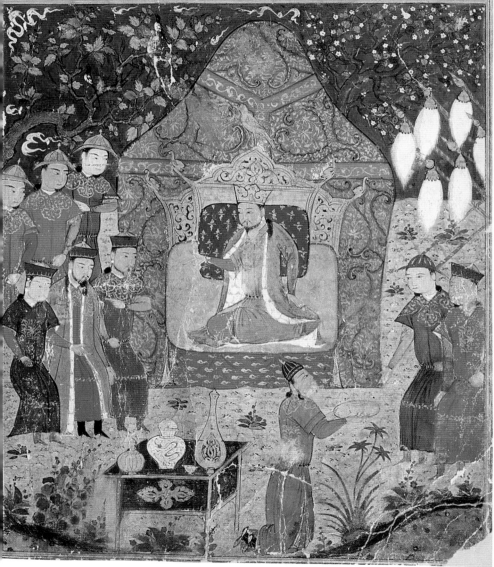

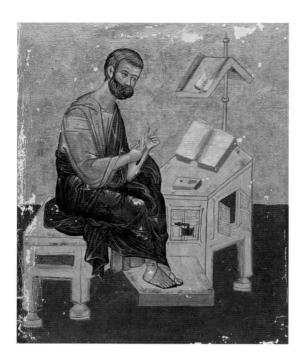

Byzantine (or Georgian)

St Mark
From a series of four saints probably
from a gospel, 16th century
Paper
23 x 19 cm (9 x 7¹/₂ in)
Private Collection

THE PAINTING Christian art was being made in the
sixteenth century that was, if anything, a backward
step from the French School *St Matthew* painted in
Reims 700 years earlier. This was because the art of
a vast region of Eastern Europe and the near East
stood still for 1,000 years, as dead and lifeless as
Egyptian art had become 3,000 years earlier. In the fourth century the Roman Empire split in two,
with one capital in Rome and the other in Byzantium (modern Istanbul), making two vast
Christian empires (the Latin and Greek Churches). By the ninth century the Greek Church decided
that religious art was a window to the Divine and that mere artists should not be trusted to paint
His likeness. So, in the style of ancient cultures of the past, the Eastern Church entered into a period
of artistic limbo, producing icons to be worshipped that were copies or variations of existing
paintings. That's where our St Mark comes in; with none of the life or expression of the Reims St
Matthew he is little more than an eastern copy of an old Roman original.

THE ARTIST This anonymous hand probably worked in Istanbul, which by now had been
taken by the Muslim Ottomans. Painting for an ever-diminishing group of Christians, the artist
had to use paper rather than expensive vellum. In Muslim Istanbul this was outpost art, the
naturally entrenched artistic views of the artist's patrons being only increased by their isolation.

The Italian Renaissance:
Cimabue to El Greco

Renaissance means 'rebirth' and by the fourteenth century this is exactly what artists began to think themselves a part of – the rebirth of the Greco-Roman world. They were self-consciously rebuilding everything the Ancients stood for, from architecture and science to sculpture and art. For almost 1,000 years painting in western Europe had languished. It was left either to monks to reproduce holy images or artisans to paint simple wall decorations under the direction of their employers.

But the towns of northern Italy were growing rich on international trade, while imported goods and ideas were flooding in and slowly transforming the structure of society. Merchant princes were emerging to challenge the authority of the church. Up until then religion had controlled life as it had done since the Middle Ages. But by 1309 the rising urban middle classes were gaining such power and wealth that the ensuing struggles between them and the papacy led to the pope moving his residence to Avignon in France for nearly seventy years. It was against this shifting backdrop that artists like Giotto in Tuscany began to go beyond what was expected of simple painters, to create magical images like no one had ever seen before. No Classical paintings had been unearthed by the time of the Renaissance, but Classical writers were widely read and from these texts it was known that painting was highly regarded. If the Ancients thought painting was worthy of an elevated place in their world, then it was felt it should have the same in the present one. Giotto was the first artist to approach the naturalism that was written about by the Ancients. He re-founded painting, and his influence on the next generation of Florentine artists is

total. But the rising tide of the International Gothic style slowed down changes until Masaccio came along in the 1420s. It's with him that Renaissance painting really gets going. By now the public was ready to see advances in painting as part of the blossoming of literature, science, commercialism and discovery that was changing the world around them. Artists of all kinds were exchanging ideas.

The brilliant architect Filippo Brunelleschi, working with precise architectural drawings, realized that to give a picture realistic depth all parallel lines should converge on one single vanishing point on the horizon. He had discovered linear perspective, the one great advance that the classical world hadn't made. Brunelleschi's friend Masaccio took up his scientific idea and applied it to *The Holy Trinity* tomb painting and his other frescos. It had never been done before. It revolutionized painting and became the keystone that held western painting together until the end of the nineteenth century. But Masaccio did even more than this. He gave his figures gravity and solidity by shading their contours and lighting them strongly from one light source. He had put together every element that characterized the art of western civilization from that moment onward – the realism of seeing paintings as a window on the world (something particular to Europe), perspective, naturalistic lighting, and shading to create three-dimensionality. But the end of Masaccio's short life did not close the door on his inventions. His methodical inventiveness and disregard for past convention became the hallmark of Renaissance vigour. In the fifteenth century he was followed in perspective by Uccello and Mantegna and in naturalism by Piero della Francesco and Verrocchio, while all the other artists of the time absorbed the new developments in one way or another. The artists working in the old Gothic style like Gozzoli borrowed from these new fangled ideas to tart up their paintings, but didn't actively pursue the scientific goals of true Renaissance artists who were trying to build new understandings about art. The next wave of great artists to do that was Leonardo, Raphael and Michelangelo. They were all active around 1500 to 1520 and defined that period as the High Renaissance. Leonardo had just finished his *Last Supper* in Milan, which set new standards in realistic picture space and animation. He completely did away with the traditional signposts that identified the disciples, and allowed their individual expressions and groupings to explain the scene instead. His scientific work led to his invention of aerial perspective. In light, the wavelength of the colour blue is shorter than the other colours in the spectrum. This makes distant things like the sky seem blue. By applying this to his landscapes Leonardo created more realistic distant viewpoints. He

also improved Masaccio's developments with light and shade (called *chiaroscuro*). By building up layer on layer of glazes he softened the harsh outlines, a technique called *sfumato* (meaning faded or smokey). Both aerial perspective and *sfumato* are best seen in his *Mona Lisa* of 1503.

Florence was the capital of the arts, but by 1500 both Rome and Venice were real rivals to Florentine ingenuity. Michelangelo's dynamic figures in the Vatican's Sistine Chapel influenced painting from the moment they were created. The human figure had never been so fully explored. His young contemporary Raphael, working on smaller scale easel paintings, created balance and subtle harmonies of lighting and *chiaroscuro* which became the ultimate goal for centuries of European academy painters. These three artists brought painting to such a height that it was beginning to be felt that painting had reached its climax and couldn't go any further. But that wasn't the view of the Venetian Titian. He created a completely new way of painting. The outlined figures of Michelangelo, Leonardo's *sfumato* and Raphael's use of subtle *chiaroscuro* became meaningless to the Venetian, who brought oil painting to its freest and most expressive yet. But not everyone was turning to expressions of emotion. The search was on for the ultimate in beauty in the paintings of the Mannerists like Parmigianino. But the search was an elusive one. Elongated limbs and contrived elegance was a pretty style for a while, but it wasn't solving anything in painting in the way that perspective, colouring, lighting, solidity, depth and composition had done earlier. It was a dead end. And though powerful individual ideals carried on, like the rampant godly emotionalism of El Greco, the intellectual drive of the Renaissance had passed away by the mid-sixteenth century.

Cimabue
(Cenni di Peppi)

b. Pisa c.1240; d. Pisa 1302
Madonna and Child Enthroned with Six Angels, c.1270
427 x 289 cm (168¹/₄ x 113³/₄ in)
Louvre, Paris

THE PAINTING The advances in Roman art that were lost throughout Europe during the Middle Ages were partly preserved in Byzantine art. Those artists in the eastern Mediterranean who dutifully copied the earliest Christian images were holding on to some vestiges of solidity and perspective, if only by accident. By the thirteenth century the demand for these images across northern Italy had become huge. Cimabue, working in this popular imported style, was on to a good market. He had a major advantage over his artist cousins in Constantinople – he wasn't Greek orthodox. The religious restrictions that confined them to repeating imagery didn't apply to him. So like the Greeks who leap-frogged Egyptian art, Cimabue took the best of a foreign, static art and developed it into something wonderful. His Madonna sits enthroned on high. Twice life-size, she is a giant looking down at us. Like the flanking angels she smirks with a palpable sense of superiority. Each figure is painted in new, light, pastel shades and the more realistic skin tones that Cimabue had developed, all surrounded by dazzling gold leaf. It was awe-inspiring. Its once immense power as a religious image may have diminished over time, but it is easy to see how these haughty faces from heaven inspired the masses to worship, and the next generation of artists to paint.

THE ARTIST In thirteenth-century Italy Cimabue became the first 'star' painter. In the sixteenth century Vasari began his influential art history, *Lives of the Artists*, with Cimabue telling us that he let 'the first light into the art of painting'. His mastery of the Byzantine style and the developments he brought to it made him the talk of Pisa. Fame led to his legendary arrogance and pride. He preferred to destroy his paintings rather than hear them criticized. His obstinate attitudes earned the nickname 'Cimabue' meaning 'ox-head'. But his openness to new techniques, like the innovative sculptures of Nicola Pisano, helped to breath new life into Italian painting. Dante gave him lasting fame, of a sort, when he wrote in his *Divine Comedy*:

> Once Cimabue thought to hold the field,
> As painter; Giotto now is all the rage,
> Dimming the lustre of the other's fame.

Unfortunately for Cimabue, Dante was right. Cimabue may have given new life to the old techniques, but Giotto was about to do something much greater.

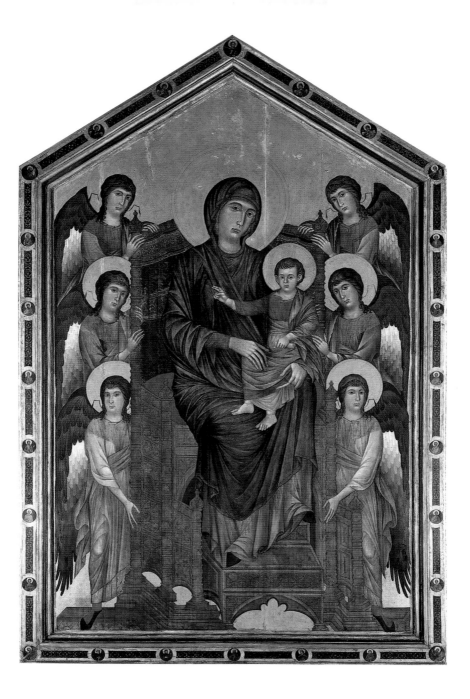

Giotto di Bondone

b. Vespignano, nr Florence *c.*1267; d. Florence 1337
The Dream of Joachim, *c.*1305
Fresco detail
Scrovegni Chapel, Padua

THE PAINTING If any one series of paintings can be called the most important in the history of western art, it would be Giotto's in the Scrovegni Chapel. Built by the son of a notorious moneylender who hoped it would atone for his father's sins, this painted barrel of a room is like a mini Sistine Chapel. The blue, starry ceiling rises above a painted architectural framework of inlaid marble and statue-filled niches. Each panel tells a different biblical story. In this detail Joachim, unhappy with his childless marriage, has gone out with the shepherds to grieve. We see this just as the angel appears to tell him his wife is pregnant, with Mary, Mother of God. What was so new here, and so important, was that Giotto had painted a much more realistic scene than anyone was used to. It's not just the foreshortening and three-dimensionality, though it is far better than anyone had seen since Classical times. Giotto has also painted emotionally real people, who are more important than the angel's revelation. His bright, original colouring and feeling-filled characters must have seemed like scenes from real life compared to the rigid, fully frontal Madonnas of Cimabue.

THE ARTIST The old world was swept away by Giotto. Even in his own lifetime he was seen as the most significant thing ever to hit art. He wasn't working in an artistic vacuum, but it is fair to say the Renaissance began with Giotto. A contemporary writer said he 'translated the art of painting from Greek to Latin and made it modern'. He was able to translate it because he knew the old style; legend has always put him as a pupil of Cimabue. But its limitations forced him to think up totally new ways of painting. He threw away all the old conventions and created new compositions, which for the first time had real pictorial space, depth and subtle feeling. The blank staring faces of Cimabue were gone forever. Giotto put humanity back into painting and the public loved him for it. He almost single-handedly turned the old view of the painter as a simple craftsman on its head. He showed people that a good artist was a master of original, subtle thought. With Giotto came the celebrity cult of the artist. From now on the history of art becomes not just a list of what was painted when, but the history of great artists.

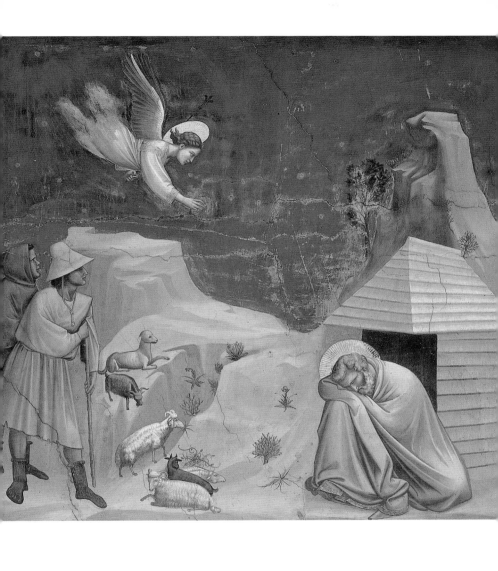

Masaccio
(Tommaso di Ser Giovanni di Mone)

b. San Giovanni da Val d'Arno 1401; d. Rome 1428
The Banishment of Adam and Eve, c.1427
Fresco detail (after 1989 restoration)
Brancacci Chapel, Santa Maria del Carmine, Florence

THE PAINTING Masaccio's most important work is the fresco series in the Brancacci Chapel, and this is its most famous detail. Florentine artists such as Fra Filippo Lippi, Piero della Francesca, Fra Angelico, Michelangelo, Leonardo and Raphael all came to learn from it. It shows his mastery of depth, gravity and form, combined with his ground-breaking new use of light. Look at the shadows cast by the rising sun on Adam and Eve's bodies and on the ground under them. No one had previously understood that solidity and gravity in painting lay in this use of one true light source. Giotto had moved a step away from Cimabue's two-dimensionality, but Masaccio actually solved the problem of flatness. He also expressed human emotion in a way that is totally recognizable to us today. As Adam and Eve are expelled from Eden, feelings of shame and despair are in their sobbing, hidden faces and their heavily anguished movements. We hardly even need the spitting voice of God following them out of the gates. But Masaccio's giant leap into understanding light, solidity and gravity was too advanced for most to follow, and it took another generation before it was fully appreciated.

THE ARTIST The sixteenth-century art historian Vasari categorized painting in three progressive stages, with Giotto, Masaccio and Leonardo as their founders. Masaccio – which means 'Messy Tom' because he was too into art to care about how he looked – was to have a profoundly important influence on other artists. He is credited with founding, with Giotto's influence, the entire Florentine school of painting. Without him Raphael might never have become a great artist. Masaccio understood the new laws of architectural perspective developed by his Florentine contemporary, Filippo Brunelleschi, and with them conquered the problems of perspective in painting for the first time ever. His *Holy Trinity* tomb fresco, with its classically columned alcove painted on a wall, amazed those who first saw it. To fifteenth-century eyes it looked like a deep room had been created in the church wall, and his dramatic use of perspective spread fast. He also took the breathtakingly realistic new sculptures of Donato Donatello and transferred their sense of solid reality to painting. No one else had managed to do either. But at age twenty-seven, Masaccio was dead (Vasari thought he was poisoned). His titanic talents were gone before he could transform the art of fifteenth-century Florence, and indeed Italy, any further.

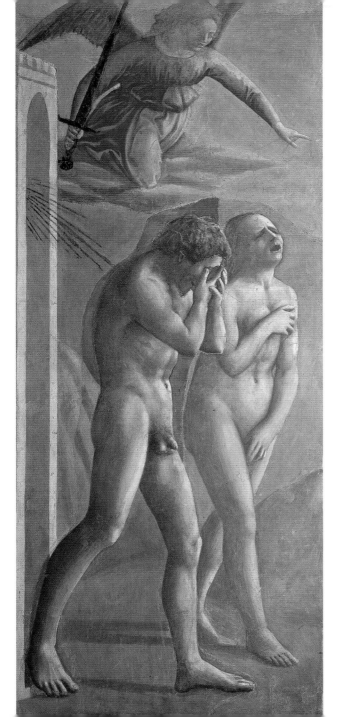

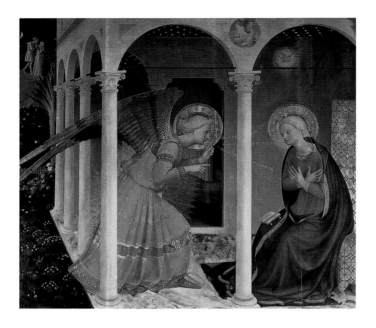

Fra Angelico
(Guido di Pietro)

b. nr Vicchio c.1395; d. Rome 1455
The Annunciation (Cortona Alterpiece), c.1438
Tempera on panel
175 x 180 cm (69 x 71 in)
Museo Diocesano, Cortona

THE PAINTING In Fra Angelico's first mature painting, the Archangel Gabriel visits Mary to tell her she is pregnant with the Son of God. He uses his expertise at painting the new architectural perspective to place her in a perfect Classical building. Gold shimmers everywhere, and the angel is a beautiful piece of heavenly propaganda. The gold leaf and hard porcelain faces echo earlier Gothic fashion like Cimabue's. Fra Angelico knew what the public wanted. It was still the popular taste, so he simply used the parts of it that he liked and stuck them on to the new style, creating a picture full of old-world Gothic symbolism. Outside, the enclosed garden is full of flowers, symbolic of Mary's virginity. The cobalt-blue sky on the ceiling mirrors her cloak to remind us that she is the Queen of Heaven. On the hill Adam and Eve are thrown out of Eden, and they are the only parts of the picture not painted in brilliant colours. Mary's child will redeem their original sin and bring them, and us, back to brilliance.

THE ARTIST Fra Angelico was a painter and Dominican friar who became one of art's most publicly loved characters. Angelico, meaning 'angelic', is a fitting nickname. He painted for deeply religious reasons, but he did it, as in this picture, with humility, wearing his learning and considerable skill lightly. He joined the monastery of San Marco in Florence when he was only seventeen and stayed there, painting frescos, all his life.

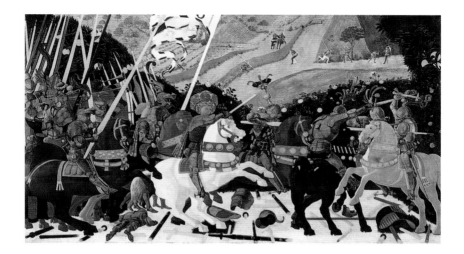

Paolo Uccello
(Paolo di Dono)

b. Florence c.1397; d. Florence 1475
The Battle of San Romano, 1432
Tempera on panel
182 x 319 cm (72³/₄ x 125¹/₂ in)
National Gallery, London

THE PAINTING This is one of the most striking and enigmatic of all Renaissance paintings. It looks like a surreal Gothic fantasy of toy soldiers. When Florence destroyed the Siennese knights at San Romano in 1432, Lorenzo 'The Magnificent' Medici had the battle commemorated with this picture, as part of a set of three huge paintings that hung in his bedroom at the Medici Palace. The soldiers are led from a brilliant white charger; a lance skewers the armour of the one on the right, and there are broken and lost weapons everywhere. But the lance shards aren't randomly placed. They pull us straight into a scene of calculated perspective, each lance drawing us to the distant central vanishing point. Uccello's fallen knight in the left corner is a virtuoso performance of foreshortening, looking rather odd to us but amazingly new in 1432. This picture, however, has always looked unnatural. Uccello followed a dream of perfect perspective, and filled it with old-fashioned Gothic brilliance without any of the realistic lighting of Masaccio.

THE ARTIST Uccello was a true eccentric, completely obsessed with perspective. He famously told his wife, when refusing to go to bed with her, that perspective was his favourite mistress. He died a pauper because of this single-mindedness, as one of the true founders of the Renaissance, dedicated to ideas not commissions. Uccello's intellectual, medieval fantasies struck a chord with twentieth-century viewers. He has never been so popular, being lauded first by the Cubists, then the Surrealists.

Fra Filippo Lippi

b. Florence c.1406; d. Spoleto 1469
The Barbadori Alterpiece, 1437–38
Tempera on panel
217 x 244 cm (85¹/₂ x 96 in)
Louvre, Paris

THE PAINTING This is the first painting of a kind that dominated religious art for centuries. For the first time the Madonna and Child are placed with the other people in the room, not enthroned above them. The throne is still there, but the artist can't bring himself to use it. The Virgin walks down to us, as much a part of our world as the kneeling saints. Filippo Lippi liked the tradition of making her larger than life, so he ignored the new developments in perspective and made her bigger than the saints. He used perspective perfectly in the background because it suited him, although it confined him to one distant viewpoint. To compensate for this constraint, the space is filled with angels, looking in all directions like day-dreaming school kids. Their colours and wings intentionally break up the harsh sense of depth. It is as if he is saying, 'I'm better than your rules, and here's the proof'. He didn't care what people thought, in art or in life. He was looking for his own answers to the questions of art, and borrowed where he liked. We can see Masaccio in the solid monumentality of the figures, and the delicate faces are developed from the Gothic style that still seems stiff in the faces of Fra Angelico's *Cortona Alterpiece*. (Filippo Lippi's faces later became the trademark of his pupil Botticelli.) This incredible mixture of influences shows a Renaissance artist struggling to find the perfect path.

THE ARTIST Filippo Lippi was a friar by accident rather than vocation. Brought up in a convent as an orphan, he was inspired to paint by watching Masaccio do his best work in the convent's Brancacci Chapel. He stayed and took orders, but it didn't take him long to have an affair and two children with a nun. Putting his intimate knowledge of her body to good use, he used her as a model for most of his Madonnas. The devout life and work of Florence's other painting friar, Fra Angelico, now seemed all the more 'angelic'. Filippo Lippi never married, but still managed to use his influence with the Medicis to get Pope Pius II to absolve his, and the nun's, monastic vows. His colourful autobiography mentions his kidnap by Moorish pirates, while there is also an account of his captivity and torture in the Medici Palace for embezzling funds. He escaped through a window with a rope made from his sheets.

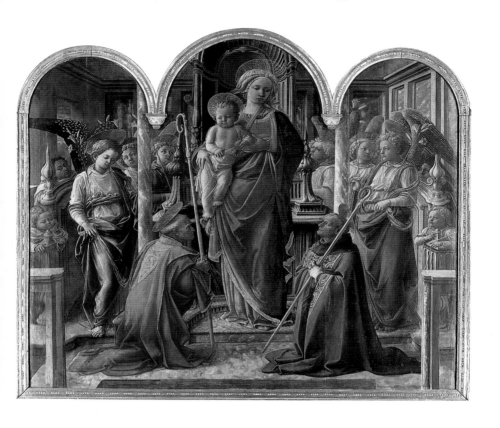

Piero della Francesca
(Piero dei Benedetto Franceschi)

b. Borgo San Sepolcro c.1410–22;
d. Borgo San Sepolcro 1492
The Dream of Constantine,
from *The Legend of the True Cross* cycle, c.1452–57
Fresco, 329 x 190 cm (130 x 75 in)
San Francesco, Arezzo

THE PAINTING Piero della Francesca's greatest fresco is the monumental but serene *Legend of the True Cross*. In this panel the Roman Emperor Constantine sleeps in his camp the night before a critical battle with Maxentius. His bodyguard sits at his bed, while two perfectly uniformed Roman soldiers balance the picture. They look like stage-hands holding open the curtains. In the Emperor's dream an angel told him that if he fought the battle as a Christian he would win the day. The dream is the supposed reason for the Roman Empire's conversion to Christianity. Not wanting to distract us from the grandeur of the story, the artist sets the whole scene up with just a tent, four figures and an angel. What is really new here is the sense of light and shade, used to give everything solidity and depth. The angel appears in a flash of light. The guards don't notice, as it is Constantine's dream. The angel is not in a position people would have recognized. It is foreshortened at a difficult angle and its face is hidden. Only the urgently pointing finger and outstretched wing tell us who it is. Piero della Francesca combined Masaccio's lighting and depth with Uccello's perspective, and pointed the way to the High Renaissance for artists like Michelangelo.

THE ARTIST Like Botticelli, Piero della Francesca fell out of history almost as soon as he died. He was influential to many north Italian artists but the public forgot him. Even the Renaissance art historian Vasari couldn't find much to say about him. Unlike other Tuscan artists he wasn't drawn to big artistic centres like Florence. A small-town man, he stayed in his beloved Borgo San Sepolcro, painting it in his landscapes and serving there as a councillor. He painted in other small towns across Tuscany, but then gave up painting to stay at home and write perspectival and mathematical theory. For centuries most of his paintings were tucked away in far-flung churches, which could explain his obscurity. Like that other perspective theorist, Uccello, he was only recognized in the twentieth century as a towering figure of the Renaissance. The monumentality of his figures and the light crispness of his colours woke people up to his art. Or maybe unconsciously it has got more to do with our post-Cubist eyes and affinity with the Surrealists that his tough and austere paintings appeal so much more to us today.

Benozzo **Gozzoli**

b. Florence c.1421; d. Pistoria 1497
Journey of the Magi, 1459
Fresco detail
Palazzo Medici-Riccardi, Florence

THE PAINTING Lorenzo the Magnificent, who commissioned Uccello's *Battle of San Romano* and imprisoned Fra Filippo Lippi for embezzling, is in the middle of this caravan of incredible pomp. Idealized as a handsome young king – which he certainly wasn't – he glitters in gold on a perfect stallion. The painting is part of his tiny chapel in the Medici Palace, and stands out as one of the century's best-loved paintings. Dressed up as a religious theme, as the three kings on their way to Bethlehem, this painting is actually all about the power and wealth of the Medici family. With Lorenzo at its centre, the parade is a who's who of fifteenth-century society, including his friend Constantine XI who died when his empire fell to the Turks six years earlier. The whole thing was painted to flatter the Medici's quasi-royal status and to help their papal ambitions. Lorenzo was busy pulling strings to get his son Giovanni made pope, which he managed a few years later with the help of grand displays like this painting. The artist even put his own portrait in the background. His painting style was very popular all over northern Italy. The combination of old and new filled a void left between the old Gothic style, used for the mountains, and the ultra-modern perspective paintings from which the foreground figures borrow their sophistication. That said, this painting is undeniably beautiful. It doesn't matter to us that the rabbit and dog up the mountain are bigger than the hunter. It is populist art, painted with skill.

THE ARTIST Gozzoli was a pupil of Fra Angelico but wasn't interested in following his path. Fra Angelico's art was in the service of religion and had a humble integrity that was always admired. Gozzoli's motives were different. He mixed up styles that he thought would sell – and they did. He knew a lot of the new techniques but was not too bothered about what they meant for art. Gozzoli was the last painter in the most developed and glitzy Gothic style. He managed to give the Florentines the traditional Gothic they still loved, but improved it with new tricks of perspective, solid volume and lighting, making them feel that they were keeping up with new trends without having to understand where Renaissance art was really going. He didn't challenge anyone or pose hard questions, which made him popular in his lifetime, but he had no artistic followers.

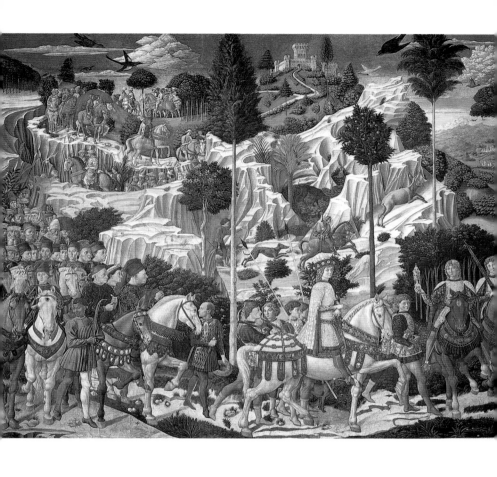

Andrea **Mantegna**

b. Isola di Carturo, nr Padua 1430–31; d. Mantua 1506
St Sebastian, 1459
Tempera on panel
68 x 30 cm (26³/₄ x 12 in)
Kunsthistorisches Museum, Vienna

THE PAINTING The colour and stature of Sebastian's body echoes the cold dignity of the Classical column to which he is tied, while his attackers casually stroll up the path. His body has become a pincushion, but his expression is one of unquestioning faith and resignation. This is martyrdom at its noblest. However, Mantegna has manipulated this Roman scene. Sebastian was a praetorian guard in third-century Rome, when there were no ancient ruins in the city. Though we are supposed to see the broken arches as a reflection of Sebastian's steadfast dignity, to fifteenth-century viewers they were pagan relics always doomed to be destroyed. Only Christianity, embodied in Sebastian, was everlasting. Mantegna uses the revered dignity of Ancient Rome, but reduces it to the folly of pre-Christianity. Death was everywhere in the fifteenth century (the plague hit the population every fifteen years), and Sebastian was the saint for protection against it. So this is a picture about death – Sebastian's death, the protection he gives from death, and the nobility and salvation that comes from dying a Christian. The religious context and artistic framework might not be immediately obvious today, but the beautifully expressed resignation in the face of death has just as much meaning now as ever.

THE ARTIST Mantegna was one of the most important painters of the fifteenth century. The hardness of his painting reflected his strong character. He lived with his adoptive father who was also his teacher and employer, but broke free by suing him, aged seventeen. One of the first artists to make engravings of his paintings, Mantegna's progressive work carried the Italian Renaissance into northern Europe where it was taken up by artists like Dürer. He was dedicated to examining everything from the antique world. Other artists followed, and soon the Roman Empire was living again in paintings all across Italy. His style is austere and monumental, reflecting his ideas of antique Rome. Influenced by Uccello's perspective, Donatello's solidity and van der Weyden's crisp, hard detail, Mantegna forged these together with his own antique scholarship to create a strong and influential style. The year after he painted *St Sebastian* he became court painter to the humanist patron the Duke of Mantua, where he remained for the rest of his life.

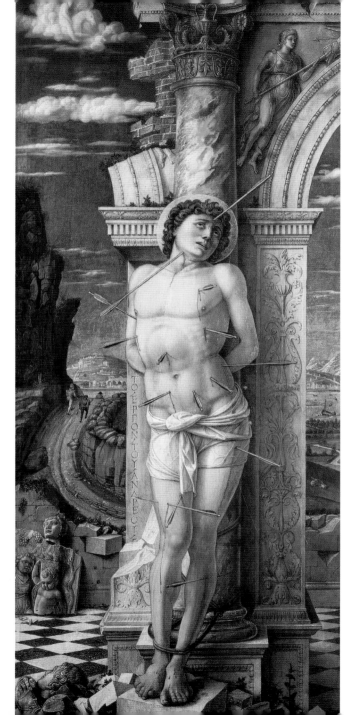

Andrea del **Verrocchio**
(Andrea di Cioni)

b. Florence 1435; d. Venice 1488
Baptism of Christ, 1470–73
Tempera on panel
177 x 151 cm (69³/4 x 59¹/2 in)
Uffizi Gallery, Florence

THE PAINTING Verrocchio teamed up with his students Leonardo and Botticelli to make this painting, the last of his career. It became his most famous picture. Its power is in the expressiveness of the characters, especially of Christ and John, and the realism of the bodies and the landscape. It is said that the parts painted by the eighteen-year-old Leonardo were so good that Verrocchio threw down his brush and quit painting forever. What annoyed him so much was the angel on the left (the other one was by Botticelli). The face is delicate and angelic, with glowing skin quite unlike the worn faces of Christ and John, while the dense and fine cascading hair looks as if you could touch it. It seems that Verrocchio left Leonardo to finish the landscape too. It has all the hallmarks of Leonardo's later works, like the landscape he painted thirty years later in the *Mona Lisa*. But Verrocchio's huge talents are clear in his pioneering use of anatomy, evident in the feet and in John's left arm. The scene is dimly lit, but the light is all coming from the same place, somewhere mid-left. Verrocchio was one of the first to handle this light and shade (*chiaroscuro*) in a newly sensitive way as it falls on the muscles of the figures.

THE ARTIST Verrocchio can be called the first complete Renaissance artist. He worked in every field possible, and was constantly questioning accepted practices and coming up with new ways of doing things. For Verrocchio there wasn't anything that couldn't be questioned, improved on and mastered. This optimistic enthusiasm and love of hands-on experiment, together with the success he had in so many areas, must have had a huge impact on his student Leonardo. Not only was he the most important sculptor between Donatello and Michelangelo, but his new style of painting became the basis of Leonardo's style. Verrocchio, which means 'true eye', had an enormous workshop in Florence that dominated in almost every artistic area. His versatility was incredible, and included sculptures in stone, bronze and terracotta, as well as paintings and metalwork. Verrocchio himself concentrated on sculpture. His extraordinary *tour de force* is the tough old warrior of his *Colleoni on His Mount* in Venice. People have sometimes overlooked his advancement of painting because Leonardo's genius eclipsed him.

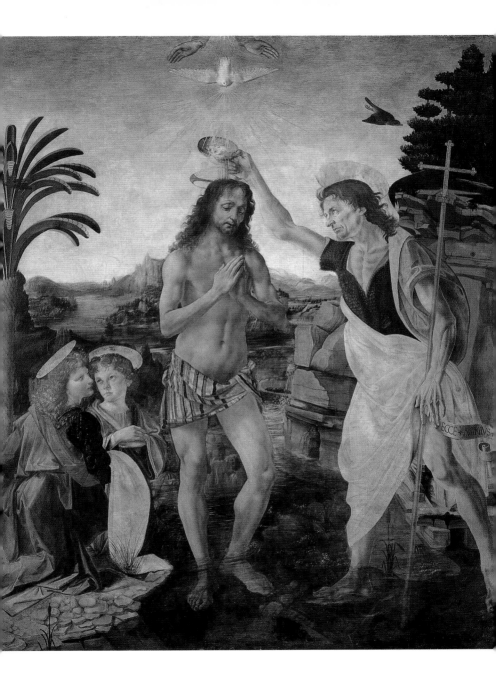

Domenico **Ghirlandaio**

b. Florence 1448–49; d. Florence 1494
Birth of the Virgin, 1486–90
Fresco detail
Santa Maria Novella, Florence

THE PAINTING Ghirlandaio had a gift for story-telling. This is a section of his most interesting and important commission, a major fresco cycle for the Tornabuoni family chapel in Santa Maria Novella, Florence. Instead of attempting to re-create a scene from biblical times, like Verrocchio did in his *Baptism of Christ*, Ghirlandaio painted the people he knew in fifteenth-century Florence. The clothes are taken straight from life and could have been seen on any Italian street. The room could be part of a fashionable palace, with the panelling, columns and painted, dancing putti demonstrating how up-to-date and stylish it was. Instead of showing the Virgin Mary's birth as some sort of miraculous event to be honoured, it looks like any birth in Italian high society. Only women are in the room, with the midwives and servants gathered around Mary, while visiting relations pour down the stairs to congratulate the new mother, St Anne. It is all very homely and natural. Ghirlandaio was an excellent portrait painter, in the style of Filippo Lippi, and these women would be known faces to viewers of the time. He takes us into a deep space by mirroring, at the back of the room, the columns that frame the frescos at the front, and by including the staircase that leads us into a far-away corner.

THE ARTIST Ghirlandaio was a member of an old family of craftsmen and artists. Perhaps it was because he had a start in Verrocchio's workshop, where he may have worked with Leonardo and Botticelli, that he outstripped everyone else in the family firm and went on to run it. As head of a growing workshop his fame spread to Rome, and in 1481 he was summoned to help with work on the Sistine Chapel, some thirty years before Michelangelo got there and transformed it. He took his influences from his tutor Verrocchio, and from Filippo Lippi and Masaccio. He also liked to imitate the style of Netherlandish painters like Hugo van der Goes, swapping their northern Gothic architecture for the new Renaissance classical buildings but keeping the cluttered and finely detailed parts. Ghirlandaio's talents, however, were not enough for one of his gifted apprentices who thought his workshop lacked a certain visionary genius. The sixteen-year-old Michelangelo, after three years of learning the techniques of the trade, left Ghirlandaio to study the antique sculptures in the palace of the Medici family.

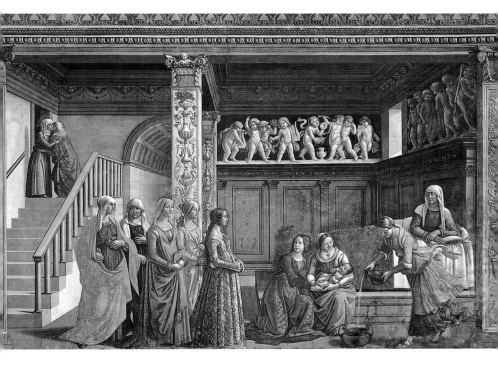

Sandro **Botticelli**
(Alessandro di Mariano Filipepi)

b. Florence 1444–45; d. Florence 1510
The Birth of Venus, c.1485
Tempera on canvas
172.5 x 278.5 cm (68 x 109³/₄ in)
Uffizi Gallery, Florence

THE PAINTING Venus, the goddess of love and fertility, is born. In the late fifteenth century most educated people knew something about the classical world. They felt that the ancients, who had known so much about science and art, were better than they were, so their myths took on a special significance. To believe in them would have been heretical, but the combination of ancient mystery and being able to show off how clever you were by knowing about them was a powerful mix. And Venus, the classical embodiment of beauty herself, had the added advantage of being all about sex. Here she floats across the sea, pushed along by two gods of wind, who hint at her purpose by their sexual embrace. Nudity in Renaissance art stood for purity, and her modest pose – taken from the newly excavated ancient statue *Venus Pudica* – symbolizes sacred love. As she reaches the shores of earth a nymph prepares to cover her up. By covering her purity she becomes earthly, sexual love. Despite taking the pose from a statue, Botticelli is more interested in the outlines of art than anything else, and his Venus looks as flat as a paper cut-out. He was ignoring the solid figures of Masaccio and Mantegna. This unreality just adds to the painting's otherworldliness, as do the flat tempera paint and light colour. Setting the agenda for the stylization of the Mannerists he made the neck too long, and the shoulders and left arm are all wrong. He didn't need reality, he wanted to make a goddess. He succeeded.

THE ARTIST This painting probably best sums up the Renaissance in the popular imagination, yet the man who gave it to us died poor and almost forgotten. For most of his career Botticelli (meaning 'little barrel') was famous and successful, and during the 1480s he was Florence's most sought-after artist. He was kept so busy that he spent his whole life in the city, leaving only once to help paint the Sistine Chapel with Ghirlandiao, in 1481. But by the time Leonardo came back to Florence from Rome in 1500 Botticelli's outline painting was already looking outdated. With the High Renaissance, led by Raphael and Michelangelo, exploding soon after his death, Botticelli's work was eclipsed and consigned, until the end of the nineteenth century, to the dustbin of fifteenth-century art. Now he is seen as the finest artist of linear design in Europe.

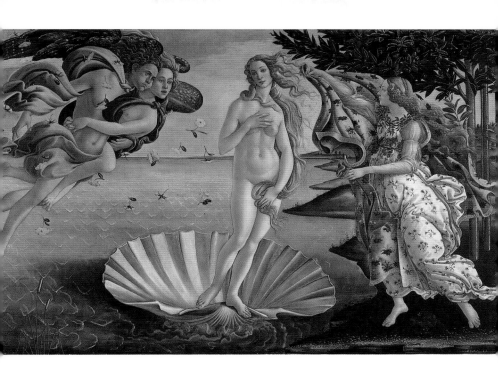

Giovanni **Bellini**

b. ?Venice 1431–36; d. Venice 1516
Doge Leonardo Loredan, c.1501
Oil on panel, 61.6 x 45 cm (24¹/₄ x 17³/₄ in)
National Gallery, London

THE PAINTING This is one of the most memorable portraits of all time. It is a painting about power, but a more subtle kind of power than the sort displayed in the vainglorious portraits of the crowned heads of Europe. This is the Doge, elected leader of the Republic of Venice. When this was painted he was one of the world's most important men, but Bellini manages to show him as a wise, fatherly figure, full of humanity and dignity. It is a powerful symbol of enlightened democracy, and shows the high regard in which the individual was held during the Renaissance. The face's bone structure and shadow-filled wrinkles and curves give a sense of solidity, while a warm sensitivity is brought out by the blues and various silvers gently working together. This is echoed in the pink gold of his clothes. His rich costume doesn't make him look showy or take away from his dignity; its symmetry strengthens the impression of a cool, balanced mind. This is a brand new way of painting a person. The background isn't a decorative landscape to fill the space. Bellini understood that there wasn't anything better than colour to move people, and he used it in wedges in pictures like this. Venetian art is all about vibrant colour and a wild feeling for the paint itself. And though he is still painting with tiny, perfectly positioned brushstrokes of incredible detail, he has used the new oil paint to bring brilliant sparkling light to Venetian art.

THE ARTIST Bellini changed painting in Venice forever when he popularized oil paint in place of the traditional, flat, egg tempera paint. Van Eyck had perfected oil paint in the Netherlands. Seeing what this was going to mean for painting, Bellini had his huge workshop changed over to it, killing off tempera for good and changing the course of Venetian art. His early style was like that of his brother-in-law, Mantegna, but he replaced his sharp style with a new atmospheric one. The expressive way he used light and colour changed Venetian art completely. He is the father of the Venetian style of painting, with its love of feeling and colour. Even though he never travelled far outside Venice, he turned it from an artistic backwater to a city to rival Rome and Florence. His direction was followed by the next generation of Venetian artists, his pupils Giorgione and Titian.

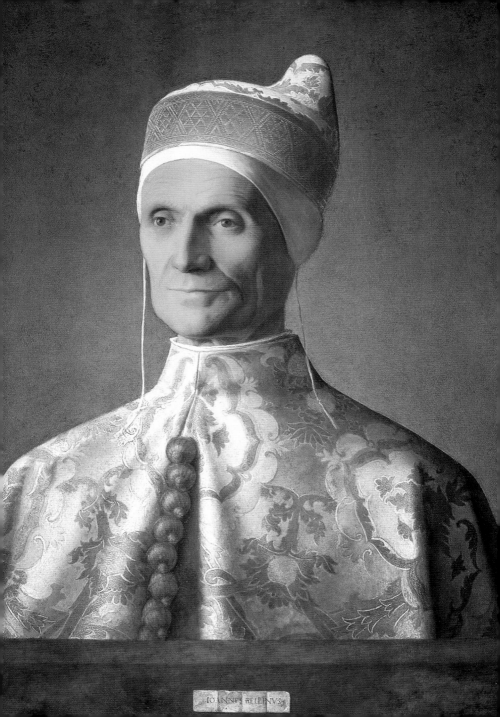

Giorgione
(Giorgio da Castelfranco, or Giorgio Barbarelli)

b. Castelfranco *c*.1477; d. Venice before 1510
The Tempest, *c*.1506
Oil on canvas
82 x 73 cm (32¼ x 28¾ in)
Galleria dell'Accademia, Venice

THE PAINTING This painting is one of the biggest puzzles in the history of art. While Leonardo's *Mona Lisa* has a questionable grin that no one agrees about, *The Tempest* has nothing at all that anyone has ever agreed about. A thunderbolt cracks over a town as trees rustle in a wind that is about to become a violent gale. The light in this thunderstorm gives this scene an anxiousness unlike anything ever painted. Giorgione ran with Bellini's idea that colour was the most important part of a picture for expressing emotion. The fact that this painting creates a feeling of eerie disquiet shows how he mastered atmosphere in paint. A naked woman feeding her child stares us right in the eye – do we know her? She is certainly not the Virgin Mary, who would never be depicted naked. Why doesn't she care about the male figure leaning provocatively towards her? We are part of a triangle of staring people – he looks at her, she looks at us, and we look at them both. Some think the painting is an allegory, with the virtues of strength (the man) and charity (the feeding woman) under threat from fortune (the storm). This does not explain the ancient wall with broken columns, nor why the male figure was originally female (visible by x-ray). The atmosphere is so strong that it demands some sort of explanation, but perhaps Giorgione would think we were wasting our time over something that he dreamt up to create a feeling, changing it as he went along.

THE ARTIST Rather like the painting, Giorgione himself remains a bit of an enigma. His career only lasted fifteen years, during which he signed nothing, and we only know of a handful of pictures that are actually by him. But he has always been considered one of Europe's most important artists. Rather than what we can see of his paintings, it is what we know of his ideas about painting and what they contributed to Italian art that matters most. Using Bellini's new light and colour he took atmosphere to its logical conclusion, painting emotionally charged pictures that didn't rely on any story, unlike religious art. He also changed the role of patronage, painting non-religious pictures for private people rather than churches. His student Titian, Venice's most important sixteenth-century artist, was to carry on Giorgione's teachings and, with his vast output and influence, change Venetian painting forever.

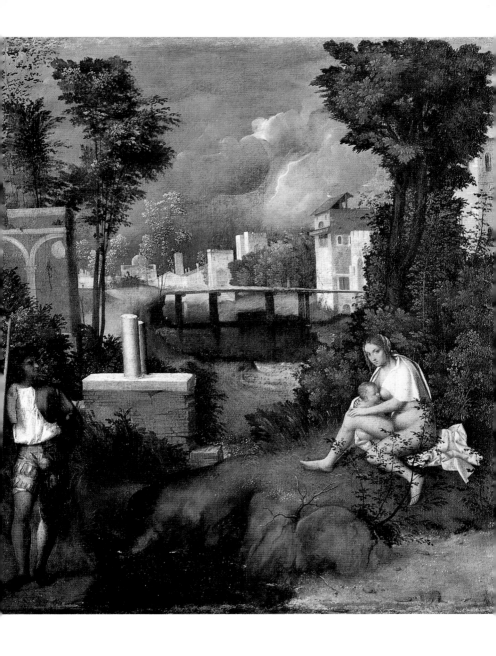

Leonardo da Vinci

b. Anchiano, nr Vinci 1452; d. Amboise, nr Tours 1519
Mona Lisa, 1503–06
Oil on panel, 76.8 x 53.3 cm (30¼ x 21 in)
Louvre, Paris

THE PAINTING The *Mona Lisa* is one of the most famous paintings in the world, and theories have always accompanied it. Is she actually a man? It is true that Leonardo brought out the female side of his male subjects, the way that Michelangelo made his women manly, but there were nude sketches of her as a woman. Her famous smile suggests that they were lovers, but she was married and Leonardo was most probably gay. But without reliable records, anything is possible, and Leonardo did keep this picture all his life. It had a huge influence, especially in France, home to the painting since Leonardo moved to the court of Francis I in 1516. Her body is at an angle while her head is almost frontal – this was a brand new pose for portraiture. The flesh tones make a strong vertical line, balanced by the horizontal landscape behind. Oddly unequal, the landscape is laid out with aerial perspective. The colour and clarity of the distance fades, like reality, the further away you look. This was one of Leonardo's advances. He also built up layers of lightly coloured varnish to create the mysterious shadowy depth of her skin, and pioneered *sfumato*, where the tones of different things are blended together to lose hard outlines. In 1549 the art historian Vasari said she 'seemed to be real flesh rather than paint'. Unlike Botticelli's *Venus*, Leonardo's *Mona Lisa* is a real person in a real setting.

THE ARTIST The illegitimate son of a peasant girl from the little town of Vinci, Leonardo became the archetypal Renaissance man – artist, scientist and thinker. His intellectual curiosity led him into countless areas, but he was on to the next subject so quickly that he left most of his projects unfinished. Science, engineering, philosophy and aviation were all areas that he sketched and wrote about, in mirrored handwriting to hide his work. He drew helicopters and airplanes, the diving suit and the tank. These were too far ahead of their time to be understood, but he did significantly add to other disciplines in his lifetime. In anatomy he dissected thirty bodies and understood the growth of children in the womb. Some artists proved they were more than craftsmen, but Leonardo invented the artist as genius, changing how art and artist were viewed forever. Like Giorgione, Leonardo didn't actually paint that many pictures, but the influence of those he did paint is enormous.

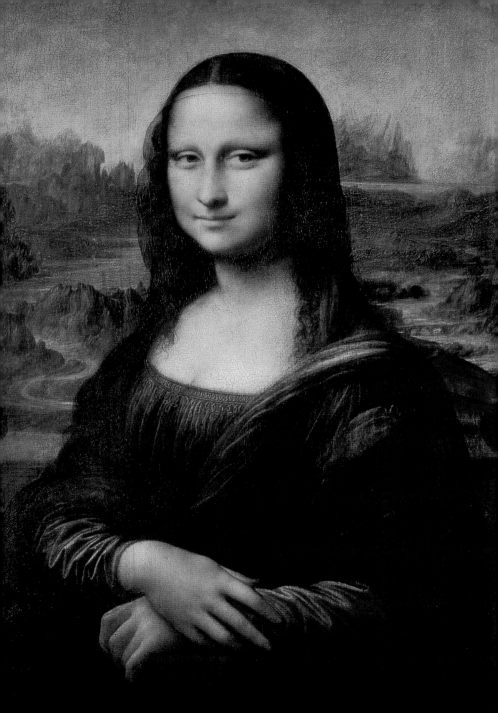

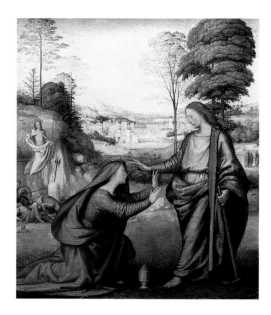

Fra Bartolommeo
(Baccio della Porta)

b. Florence 1472; d. Florence 1517
Noli Me Tangere, c.1508
Oil on canvas
57 x 48 cm (22¹/₂ x 19 in)
Louvre, Paris

THE PAINTING Behind the figures of Christ and Mary Magdalene we see Christ's earlier resurrection from the tomb. The action is played out on a theatrical stage-set of a landscape receding into the distance, a device Bartolommeo learnt from Leonardo. It is a balanced image, even with Christ to one side – Bartolommeo was a master of asymmetrical composition and colour. If Christ looks a little effeminate to our eyes it is because the figure is painted in *contrapposto*, where one part of the body is twisted in the opposite direction to the other to create more movement. Religious painting is often underscored by death, but Bartolommeo paints this with all the colour and feeling for life that are implied by Christ's resurrection and His promise of eternal life.

THE ARTIST Changing his name from Baccio to Fra Bartolommeo, in 1500 Bartolommeo quit art, burning any paintings with nudes in them and entering Fra Angelico's old monastery. He had come under the influence of the charismatic religious leader Savonarola, who was burnt at the stake for his revolutionary preaching. However, Bartolommeo took up painting again in his new home, perhaps due to his superior forcing him into it in the service of the church, or because he was inspired by Fra Angelico's wall paintings. He understood and continued Leonardo's compositional styles, his soft *sfumato* technique and his distantly blurring aerial perspective. To this he added brilliant Venetian colouring in the new oil paint, bringing new life and colour to Florentine art.

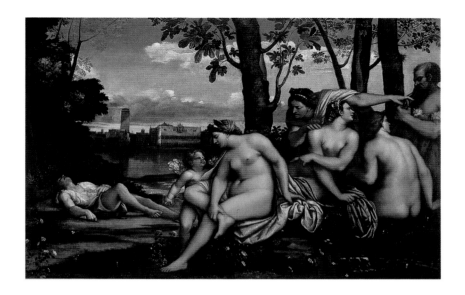

Sebastiano del Piombo
(Sebastiano di Luciano)

b. Venice c.1485–86; d. Rome 1547
The Death of Adonis. c.1512
Oil on canvas
189 x 285 cm (74¹/₂ x 112¹/₄ in)
Uffizi Gallery, Florence

THE PAINTING Adonis lies dead, killed by a boar when hunting. It is the accident that Venus dreaded but she is too late. She sits with Cupid and her nymphs, her face screwed up in anguish, holding her foot which has just been cut by a thorn. The blood drips onto some white roses, turning them red forever. It is the classical tale of love and death, but without the physical attributes. There is no spear, no hunting horn and no sign of Venus's chariot. Piombo tells the story only through poses. The masculine nymphs were borrowed from Michelangelo's *Sistine Ceiling*, but their flesh is softer, like Raphael's. The landscape is from Giorgione, and Piombo even includes the symbol of his Venetian background, the Doge's Palace. It's as if he is boasting to his new Roman patrons: 'I've got everything your Michelangelo and Raphael have, and I'm a brilliant Venetian!'

THE ARTIST Piombo fused the best art of Venice and Rome, and after Raphael's death in 1520 he became Rome's most important portrait painter. As soon as he reached Rome, Piombo made friends with Michelangelo. This friendship, not coincidentally, helped his career. At the top of the Roman social ladder was the pope. Piombo became very close to him and was made Keeper of the Papal Seals – the 'Piombo', hence his nickname. It was a very well paid and work-free job. With good income and the pope's ear Piombo hardly painted, and finally lost Michelangelo's friendship when he attempted to control his work through the pope.

Raphael
(Raffaello Sanzio)

b. Urbino 1483; d. Rome 1520
The Marriage of the Virgin, 1504
Oil on panel
170 x 118 cm (67 x 47¼ in)
Pinacoteca di Brera, Milan

THE PAINTING This is the triumph of Raphael's youth, painted when he was only twenty-one. St Joseph, identified by his flowering rod, puts a wedding ring on the Virgin's finger. They are surrounded by a balanced group of men on one side and women on the other, their heads all turned at different angles (showing off Raphael's mastery of his early teacher Pietro Perugino's style). The action-filled foreground only takes half our attention. We are forcefully drawn back, through the perfectly lined perspective, by the grid paving that ends in a temple dominating the skyline. The open door and arches take us even further back into the misty landscape behind. Raphael has proudly signed the temple, pointing the way to taking over from his cousin Donato Bramante as architect of St Peter's in Rome ten years later. The lively sense of action and perfect balance, all lit by soft yellow sunlight, make this one of Raphael's most admired paintings.

THE ARTIST Raphael grew up in the court of Urbino, where his father was court painter, but following *The Marriage of the Virgin* it looked like the ambitious Raphael had outgrown Umbria. He moved to the flourishing artistic capital of Florence, dropping some of his early style and picking up new developments from Michelangelo, Leonardo and Ghirlandaio. Where Michelangelo turned away from court life and concentrated on art, Raphael became a social mover as well as an artistic prodigy. He built up a steady output of exquisitely delicate and well-balanced Madonnas, bathed in the light of the midday sun. With this and his sociability he became so famous that by 1508 he had been summoned to Rome to decorate the pope's private apartments. His frescos reflect his mature style, that incorporated something of the grandeur of his rival Michelangelo. His paintings, and the prints that were made of them, have influenced artists for centuries. According to the sixteenth-century art commentator Vasari, Raphael died prematurely at thirty-seven because he 'pursued his amorous pleasures beyond all moderation' and this time he had been 'even more immoderate than usual'. Vasari also says that Raphael was to be made a cardinal. Whether or not this is true, the fact that it was mentioned at all, for a mere painter, proves just how far the artist had been brought by the High Renaissance trio of Raphael, Leonardo and Michelangelo.

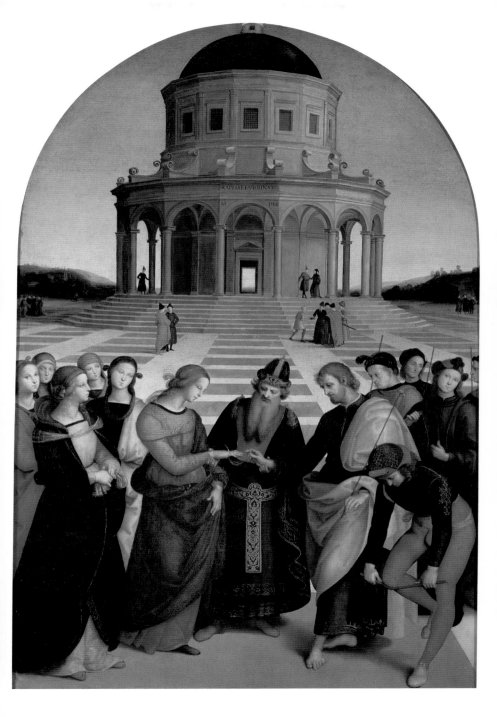

Michelangelo Buonarroti

b. Caprese 1475; d. Rome 1564
The Creation of Adam, Sistine Chapel ceiling, 1508–12
Fresco detail
Sistine Chapel, Vatican, Rome

THE PAINTING Still one of the most powerful images ever painted, *The Creation of Adam* forms the central panel of the Sistine Chapel ceiling. In this monumental composition, God touches life into the languid body of Adam. His other arm holds back the life of the heavens, which seems to want to spill on to Earth from the red oval opening. The complexity of the ceiling's design and the monumental brilliance of its execution, where every interwoven panel is a celebration of humanity, are Michelangelo's *tour de force.* It is full of bodies – some biblical, others false sculptures holding up the roof, and many nude. The artist explored his beloved male nude in every imaginable pose. It is a uniquely energetic painting, where every part writhes with movement. It was an incredibly hard fresco to paint. Four years on his back up a scaffold left Michelangelo physically and psychologically battered. Even though he thought of himself as a sculptor, he managed to paint his view of Christianity in the most important chapel in Christendom, and its influence changed art forever.

THE ARTIST After an apprenticeship with Ghirlandaio, Michelangelo lived and worked with the powerful Medici family, befriending future popes and rulers. The Medici were thrown out of Florence when Michelangelo was nineteen, and at this time he travelled across northern Italy and to Rome. He sculpted the *Pièta* in the Vatican for a French cardinal, before resettling in Florence in 1501. Here he carved *David,* the most important sculpture since, or perhaps including, antiquity. The fame of his colossus of male heroic beauty instantly catapulted him to stardom. Noble and triumphant, it captured everything that the Florentines wanted to see in themselves. In 1505 Pope Julius II summoned him to Rome to create a magnificent tomb. The commission lasted on and off for forty years, and Michelangelo described the small-scale outcome as the tragedy of his life. Leader in painting and sculpture, he also added architecture to his list of achievements by taking on St Peter's in Rome, which was built mainly to his designs. Michelangelo created the idea of the solitary, sombre genius of a universal artist struggling with inner demons to create the best art in every field. This was not at all like the urbane Raphael, who was paid ten times the amount Michelangelo got for the Sistine ceiling for some tapestries that once hung beneath it.

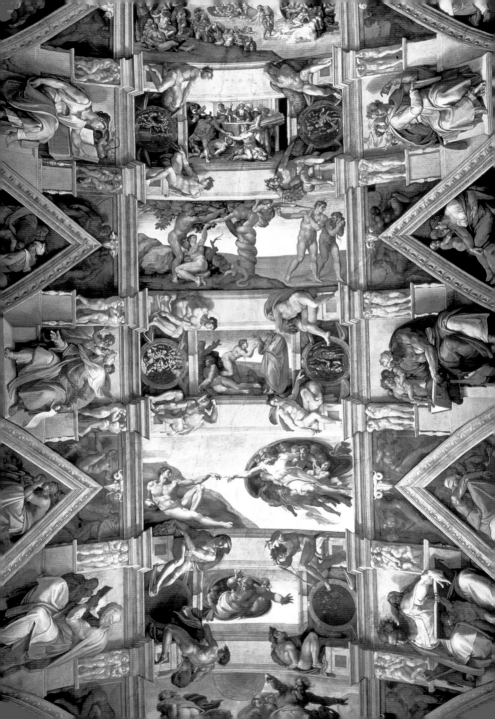

Bronzino
(Agnolo di Cosimo)

b. Monticelli, nr Florence 1503; d. Florence 1572
Allegory with Venus, Cupid and Time, c.1545
Oil on panel
146 x 116 cm (57½ x 46½ in)
National Gallery, London

THE PAINTING Cupid incestuously fondles the breasts and kisses the lips of his naked mother, Venus. Cupid is usually depicted as an infant, but that wouldn't have been much use to Bronzino here, so he has made him adolescent. With flushed cheeks Venus lustfully gazes at him, her tongue about to enter his mouth and her arms outstretched. In one hand she holds the golden apple won for her unparalleled beauty, and in the other her fingers suggestively stroke the shaft of Cupid's arrow. Foolish Pleasure throws rose petals over the couple, not noticing the thorns piercing his foot. The masks at his feet are of a nymph and a satyr, ancient figures of lust. To the crime of incest Bronzino adds an illusion to sodomy, with Cupid's quiver carefully poised at his buttocks. But this isn't simply a bawdy display of sex. It's a cautionary tale of excess. The horrific figure behind Cupid is Jealousy, but also a syphilitic man in agony. The new-world disease was rife in Europe. The beautifully masked Deceit holds a sweet honeycomb in one hand, hiding the truth of the barbed tail in the other hand. Cupid crushes a dove – the ancient symbol of fidelity – underfoot. The blue silk covering that makes their opalescent skin shimmer so brilliantly is being ripped away by Time, who will uncover the real horrors of deceitful lust for all to see. It is a moral for a lustful world, but a world that we must voyeuristically enter to understand. This hypocritical joke and its triumphantly secular and sexual content appealed to the profligate Francis I of France, who was probably given the picture by Bronzino's patron, Duke Cosimo di' Medici.

THE ARTIST Bronzino (meaning 'bronze coloured' or 'tanned') was the master of Florentine painting in the mid-sixteenth century and one of its best portrait painters. His slick and beautiful interpretation of Michelangelo's figures and his development of the Mannerist style kept him busy at the Medici court for the rest of his life. His use of paint was flat and luminous, opaque blocks of colour that gave an unsettling reality to the strong angular poses of his sitters. In his pictures the Medici saw a reflection of themselves that the mirror was too honest to show. There was a style to Bronzino's art that seemed knowledgeable, assured, strong and swaggering – everything that the Medici wanted.

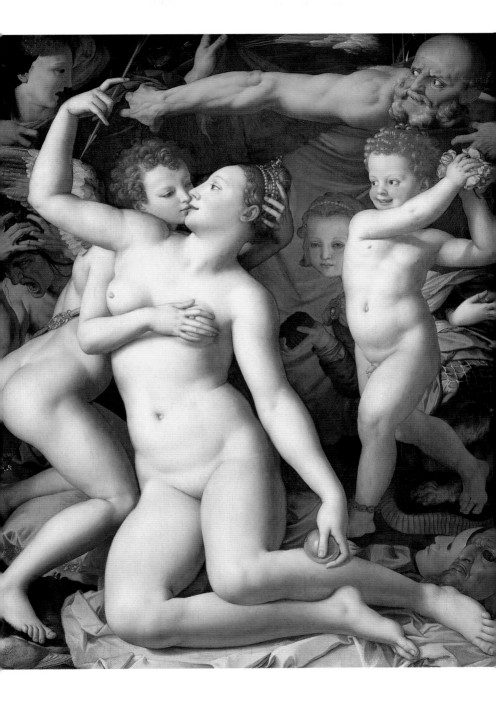

Correggio
(Antonio Allegri)

b. Correggio c.1489; d. Correggio 1534
Jupiter and Io, c.1532
Oil on canvas
163.7 x 70.5 cm (64½ x 27¾ in)
Kunsthistorisches Museum, Vienna

THE PAINTING This is one of Correggio's most advanced pictures. Ovid's classical story of sex is painted with incredible imagination and skill. Throughout the Renaissance and up into the nineteenth century, classical mythology was the only acceptable way western art could portray sexual subjects. This painting comes from a set of four, the *Loves of Jupiter*, painted for the Duke of Mantua as a present to Charles V of Spain. Ruler of the gods and husband to Juno, Jupiter had a string of sexual liaisons with other characters. He seduced them by coming to them in different forms, shown in this series where he appears to Io as a cloud, to Leda as a swan, to Danae as a shower of gold, and to Ganymede the shepherd boy as an eagle to carry him off. Here he envelops Io's body, materializing in human form as he begins to kiss her. Io is in a state of abandoned ecstasy. This blatant but refined eroticism is totally new to art. Io's finely outlined form is balanced between the brown of the bank and the grey of Jupiter, with her left leg guiding us in a sensuous diagonal across her body and the painting. There is no shyness or confused meaning here. Correggio has painted a true erotic moment, which is why the work is as powerful now as ever.

THE ARTIST Incredibly Correggio was hardly known outside Parma, and he died in relative obscurity. It was only after his death that he achieved fame and influence. Outside Venice, Correggio was northern Italy's most important painter in the first half of the sixteenth century. He absorbed the influences of Mantegna and, after a stay in Rome, of Raphael and Michelangelo. Back in Parma he developed his own lively naturalism and filled its church domes and ceilings with his most important frescos. He invented the three-dimensional illusion where fabulous visions of heaven seem to stretch into the sky, with hundreds of saints and angels twisting in layers of clouds, wings and brilliant golden light or – as a contemporary and incomprehending priest said – 'a stew of frogs' legs'. This *trompe l'œil* ('tricking the eye') inspired countless imitators in the following century of Baroque art. His paintings had a profound impact on the French Rococo 200 years later, where his art was considered as important as Raphael's. Boucher's nudes are a direct result of Io's fleshy, natural eroticism.

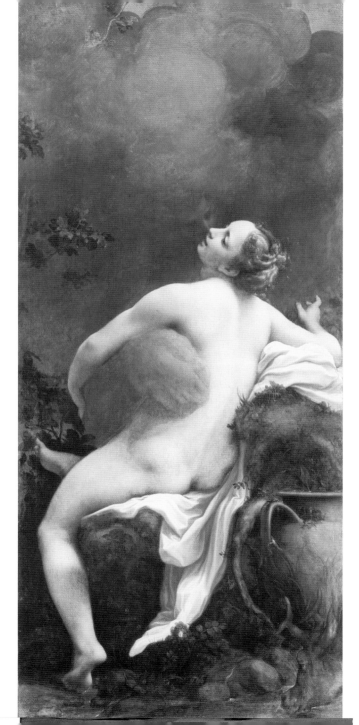

Titian
(Tiziano Vecellio)

b. Pieve de Cadore c.1485–90; d. Venice 1576
The Bacchanal of the Andrians, c.1523–24
Oil on canvas
175 x 193 cm (69 x 76 in)
Prado, Madrid

THE PAINTING For this picture, Titian set out to re-create the heights of painting from the ancient world. There weren't any antique paintings known in sixteenth-century Venice so Titian relied on the translated description of the second-century writer Philostratus, who saw a painting like this in Naples. Titian creates the island of Andros with a diagonal wedge of green and another of blue, interwoven with the flesh tones of the figures. Bacchus has taken his yearly trip, by the distant boat, and makes a river of wine flow from the elderly god on the hill. The party has already started; the revellers dance, drink, talk and play music in a rhythmic oval that takes our eye effortlessly through the whole scene. Some figures, like the central reclining man, are taken from Michelangelo. Others are from antique sculpture, like the urinating putti, a symbol of fertility leadingly placed next to the resting nymph. She holds her emptied wine bowl and waits for Bacchus to come. She symbolizes sensual pleasure but Titian also makes her body work as an arc, bringing our eye back up and into the scene to look again at the shimmering fabrics and glowing flesh that are so natural in his landscape.

THE ARTIST Variously called the greatest Venetian painter of the sixteenth century, any century, or even the greatest painter ever, Titian has never lost critical favour. He developed an entirely new way of painting that didn't just rely on draughtsmanship, but used the texture and colours of his oil paint. During his early apprenticeship with Bellini he learnt the value of oils and colours to transmit atmosphere and mood; he took this and redefined Venetian art with it. Without him the painterly style of Rubens, Delacroix and countless others wouldn't have come about. He built his own strong style, exploding with bold energy, on to the moods and mysterious landscapes from his early work with Giorgione. Titian composed pictures with colour rather than forms in mind, so figures really started to look at home in their landscapes and not like cut-outs placed in a scene. When most of Europe was following the elegant, but soon to be obsolete, ideals of Mannerism, Titian fused the monumentality of Mantegna and Michelangelo with his own wild freedom. He locked the whole thing together with thick flashes of colour, and created not just a style but an entirely new direction for painting.

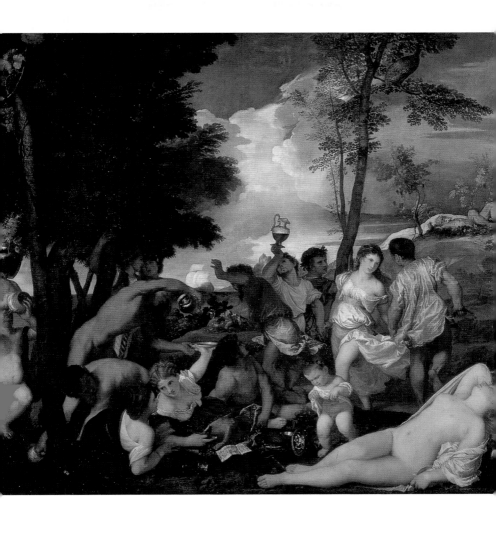

Paolo **Veronese**
(Paolo Caliari)

b. Verona 1528, d. Venice 1588
Venice Enthroned between Justice and Peace, c.1574
Ceiling panel, oil on canvas
Doge's Palace, Venice

THE PAINTING Veronese was the most gifted decorative painter of the Venetian Renaissance. High on the grand gilt ceiling of the Doge's Palace he painted a series of pictures glorifying his adopted city. Here Venice sits in gold embroidered silk, wrapped in royal ermine. At her feet Peace, with her olive branch, and Justice, with her sword, pay homage. In Plato's *Republic*, Justice held together the ideal city, and Venice was the self-conscious heir to his perfect city-state. Peace to the Venetians was something that had to be fought for. Veronese painted this to be seen twenty feet up on the ceiling, so if you look up at it, rather than down, it makes much more sense. We are standing further down the steps, looking up at Venice, enthroned dizzyingly in the sky. This would have triggered heavenly thoughts of Byzantine Madonnas, like Cimabue's, that were common to Venetians. It is an incredibly grand thought that a state would have these two great notions of Peace and Justice as servants, but the Venetians in the sixteenth century were a very grand lot, and Veronese played up to their vanity. But the powerful Venice of 1501, when Bellini painted his humane looking *Doge Loredan*, without any trappings of position, was disappearing fast. The sea route to India had been discovered, ending Venice's monopoly on trade, and the Turks were taking the eastern Mediterranean from Venice, who lost Cyprus to them in 1570. In this light the popular pomp of Veronese's paintings seems like a desperate assertion of pride by a slowly waning power.

THE ARTIST Born in Verona, hence his nickname, Veronese was one of the leaders of sixteenth-century Venetian art along with Titian and Tintoretto. But unlike these two, Veronese used colour not to blend forms together, but to separate them. Where Tintoretto painted with atmospheric colour, thickly applied, Veronese used clear, bright light and even paint to give grandeur. The dangerously irreligious way he painted *Venice Enthroned* brought him to the attention of the Inquisition in 1573 for another painting, *The Last Supper*. This is an enormous Venetian feast, with dwarfs, dogs, clowns and drunken revelry; Christ seems to be there by chance. Veronese said, with false naïvety, that it was such a big painting he 'had to fill it with figures'. He famously escaped the Inquisition's wrath by just changing its title to *The Feast in the House of Levi*, to lessen its importance.

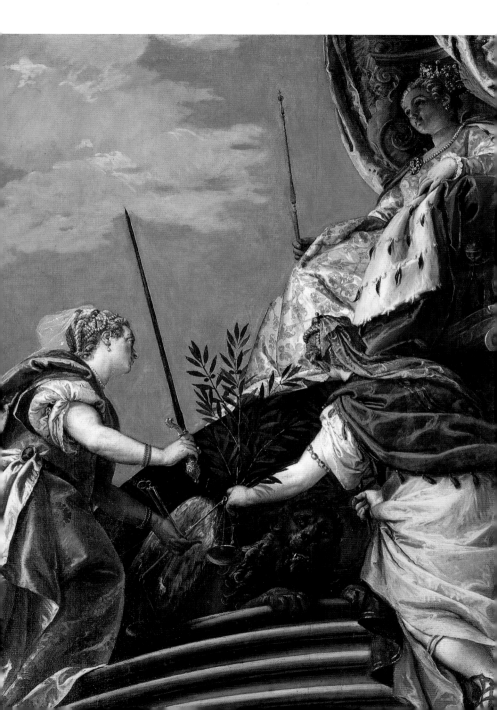

Tintoretto Jacopo Robusti

b. Venice 1519; d. Venice 1594
Finding of the Body of St Mark, c.1562–66
Oil on canvas
405 x 405 cm (159^1/$_2$ x 159^1/$_2$ in)
Pinacoteteca di Brera, Milan

THE PAINTING In the forgotten Christian catacombs of the now infidel city of Alexandria, the body of St Mark, patron saint of Venice, is being stolen. Devout Venetians had saved his remains in AD 828. The men checking the body on the right are about to be stopped by the brilliantly lit spirit of St Mark on the left. They haven't noticed him yet, but the foreground figures have. At the instant St Mark appears, his heavenly presence makes an evil spirit leave the mouth of the falling man and the others jump back in shock. But the man who commissioned the painting, Tomasso Ragone, kneeling piously in his brilliant golden robes, uniquely understands the events. The corpse they are looking for is on the carpet at St Mark's feet, foreshortened and lying away from us, like Uccello's fallen knight. All the action happens in a haunting vaulted room that recedes at a strange angle to an obscure opening in the floor. The off-balance perspective makes it less harshly regular than Raphael's *Marriage of the Virgin* and it gives everything a new sort of edgy balance. Tintoretto carries on Titian's colour and handling of paint, but in this covert underground scene he plays them both down to create the dark atmosphere.

THE ARTIST The nickname 'Tintoretto' comes from his father's job dying cloth, and his working-class origins had a unique effect. Until his death he lived in a tiny house in north Venice, only leaving the city once for a brief trip to the mainland. A disregard for money meant that he undercut more expensive artist's studios and won huge numbers of commissions all over the city. The Doge's Palace is still covered with some of his best works. He also worked so incredibly fast that other artists who couldn't compete called him an incapable draughtsman who used colour badly. Neither of these accusations is true but Tintoretto, in the footsteps of Titian, cared much more about the feel of oil paint and the amazing textures and forms he could make with it. He painted directly on the canvas in a free and frantic way, sometimes leaving the details of accuracy to one side in what can look like a frenzied effort to see his ideas finished. He is the heir to Titian's greatness, but he added to Venetian painterly colour a distinctive edginess of composition, which was a huge influence on El Greco.

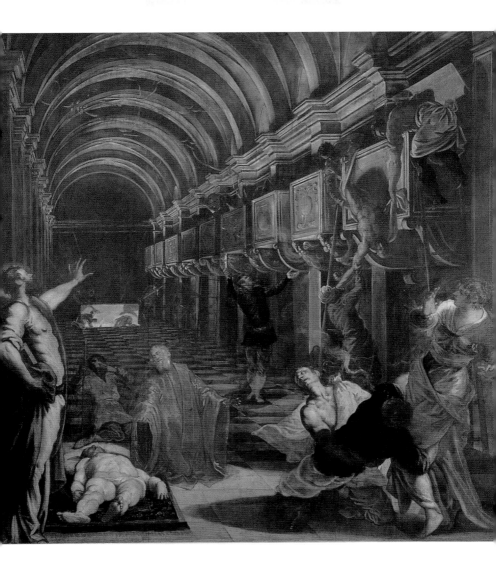

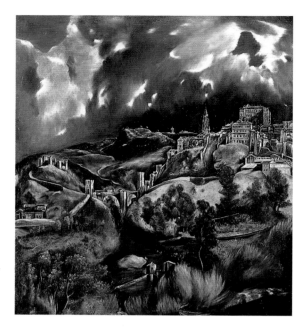

El Greco
(Domenikos Theotocopoulos)

b. Candia 1541, d. Toledo 1614
View of Toledo, c.1597
Oil on canvas
121 x 109 cm (47³/₄ x 42³/₄ in)
Metropolitan Museum of Art, New York

THE PAINTING Until Expressionism came along over 300 years later, this was unlike any other landscape ever painted. Its extraordinary individuality almost makes a mockery of art history. El Greco's home for forty years, the city of Toledo rises upward, in deathly grey, into the thunderous sky. He has painted it as some sort of post-apocalyptic ghost town. The fields are vividly green but the city itself is monotone, set against the night black of an approaching storm. This was painted when he was most emotionally expressive. El Greco thought that art could bring us beyond reality and help us glimpse spirituality. His death brought these high ideals of the Renaissance to an end.

THE ARTIST One of history's most original and visionary artists, El Greco fell into total obscurity from his death until the twentieth century, despite his own enormous feelings of artistic self-worth. Born in Venetian-ruled Crete, El Greco ('the Greek') painted to the strict formulas of Icon art before moving to Venice, where he fell completely under the influence of Tintoretto's free style. He saw Tintoretto's disregard for rules as his way out of painting's strait-jacket. He transformed his vivid colour and slight Mannerism into his own, totally individual, style. Shunned in Venice and Rome he ended up in the artistic backwater of Spain, where his fervent Catholicism could be voiced in wildly colourful and expressive religious paintings, happily commissioned by the locals but rejected at court. He is now considered Spain's first great painter.

The Renaissance in Northern Europe:

van Eyck to Bruegel

Running parallel to the Renaissance in Italy was a very separate one further north, in the Netherlands. These were the two richest regions of fifteenth-century Europe, and demand for painting was strong. Cities like Bruges, Ghent and Antwerp had economic and cultural links with their Italian counterparts. For instance, the couple in van Eyck's *Arnolfini Marriage* were Italian, working in the Bruges arm of the family business. But painting here had never been overhauled by revolutionary artistic events like it had been in Italy. The Renaissance in the south was about re-creating classical Rome; there was a buzz of expectancy about the times they lived in. That did not exist in the north. Architecture stayed decidedly Gothic, and religious insecurities and political monarchy didn't encourage anyone to embrace fully the pagan imagery or ancient republican texts of the Italian city-states. In Italy Masaccio and Leonardo were respectively credited with discovering linear and aerial perspective, and had been loudly praised because of it. But completely independently, the artists of the Netherlands had, in some ways, quietly stumbled across them too. The artists there, working in their medieval guilds, were painting exactly what they saw, mimicking the real world. They did it so incredibly well that they came to the same conclusions as their southern Renaissance cousins about many things. It was all very different in Italy, where they didn't mimic nature but instead theorized about how perspective, lighting and solidity would change art.

The major development that allowed the Netherlandish painters to imitate nature so exactly was oil paint, used there for centuries but perfected and popularized in the

time of van Eyck. The old tempera paint was fast-drying, which meant artists had to work at breakneck speed in small areas to finish what they were doing before the whole thing dried. It was not a technique that encouraged labour intensive detail. But oils were perfect for building up the minutest details, and van Eyck and van der Weyden were the first and greatest of all northern painters to exploit it.

The Renaissance was also the great awakening of the consciousness of the individual – thought became free of the Church and people questioned everything for themselves, nowhere more so than in Italy. As van Eyck's highly detailed style suited the exploration of the human face so well it was in high demand for portraits, especially in Italy. Bellini followed the Netherlandish lead and switched to highly detailed oil painting in Venice, while Mantegna in Mantua copied the works of van der Weyden. But this cross-pollination didn't reach every artist. Bosch proves just how different artists could be. His painstakingly accurate detail comes out of the local tradition, as do his magical demons and limitless symbolism. But his incredible imagery seems to come from the dreams of a medieval artist, not one working at the time of Leonardo, Michelangelo and Raphael. Contrary to popular belief he wasn't a mad genius working in a vacuum. Thirteen years after Columbus discovered America, Bosch painted his greatest medievalist masterpiece, *The Garden of Earthly Delights*. It has nothing to do with mainstream Renaissance art theory, but it does, like Bosch himself, have everything to do with the religious quandary in the Netherlands. Throughout the fifteenth century the place had been overrun by wars, plagues, famines and economic crises. It looked like God had abandoned them, and many people were scared of the consequences. Religious fanaticism spread, as did witch-hunts, guilty souls flagellating themselves in the streets, and new sects proclaiming salvation. The Catholic Church was proving itself incompetent at providing the religious comforts its flock needed. It had been vying with the secular princes for power for so long that it was losing touch with its celestial purpose.

Only ten years after Bosch's painting, the German Martin Luther would make his protests that finally led to the break up of the old order. The Germans, geographically between Italy and the Netherlands, also found themselves artistically stuck in the middle. Dürer was historically from the traditions of the north but intellectually he was a member of the Italian Renaissance. His attempts to find the 'formula' for the perfect human proportions, along with his systematic study and sketching of nature, were the sort of rigorous practices carried out by the best Italian artists. He studied painting in Italy, and his engravings (some of the best ever created) spread the

principles of perspective, solidity and composition all over northern Europe. Other German artists took up the Italian challenge in different ways. Grünewald, like most Germans, was still painting the concerns and medieval imagery of the past. His gritty religious scenes used an incredible expressiveness, as well as gory detail, for the figures of the crucified Christ. Similarly Cranach knew what was out there but he used the new tricks to give his sexy paintings more punch rather than to follow or expand the new findings. Altdorfer did the same, but he was also wrapped up in a growing patriotism that was rejecting the imagery of the Italians, but not their developments. He set about creating a grand tradition of German landscape painting. Holbein, the youngest of the talented Germans, found himself painting in a region factionalized by religion, where finding work became so difficult he had to move out. He went to England, a country that at the time was on the outskirts of art. France was also turning around its artistic fortunes. Fouquet and then Clouet helped to bring about a culture of artistry, which was heavily backed by the French king's patronage.

The hyper-realism of artists like van Eyck carried on as the national style in the Netherlands right into the nineteenth century, but it never really matched the brilliance of the earliest masters. Lack of church patronage in Protestant Holland was just as marked as it was in Germany, and painters had to find a new market or face extinction. Altarpieces for churches were out, while small-scale paintings for the rising middle classes were in. Bruegel's comical and moralistic pictures filled the gap and started a tradition of humane non-religious art in the north that continued for 400 years.

Jan van Eyck

b. ?Maasseick c.1395; d. Bruges 1441
The Arnolfini Marriage, 1434
Oil on panel
82 x 60 cm (32¹/₄ x 23¹/₂ in)
National Gallery, London

THE PAINTING Van Eyck's most famous portrait asks more questions than it answers. Until recently it was thought to be a portrait of Giovanni Arnolfini and Giovanna Cenami, but we now know that they got married fourteen years after this painting was made. The Netherlandish ruler Duke Philip the Good was both van Eyck's and Giovanni's employer and bought all his silk from the Italian, which was a reason given for all the brilliant fabrics in the painting. But there could be another reason. The lurid red of the bed might signify lust in the shoeless couple holding hands, about to try for a child as they are watched over by a carving of St Margaret, patron saint of pregnant women. The woman looks pregnant already but enormous stomachs were the fashion, and if it were a wedding portrait, with the dog symbolizing fidelity, it would not have included a pregnant bride. The painting has been called a sort of photo-document of the wedding itself. Beneath a single candle representing the all-seeing eye of God is a mirror, catching all the details from the other side. In the mirror you can see two people standing at the door – van Eyck and Philip the Good? We will probably never know, but above it van Eyck wrote, in Latin, 'Jan van Eyck was here, 1434'. Did he mean in the room, painting? In the mirror greeting them? Or was it written, as has been thought, like a witness's signature to their marriage? Whatever the truth, the picture is a brilliant advertisement for van Eyck's revolutionary new style of realistic oil painting.

THE ARTIST Van Eyck has been credited with inventing oil painting and so changing art forever – he didn't. But he popularized oils so much that he might as well have invented the technique. By mixing ground-up colours with slow-drying oils rather than fast-drying eggs, van Eyck allowed himself the time he needed to perfect all the subtle details, from the hairs of the fur to the fruit at the window. This was impossible with the old egg-based tempera paint. He could build up layers and layers of translucent oils to create the incredibly fine detail that has been the trademark of Netherlandish painting ever since. But his reputation wasn't built just on that. Like Masaccio in Florence he was developing a real light source, giving his figures gravity and his spaces real depth.

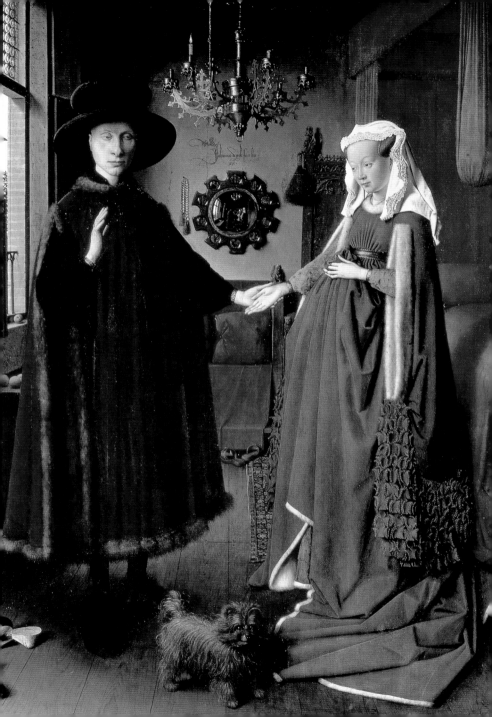

Rogier **van der Weyden**

b. Tournai *c*.1399–1400; d. Brussels 1464
Saint Luke Painting the Virgin, 1435–37
Oil on panel
138 x 111 cm (54¹/₄ x 43³/₄ in)
Alte Pinakothek, Munich

THE PAINTING The intimacy of this painting has held people's attention for almost 600 years. Van Eyck had recently painted a similar composition to this one, which was technically brilliant but did not have van der Weyden's human charm, and has not stood the test of time in the same way. Flemish painters were interested in the beauty of incredible detail, as it was their way of imitating nature, but van der Weyden became equally absorbed with the expressiveness of his characters. The patron saint of painters, St Luke, is kneeling down to sketch the Virgin and Child, but his Christ doesn't look blankly divine and all-knowing like in other paintings. His fingers and toes are stretched out and wiggling, and He's laughing, happily staring up at His mother like a normal child. She smiles back, without any of the usual impersonal grandeur. Her clothes, like the room, are still amazingly grand (she could be a rich Flemish aristocrat in her garden study), but we are looking down on her from the same plain as the painter and St Luke. Instead of setting them up as a fabulously heavenly pair, sitting on a throne surrounded by angels, the artist puts them in the same room as us. The sense of closeness in the small room is increased by the long view down the twisting river, and van der Weyden makes us feel the space by putting another couple standing at the battlements. Without them his river view might look like a painting hanging in the next room. Despite the concern for accuracy this was painted at a time when symbolism was everywhere, which is why the ox hiding under the desk behind St Luke would not have looked odd. The saints needed to be seen with their familiar attributes, as without them they were just mortals.

THE ARTIST 'Roger of the Meadow', as his name translates, was one of the most influential artists of the fifteenth century. He and his studio of helpers were imitated all over Europe, even in Italy. But when he died he was forgotten, leaving only his art behind. Who van der Weyden really was and how he lived is still a mystery. His work has been confused with other artists, and it is only since the twentieth century that he has been rediscovered as one of the world's greatest painters.

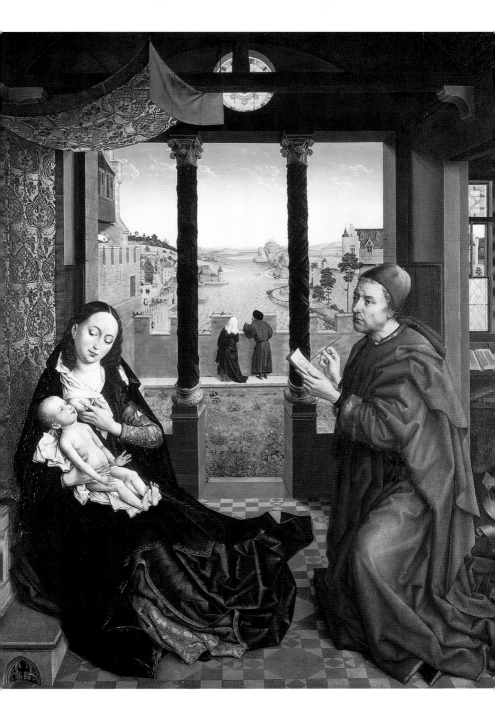

Hans **Memling**

b. Seligenstadt 1430–40; d. Bruges 1494
The Annunciation (two exterior panels of a triptych), *c.*1472
Oil on panel
83 x 26.5 cm (32 ³/₄ x 10 ¹/₂ in)
Groeningemuseum, Bruges

THE PAINTING These panels formed the doors to a triptych that is now broken up. The separated sections hang in New York, Vicenza and Bruges. Only these two outer doors remain in Memling's adopted Netherlandish town. He painted them in the monotone technique called *en grisaille*, which makes them look less like painting and more like carved sculptures standing in arched stone niches. Fra Angelico painted *The Annunciation* twenty-five years before, in Florence, but Memling wasn't interested in his kind of Gothic symbolism, his use of sparkling gold or his depictions of Renaissance architecture. God is divinely giving life and ultimately saving humanity, but Memling painted it with amazing restraint. The figures are cool and graceful, painted with typically Netherlandish precision, and they feel real because Memling's mastery of light and shadow gives them depth and solidity. The Archangel Gabriel is holding his attribute, the fleur-de-lis topped staff. His banner says *Ave Gratia Plena Dominus Tecum*, which means 'Greetings most favoured one! The Lord is with you'. This is a slightly more subtle way of telling the story than Fra Angelico's approach, with his angel firing Latin sentences from his mouth into the air. That would not have been realistic enough for the down-to-earth middle-class art of the Netherlands. We know it is the Virgin because in the jug next to her is the lily, symbolic of springtime (when the Annunciation happened) and of her purity.

THE ARTIST German-born Memling was the most important artist of his day in Bruges, where he lived through the fighting and upheaval of the change from Philip the Good to Spanish rule in the Netherlands. He was the heir to van Eyck and van der Weyden, but where van der Weyden was a painter of emotion Memling was one of restrained coolness and perfect balance. His eye was trained for minute detail, in faces as well as landscapes. This is the kind of detail that inspired Bellini in Venice to paint his highly detailed portraits, like *Doge Loredan*, in the northern technique of oil paint. Lots of Memling's paintings ended up in Italy, like the centre panel of this triptych. Throughout the ninetheenth century Memling was considered the most important Netherlandish artist of his time, and is still considered one of the greatest.

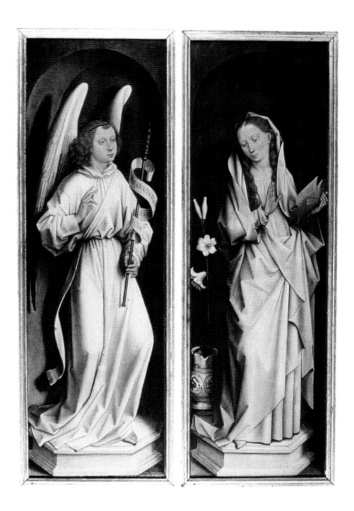

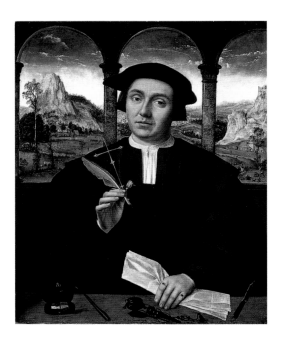

Quentin **Massys**

b. Louvain 1465–66; d. Kiel, nr Antwerp 1530
Portrait of a Man, c.1510–20
Oil on panel,
80 x 64.5 cm (31¹/₂ x 25¹/₄ in)
National Gallery of Scotland, Edinburgh

THE PAINTING Massys learnt a lot from Leonardo, and this is his male *Mona Lisa* to prove it. As with the *Mona Lisa*, we know little about this sitter. Do the ink in front of him and the quill in his hand mean he is a writer? Why does he also hold a rosebud and a pink crucifix, and have a halo? One of Massys' great friends and influences was the world's first best-selling author, the intellectual Erasmus. It would be tempting to link this portrait to him if only the surviving portrait Massys painted looked more similar. The distant receding landscape shows the influence of Leonardo's new aerial perspective that faded gradually away, and though Massys still loves to use highly accurate detail he has softened the skin textures with Leonardo's technique of building up layers of paint and shadows (*sfumato*). The man's oddly engaging expression has something of Leonardo's enigmatic expressions too, yet worn on a very northern European face.

THE ARTIST Massys was a tinsmith until he was twenty, and only took up painting to impress a girl and woo her away from another painter. Although he was self-taught, within five years he had become a master of the Antwerp painters' guild and by 1510 was the city's best painter. Massys helped bring the minutely observed Gothic traditions of northern painting together with the new brand of realism that was forming in Italy, helping to unite the two great artistic cultures of Europe.

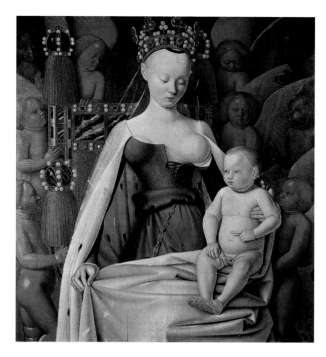

Jean **Fouquet**

b. Tours *c.*1420; d. Tours 1481
Virgin and Child, 1452
Oil on panel
95.3 x 86.4 cm (37½ x 34 in)
Koninklijk Museum, Antwerp

THE PAINTING One of France's greatest fifteenth-century paintings was also one of the strangest. The figures look like cold pieces of marble, surrounded by dumb-faced angels in hellish Technicolor. Christ is as expressionless as the cherub angels, and why do the Virgin's breasts look like spherical implants, bursting out of her undone bodice? Her fashionably shaved head shows off her perfectly beautiful features, as she demurely looks downward. She is certainly no ordinary Virgin, but then she wasn't meant to be. This is Agnes Sorel, King Charles VII's mistress. Christ is pointing at the other panel that used to be attached to this one, showing Etienne Chevalier, the King's Treasurer. Chevalier had both panels painted to hang over his recently dead wife's tomb, but his secret was that he too was in love with Agnes. She is painted like an untouchably perfect idol, which to him she was. So on one level it is a painting about religion, a devotional painting of a goddess, while on the other it is a painting about sex, still devotional, of a different sort of goddess. It is a rare combination of two powerful human preoccupations.

THE ARTIST Fouquet rose to become the only truly Renaissance artist of fifteenth-century France. During a stay in Rome, where he painted the pope's portrait, he understood and took on Leonardo's developments in perspective together with the sculptural innovations of Donatello. The icy detachment of some of his figures, like this Virgin, reflects his own cool character.

Hieronymus **Bosch**
(Jeroen van Aken)

b. s'Hertogenbosch *c*.1450; d. s'Hertogenbosch 1516
The Garden of Earthly Delights, *c*.1505
Central panel of a triptych, oil on panel
218.5 x 195 cm (86 x 76 in)
Prado, Madrid

THE PAINTING This fantastical world of frolicking people had one purpose for Bosch – to show us that lust leads to hell. Like Bronzino's famous allegory of sex, Bosch's is a moral tale, but it couldn't be further from Bronzino's polished Renaissance world. The centre panel of a triptych, between Eden and Hell, it shows that lust is the sure way to damnation. It is easy to see from Bosch's paintings why people think he was a madman with an imagination tainted by illness, but he was painting for an audience that understood him. Even so his greatest work is still full of mysterious images that we can't understand today. Some are from fifteenth-century Netherlandish slang, puns and sayings that were obvious and funny then but have been obscure for centuries. To the Netherlanders in the fifteenth century the fish was a phallic symbol and the berry stood for sex. So birds feeding berries to open-mouthed men and swimmers nibbling at them were sexual puns; like the winged strawberry in the left corner looking like a mating dragonfly on a woman's back. The fruit parings (peelings) that so many of the couples are inside represented pairings of people; the Netherlandish play on paring/pairing is the same as the English. The fruit paring itself is hollow, however, signifying the emptiness of sensuality. The 'Pool of Venus' in the background is ringed by men riding (the same innuendo then as now) in a frenzy around the women. Some carry outstretched fish and others are already together in a hollow fruit paring. But despite the lewd associations there isn't much graphic imagery here. Bosch didn't want to titillate. He wanted to show the degrading effect of lust on humanity, because he truly hated animalistic baseness in mankind.

THE ARTIST Although understood in his time, Bosch was still a total anomaly in Netherlandish art. There was no one else like him, nor has been since. He totally ignored the Renaissance, and relied on Gothic ideas of body types, composition and style to carry his personal visions of heaven and hell. He was an upright, religious, middle-class provincial who was independently rich enough not to need money from his work, so he was free to paint totally individually. But his individuality meant he was misunderstood. After his death he was virtually forgotten until he was rediscovered again in the nineteenth century. In the twentieth century he inspired Surrealists like Dalí.

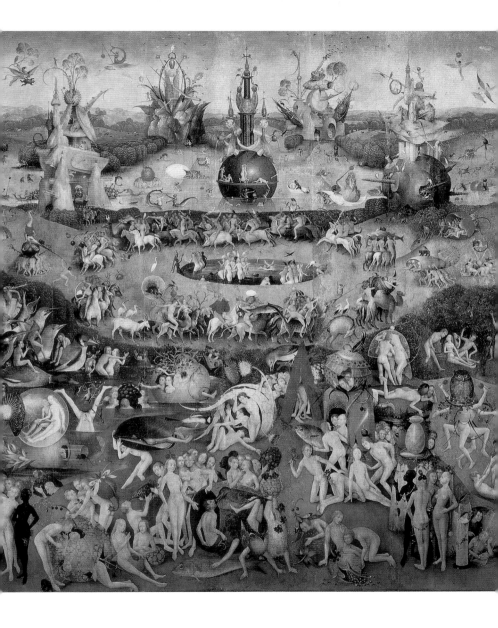

Albrecht **Dürer**

b. Nuremberg 1471; d. Nuremberg 1528
The Martyrdom of the Ten Thousand, 1508
Oil on panel transferred to canvas
99 x 87 cm (39 x 34¼ in)
Kunsthistorisches Museum, Vienna

THE PAINTING A man with a hammer is about to crush the head of his foreshortened victim while the Persian King Saporat helps him to aim. Next to him the blindfolded man's head is about to join the others on the ground. The king had been ordered by the Roman Emperor Hadrian to massacre these 10,000 Christians, and in every corner of Dürer's Mount Ararat there are bloody murders. Forty-five years earlier the Turks had conquered the eastern Christian Empire and were threatening Europe from Spain to Vienna. Frederick the Wise, the Elector of Saxony, commissioned this for his church as a constant reminder of who the enemy really was. Dürer was doing something rather like what Michelangelo had started that year in the Sistine Chapel; he was trying to master every twist of the human body. In the centre, a figure is holding a banner saying *Albrecht Dürer, German*. What's he doing there? Dürer probably would have said 'why shouldn't I be? It's my painting!'

THE ARTIST Dürer was the greatest artist in fifteenth-century Europe outside Italy. He is credited with single-handedly carrying Italian Renaissance ideals into northern Europe. Like his Italian contemporary Leonardo he wrote about perspective, measurements, fortifications and his lifelong obsession, the proportions of the human body. And like him he was pushing the boundaries of what it meant to an artist in society. Dürer spent his life trying to increase the status of art and himself. His self-consciousness led to his first self-portrait aged thirteen, and he just kept on painting himself. With Rembrandt, he is one of the only artists to keep a record of his artistic development through how he looked. The most famous self-portrait shows him staring directly at the viewer in the way that was reserved for Christ, or kings. Dürer actually painted himself looking like Christ with long flowing hair, beard and hand raised as if blessing us. He was deeply religious, but was trying to show that as a great artist he was like God, as he could create life on canvas. This was dangerous stuff in fifteenth-century Germany. Rembrandt is also the only artist who comes close to Dürer's incredible printmaking talent. Dürer was the only Renaissance artist to spend serious time making prints. Because they were cheap and easy to distribute he became the first mass-market artist, and one of the most famous artists ever, from his own time to now.

Matthias **Grünewald**
(Mathis Gothardt Neithardt)

b. ?Würzburg c.1470–80; d. Halle 1528
The Mocking of Christ, c.1503
109 x 73.5 cm (43 x 29 in)
Alte Pinakothek, Munich

THE PAINTING In this painting Grünewald captures all the dumb thuggery and bloodlust of the mankind that Christ was born to save. Christ has just been arrested and is on His way to be judged. He is spat on and beaten by a mob incensed that this mortal claimed to be the Messiah. Grünewald has painted the story at the point where someone is calling out, 'Now Messiah, if you are the prophet, tell us who hit you'. Here the jailer shouts the words and the grotesque-faced man behind him grabs Christ's hair with one hand, about to pummel Him with the other. Christ is blindfolded, bleeding and looking pretty pathetic. His thin, bearded face and down-turned mouth have none of the divine resignation you'd expect. It was all very real-looking to a fifteenth-century German. This could be a battered criminal being dragged through the streets of any German town on his way to being tied up in the stocks. Grünewald isn't letting anyone forget that Christ was a living human being. He makes us sympathize with the haggard broken figure, without any heroism, and reminds us that He forgave the sins of this ugly, vulgar crowd of humanity that we are all part of ourselves.

THE ARTIST Grünewald was second only to Dürer as Germany's greatest Renaissance artist. They were both religiously troubled Protestant converts who had unhappy, childless marriages, but the rest of their lives couldn't be more different. Dürer made very sure that his Renaissance attitudes would bring him fame, fortune and lasting respect. Grünewald was so unconcerned with these things – or so bad at making them happen – that his real name, Neithardt, was only discovered in the 1930s. He had a feeling for colour and a reliance on paint that his contemporary Dürer could not match. He was an excellent draughtsman but he never made the etchings that could have made him famous; instead he stuck to making dramatic, colourful paintings. His incredibly powerful imagery was recognized in his lifetime, but it wasn't enough to get him work when he left his patron, the Archbishop of Mainz, after he supported the wrong side (the peasants) in the Peasants' War. He worked as an architect, then sold quack medicines and paint. In 1528 he died of the plague while working as a hydraulic engineer. The city councillors who employed him said on his death, 'he didn't achieve very much'.

Albrecht **Altdorfer**

b. Regensburg 1480; d. Regensburg 1538
The Battle of Alexander the Great at Issus, 1529
Oil on panel
158 x 120 cm (62$^{1}/_{4}$ x 47$^{1}/_{4}$ in)
Alte Pinakothek, Munich

THE PAINTING This is Altdorfer's masterpiece. In this massive battle scene he has crammed thousands of armoured knights into every piece of land. Only the mountain peaks that recede through the sea and into the mist are figure-free. The landscape looks a bit like Leonardo's in the *Mona Lisa*, but Altdorfer was no lover of Italian art. Painting the alpine landscape near his home town, south of the River Danube, he was part of a loose group of artists called the Danube School. They painted their native German landscape in an expressive way, conjuring up emotions with it. This scene is one of the most grandiose in art. Alexander is in the centre-left on his golden chariot, driven by three white horses. He has just beaten Darius, and their legions of warriors are still lancing, spearing and fighting. The immense battlefield is laid out, but Altdorfer hasn't painted it with the perfect mathematical perspective of the Italian Renaissance, as Dürer would have done. He knew how to use perspective (the figures get smaller in the distance), but his horizon is impossibly high, which no Italian Renaissance painter would have dreamt of doing. He did not need to follow perspective slavishly. He wanted to create a mythically grand epic with the sun setting in one corner and the moon coming out in the other, and it works. He was helping to create a German grand tradition of painting because he didn't like or want to use the foreign Italianate imports from south of the Alps. This classical subject was commissioned as part of a set for the Duke of Bavaria, but instead of painting classical warriors, Altdorfer paints up-to-date German ones.

THE ARTIST Altdorfer was a late Gothic artist who knew how to paint landscapes to bring out emotion. Like Gozzoli in Florence he was adding Gothic detail to Renaissance ideas like perspective, vanishing points and realistic colour. He was the first artist in western art to paint a landscape without any figures at all, making the view the subject. Though he didn't really have any followers he was seen in the nineteenth century as one of the first pan-German national painters. Like Bosch in the Netherlands, Altdorfer was one of his town's richest citizens and a prominent figure. In 1533 he turned down the opportunity to be mayor, to carry on with his new career as an architect.

The Renaissance in Northern Europe

ALEXANDER M DARIVM VLT: SVPERAT
CA. SISI ACIE PERSAR: PEDIT: CM. EQVIT
VI: X.A.M INTERFECTIS: MATRE. QVOQVE
CONIVGE. LIBERIS DARII REGCVM M I.D WD
AMPLIVS I QVITIB: FVGA DILAPSI.CAPTIS.

Lucas **Cranach** the Elder

b. Kronach 1472; d. Weimar 1553
The Judgement of Paris, c.1528
Oil on panel
102 x 71 cm (40 x 28 in)
Metropolitan Museum of Art, New York

THE PAINTING Cranach was a master of erotic art, and cornered the market in sultry female nudes in sixteenth-century northern Europe. Here he has taken the story of the Judgement of Paris as an excuse to paint three at once. This has always been a popular subject as it has four of art's timeless elements – sex, ego, death and power. Wrapped up in sex and beauty it is a classical story, showing off its owner's erudition and ego. Paris is judging a beauty contest, and his decision sets off a chain of events that leads to the Trojan wars and to his own death. There is a sexual power struggle between the three goddesses, as they try to bribe Paris into deciding who is the most beautiful. Not happy with three purely classical nudes, Cranach dresses them up with the jewellery and hairstyles of his day. Mercury is holding the prize of a ball in his hand, and looks as if he is from a medieval parade, while the shepherd Paris is promoted to a dashing knight in armour with a brilliant white, if far too small, horse. Cranach gives him and the winner Venus his favourite prop, a ridiculous feathered hat. Like Altdorfer, Cranach was influenced by the Danube School, with evocatively painted German alpine landscapes like this one with mountain castles and distant forests. The unnaturally elongated Mannerist bodies of his goddesses, with their penetrating coy stares, are typical of Cranach's style, which influenced a huge school of Germanic painters.

THE ARTIST Cranach's life before thirty is a mystery, but after his appointment as court painter to Frederick the Wise in 1505 he became one of the most influential painters north of Italy. He didn't look to Renaissance ideals like Dürer. Instead he developed a slick court style for Frederick and hired a massive workshop to carry out painting his Venuses, portraits and religious scenes in landscapes. Where Dürer was struggling to discover the perfect system to measure the human body, Cranach was happily painting a stylish mix of Gothic and Mannerist elements often set in up-to-date German landscapes. His portraits of his good friend the Protestant reformer Martin Luther have been reproduced all over the world, along with his prints for the first Protestant bible. But Cranach really represents that robust strain of German art that was vaguely affected by the Renaissance but never actually participated in it.

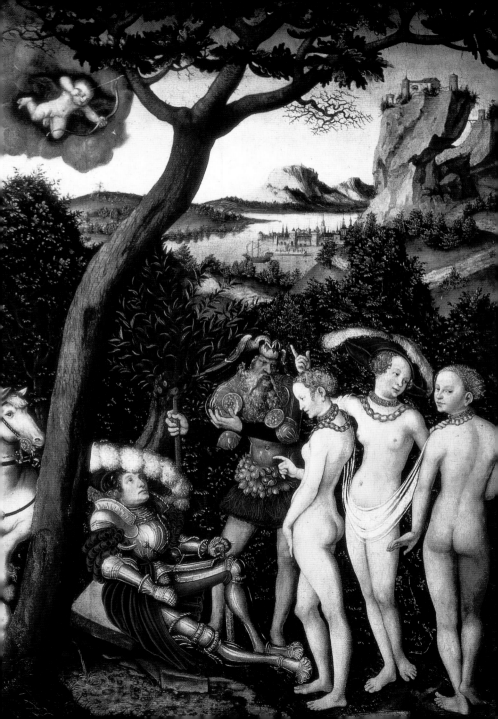

Hans **Holbein** the Younger

b. Augsburg 1497–98; d. London 1543
Jane Seymour, 1536
Oil and tempera on panel
64.8 x 40.6 cm (25$^{1}/_{2}$ x 16 in)
Kunsthistorisches Museum, Vienna

THE PAINTING Jane Seymour was the third of Henry VIII's six wives and the only one to give him the one thing he needed from his marriages – a son. She had been lady-in-waiting to his first two wives, Catherine of Aragon and Anne Boleyn, and had seen Anne executed just months before her own marriage to him. They married quietly the year this portrait was painted, only a year before she gave birth to the sickly future Edward VI. The childbirth killed her. Holbein used the old fast-drying tempera paint as well as the newer slow-drying oil paint to get the jewel-like finish he wanted. Her pose is formal, befitting a new queen, but her expression is almost characterless. Holbein was a master of penetrating likenesses of his sitters, but here he makes Jane a slightly prim, vacuous ideal of a noblewoman. Around her eyes she has something of the Cranach school of beauty, adding some fashionable looks to her otherwise exact features. She is gently lit from her upper left, and a light shadow behind and around her features gives her solidity. Holbein's precise and exacting brushwork is clear and timeless, and he doesn't care about southern 'classical beauty'. He usually painted realistic features like van Eyck and the other Netherlandish artists, but he also learnt from Leonardo and the Italians how to soften and balance an intimate portrait like this.

THE ARTIST Holbein was the best portrait painter in sixteenth-century northern Europe. He was Dürer's successor as *the* northern Renaissance artist, but because of the troubled times he lived in he had to leave Germany and look for work in England. The religious Reformation in central Europe effectively ended the demand for religious paintings, and artists who couldn't find work elsewhere were ending up in poverty or other professions, like Grünewald had done. Though Henry VIII was turning England into a Protestant state, Holbein, carrying a letter of introduction from the intellectual Erasmus, went to the artistic backwater of London in 1526 to look for patrons. It worked. Within two years he had made enough money to go home to Basel and buy a house for his wife and children. Increasing fame in English court circles managed to get him the position of Court Painter by 1536, drawing and painting portraits for the king. He only saw his family once more before he died of the plague, in London.

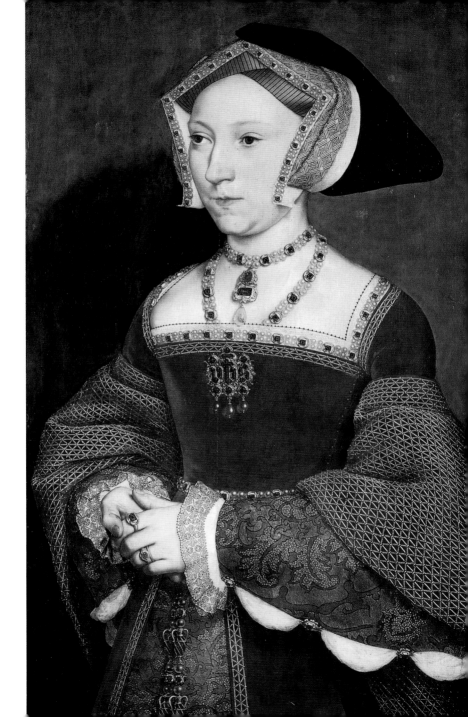

François **Clouet**

b. ?Tours c.1510; d. Paris 1572
Francis I of France on Horseback, c.1540
Oil on panel
27 x 22 cm (10½ x 8¾ in)
Uffizi Gallery, Florence

THE PAINTING The French King Francis I poses on his horse and looks directly out at us, smirking. Despite the grandeur of the balanced composition, with its Leonardo-like receding landscape and classical building, it has an engaging intimacy about it. The king's enigmatic face is mirrored in the stallion's mouth and eyes. There is a strong diagonal across the picture which might lead us to its meaning. The king's golden sceptre ends at his polished golden codpiece and carries down through his sword to the horse's genitals. Francis' court was all about eroticism, wit and art, and this tiny cabinet picture (for a private room) combines all three. Maybe Clouet was asked to paint it as a token for one of the king's mistresses. But intimate and personal as its wit suggests, Francis isn't about to let us forget just how important he is. The intricate Milanese armour with golden faces on its shoulders, elbows and knees proves his rank and fashionability. The strapwork decoration on his armour was new, and Clouet carries its fussiness on to the horse's coat to give the whole thing more balance. Francis I was the main force in the French Renaissance. He loved Italy and its arts and wanted to re-create the culture of their courts in his own country. Bronzino's witty and polished allegory of sex hung in his new country palace at Fontainebleau. In 1516 his artistic patronage had become so great that his invitation to Leonardo to come to his court was accepted. It has gone down in legend that when Leonardo died in France three years later, it was in the arms of Francis I.

THE ARTIST Clouet is one of the great artists of the sixteenth-century French Renaissance. He trained under his famous father, the court painter Jean, but it was only in the nineteenth century that the two painters became distinguished from each other. Not much is known about his life, but in his painting he fused the work of Leonardo, Bronzino and other Italians, the northern precision of his own Netherlandish background and the elegant Mannerist portraiture of France. There are only two signed paintings by him, but the style he epitomized in the French court at Fontainebleau was carried on by generations of artists. It was during his time that French art firmly left its Gothic past behind and began to develop into the world force in painting that it remains today.

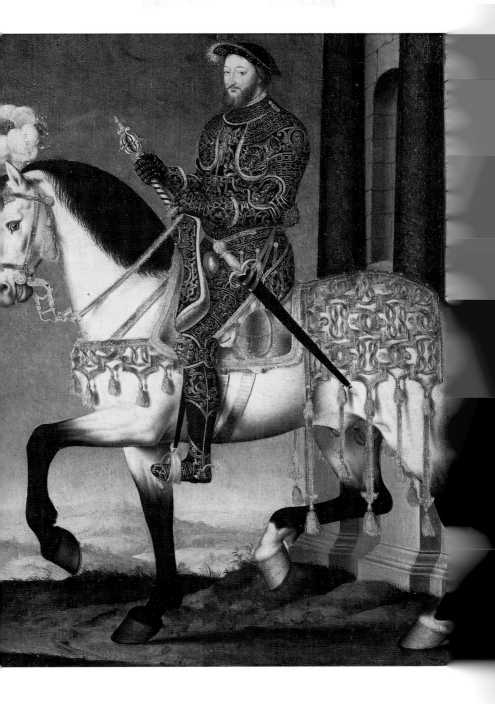

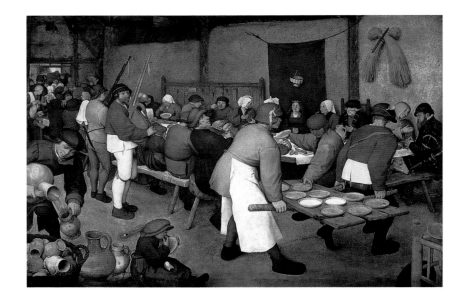

Pieter **Bruegel** the Elder

b. Brogel *c*.1525; d. Brussels 1569
Peasant's Wedding, *c*.1566–67
Oil on panel
114.3 x 162.6 cm (45 x 64 in)
Kunsthistorisches Museum, Vienna

THE PAINTING It is a peasant wedding feast in sixteenth-century Netherlands, and the beer is flowing. This is one of Bruegel's most famous paintings, and he has captured all the excitement and fun of the feast. Sitting under the wall-hanging is the smug bride, stupidly grinning, while a few seats away her new husband is shovelling a spoonful of something into his goggle-eyed face. Parents and guests are chatting as the crowd pushes its way through the barn door looking for a free lunch. The bagpipe player stares hungrily at the cooks who carry the food in on an old door. The scene is crammed with funny details that Bruegel had observed from life. He is supposed to have gone out dressed as a peasant himself to watch them as they actually behaved, and to paint them without being discovered.

THE ARTIST Bruegel was one of the most important artists of sixteenth-century northern Europe. Like other Netherlandish painters he went to Italy to learn his craft at the heart of the Renaissance. But instead of imitating Roman ruins, subjects or styles, he came back to Antwerp and painted the country peasants and landscapes as he saw them. He had learnt how to use perspective and lighting to give solidity and real space to what he painted, but he used that expertise to paint the real characters he saw around him, not the classical tales of Italy. He founded a huge family of painters and his style was imitated for centuries.

The Renaissance in Northern Europe

The Seventeenth Century:

Caravaggio to Cuyp

The seventeenth century was a time of huge change in Europe. Religiously, politically, scientifically and philosophically nothing was standing still. In France the philosopher Descartes reduced all real knowledge down to 'I think therefore I am', with implications that undermined absolutely everything the world had believed in. (His views on the infinite nature of the universe were too heretical to air.) Before the Roman Inquisition, Galileo was forced to recant his proof of Copernican theory that the planets revolved around the sun, while in England the physicist Newton conclusively explained gravity and planetary rotation. Politically the century was just as violent and chaotic as the one before. Germany had the Thirty Years War. England had its Civil War, regicide, Republic and Restoration, which dispersed the great art collection of Charles I around Europe. The nothern Netherlands, having won their independence from Spanish rule in 1581, split the region in two – a free Protestant Netherlands and a Catholic Flanders (roughly modern Belgium), still ruled by a Spanish archduke. By 1670 the Netherlands had became the world's most important trading power, with colonies from New Amsterdam (now New York) to Japan, where it held the monopoly on trade. The Dutch, British and French had eclipsed the old importance of the northern Italian city-states like Florence and Venice. And the Catholic church, once the only real power, was rejected by most of northern Europe, dividing the continent in two.

Rome initiated new artistic styles in the first half of the century, and it continued to attract most of the good artists of the time, being the city of Michelangelo and

Raphael as well as the cradle of ancient civilization. Artists from all over Europe felt it was necessary to learn in the world's greatest cultural city. But it wasn't Roman, or even Italian artists who dominated the new century. It was the Flemish, the Dutch, the French and the Spanish, who studied there but returned home to reinvigorate their own countries. The ubiquitous pilgrimage to Rome broke down the barriers between the northern and southern Renaissances. Artists in all parts of Europe still worked out of their local traditions, but now they also understood what was happening in other artistic circles. Europe began to harmonize its local differences under the cloak of the Baroque style. This was the new style of exuberance, where compositions were asymmetrically crowded with movement and action. The cool classicism of the High Renaissance had been transformed into a riot of colour and activity.

Mannerism had started in Italy and by the late sixteenth century was influencing most painters from Parma to Prague, but the tide was turning against its false aesthetic. What seemed for so long to be a noble ideal of transcending earthly beauty for something better was beginning to look like a shallow stylistic trick. Caravaggio was the first to react against its conventions of elegance. He was a strong-willed character and saw the painting of otherworldly beauty as valueless and dishonest. What better way was there to express real human emotions and situations than with real human beings? So he hired working Romans to be his models, warts and all. It outraged some of the old guard, who saw him as attacking beauty itself and reducing the grandeur of painting to merely portraying the everyday and low-life. But to others it was exactly the sort of rebirth and redirection that painting needed. His characteristically bold *chiaroscuro*, where the action is caught emerging from the shadows, was as influential all over Europe as his gritty realism. Carracci took up Caravaggio's ideas in a slightly different way. He wanted to keep as much reality as he could but he didn't want to lose the monumentality and grandeur of Michelangelo or Raphael. So he founded a school of painting that went back to basics, to drawing. His academy in Bologna trained up the next generation of painters to take inspiration from these High Renaissance masters, as well as the realism of direct observation of character and detail. His student Reni combined both of these, but wasn't afraid to draw on the flowing beauty of the Mannerists either.

Meanwhile in Flanders and the Netherlands something very different was going on. Rubens had come back from years in Italy, with brushwork that had all the painterly freedom of Titian. Being from Catholic Antwerp he was able to use his immense talents for grand compositions in huge altarpieces and religious

commissions, that came to him from his Spanish rulers. Over the border in the independent Netherlands, however, some of the greatest artists of any age – Hals, Rembrandt and Vermeer – all died in poverty after trying to make a living out of small portraits and *genre* scenes for the Protestant middle classes. All five had one thing in common – a deeply sensuous and expressive use of oil paint. And this was something that was shared by their Spanish counterpart Velázquez, whose rich use of paint has helped mark him out as the country's greatest painter. More typical Spanish traditions can be seen in the paintings of their South American colonies. There are no significant surviving paintings from the pre-Colombian world but, as in North America, the traditions of the parent colonial country were simply transported in a simplified way to the new world. Exported art traditions were carrying on in the Islamic and Asian worlds too. The Mughal Emperor in India ruled over more than one religion and was open to all influences. So the art of India drew on the Islamic influences of painters in nearby Persia, and added traditions of Hinduism and Buddhism to forge a particularly colourful Indian style that continues today. The Chinese were carrying on in a similar vein to the outline drawing principles that had been slowly developing over a thousand years, and they were exporting their traditions to neighbouring countries like Japan.

Back in Europe, Poussin's serious and classical landscapes were splitting France's artists into two camps, the *Poussinistes* and the *Rubénistes*. This represented the old Italian conflict between *disegno* and *colorito* (design and colour). It was a century of divisions, religious conflicts, wars and change. But seventeenth-century Baroque art brought together Europe's painters, while their style grew in colonies around the world. For the first time since International Gothic, Europe was sharing a common artistic aim.

Michelangelo Merisi da **Caravaggio**

b. Milan or Caravaggio 1571; d. Porto Ercole 1610
The Young Bacchus, c.1596
Oil on canvas
98 x 85 cm (38½ x 33 in)
Uffizi Gallery, Florence

THE PAINTING The young god is peering at us from over his glass of wine. Wine is the symbol of his power, and its surface ripples with movement as he offers it in his outstretched hand. The sense of action instantly draws us to him. From the glass we naturally look up the diagonal of his arm to his face. He is no traditional god. From his drunken red cheeks, dark hands and dirty fingernails, to the sensual intent of the eyes and lips, he is a very worldly god, human even. Although he was the god of wine, no one had ever painted Bacchus so young or so blatantly sexual before. Once this was thought to be a self-portrait, but now it is taken to be a male prostitute, offering himself to the artist. This incredibly frank earthiness is one of Caravaggio's greatest innovations and achievements. It helped blast away the last remains of the artificially elegant Mannerist style, which had reached its climax a generation earlier with Parmigianino. Caravaggio even went as far as using prostitutes as models for the Virgin Mary, but the church still loved the way their saints were becoming human by his brush. His critics thought this kind of realism, with its fruit rotting in Bacchus's bowl, debased art by ignoring the 'rules' of beauty.

THE ARTIST Caravaggio was one of the most influential artists in history. His brilliant use of light and shade (*chiaroscuro*), together with his powerful humanism and imagery, led to a vast following of artists throughout Europe, known as the 'Caravaggesques'. But he was also one of art's most volatile geniuses. Some of his most powerful paintings are about sex or violence, and it was a combination of both these things that was his downfall. There are plenty of theories about why he killed a man in a brawl in Rome – an argument over a shared mistress is the most likely – but it meant the end of his Roman career. He fled to Malta to escape justice and his enemies, and became one of the island's Knights of St John. But he was soon in another duel and had to flee again, fearing his life. When the Knights caught up with him a year later in Naples they nearly beat him to death. He escaped, only to be accidentally arrested eight months later. He died, within days, of a fever.

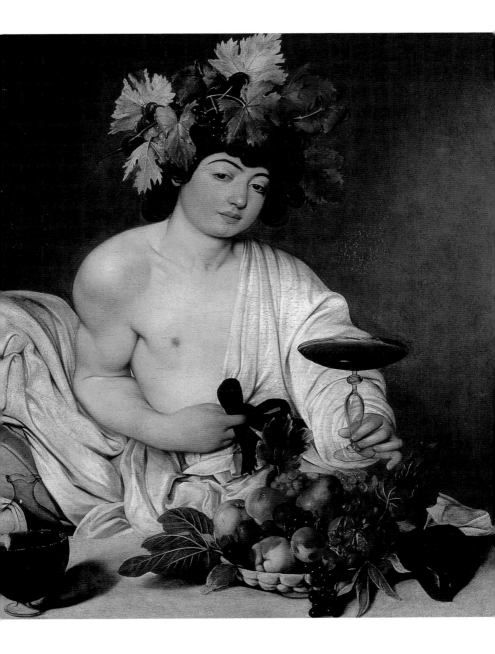

Artemesia Gentileschi

b. Rome 1593; d. Naples 1652–53
Judith and Holofernes, c.1612–21
Oil on canvas
199 x 162 cm (78^1/$_2$ x 64 in)
Uffizi Gallery, Florence

THE PAINTING Judith's sword is half-way through Holofernes' neck. His brief struggle was in vain and now it is almost over. Deep red blood spurts out of his arteries and soaks the white bed. It is a painting of pure violence, cool and considered. But importantly for Artemesia it is a painting of justified, if enraged, killing. Judith's city was laid siege to by General Holofernes' troops. Just when it was about to fall, the beautiful widow Judith stepped in with a plan. According to the Old Testament she dressed 'to catch the eye of any man who might see her' and left the city with her servant to seduce Holofernes in his camp. After a drunken banquet she met him in his tent – and left with his head. Taking it back to the city she roused the Jews to battle, and Holofernes' Assyrian troops fled in panic at the sight of their leader's severed head. This scene was close to Artemesia's heart, and it became her most reproduced subject. Its strong Caravaggesque light catches only the important angles of the picture; the rest is cloaked in darkness.

THE ARTIST Artemesia was one of Caravaggio's best followers, and like her famous artist father, Orazio, she was deeply influenced by his style. As a teenager she was already a brilliant painter, and aged twenty-three she became the first ever female member of Florence's prestigious Accademia del Disegno. Both her father and her painting teacher, Agostino Tassi, trained her to paint using the strong light and shade technique of *chiaroscuro*. However, Tassi's interest in Artemesia was less than professional. When she was seventeen Artemesia and her father had him in court for serial rape. The trauma and long case affected her for the rest of her life. Her reaction to the ordeal is visible in her art. Her *Judith and Holofernes* scenes have been read as revenge paintings, with Artemesia herself pre-emptively slicing off her attacker's head as he lies in wait for her. She had an incredibly strong character, and led a very independent life. She carried Caravaggism out of Rome and into Florence, Genoa and Naples during her travels. Her painting abilities were never in doubt, but for whatever reason, perhaps because of male patrons and competition, she struggled for commissions. She was almost written out of art history until the twentieth century, when she was rediscovered as one of the greatest Caravaggesque painters.

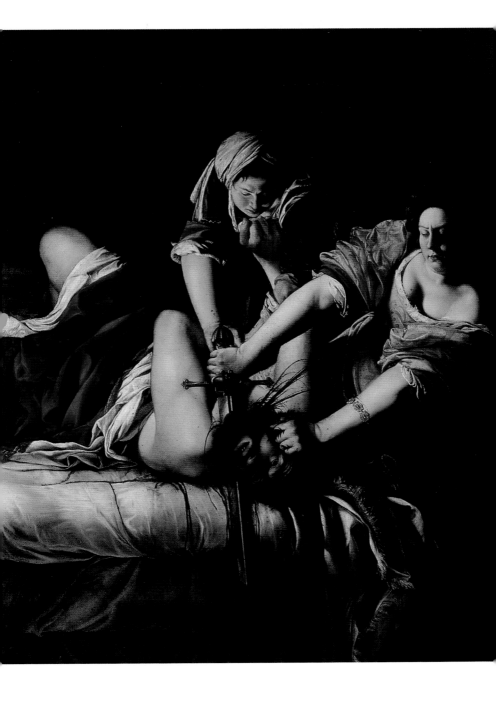

Annibale **Carracci**

b. Bologna 1560; d. Rome 1609
A Man Drinking, c.1581–84
Oil on canvas
56 x 44 cm (22 x 17 in)
Private Collection, Zurich

THE PAINTING This image of a wine drinker is one of Carracci's most enduring paintings. He is a real man, studied from life. You can see the movement in his neck muscles as his head goes back to drink. He is not an elegant figure, nor a particulary dirty one like Caravaggio might have painted. Carracci's painstaking study of the human figure paid off in this painting, which has none of the pretension of most of the Mannerist art of his day. The background is not crammed with pointless detail. He has filled every inch with the drinker, and everything important we can see in the light. Carracci himself dressed like this, like an artisan, and he was relaxed with such people. It was his exaggerated sketches of people like this that became the first caricatures. Acting the part of the aristocratic courtier painter was what he hated, and it was this lifestyle that led to his mental breakdown.

THE ARTIST Along with his artist brother Agostino and cousin Lodovico, Carracci was one of the most influential artists Italy ever saw. Together they started one of the first art academies, the Academy of the Progressives. It turned Bologna into one of Italy's great cultural cities. In trying to improve the art of the time Carracci preached drawing from live models, and drew thousands of sketches of everything he saw. The seventeenth-century art historian Count Malvasia said that he ate with 'food in one hand and a pencil in the other'. His invention of the ideal landscape, where a perfect grand scene is set up like a stage for actors to play out a story, had a massive influence on the two French painters, Poussin and Claude. Like Caravaggio in Rome, Carracci revolted against the artificial elegance of the Mannerist style. But where Caravaggio reacted to it by painting gritty realism, Carracci went back to salvage the realistic draughtsmanship of Michelangelo and Raphael. He tried to re-create the ideals of the High Renaissance, before Mannerists like Parmigianino had ended it with their decorative principles. He idealized bodies in the classical style, but added his own powerful movement, energy and *chiaroscuro*. Along with Caravaggio he started off the period of painting known as the Baroque, with its solid figures and powerful emotional movement. Of Carracci's many students there was one that he was famously jealous of – the next superstar of Bolognese painting, Guido Reni.

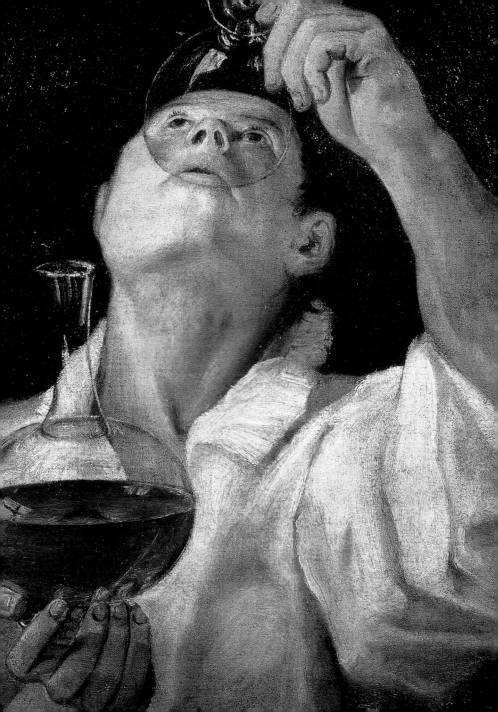

Guido **Reni**

b. Bologna 1575; d. Bologna 1642
The Abduction of Deianeira by the Centaur Nessus, 1620–21
Oil on canvas
239 x 193 cm (94 x 76 in)
Louvre, Paris

THE PAINTING Hercules fought the god Achelous for the love of Deianeira. Predictably Hercules beat him and won her love. But in this picture Reni has gone for a more popular scene from the story, that of the centaur Nessus trying to ravish her. Hercules and Deianeira needed the ferryman Nessus to take them across a river. Having taken Hercules across first (the small figure in the background), Nessus tries to make off with the beautiful Deianeira. Unfortunately for him he is about to be killed from the shore by Hercules' poison-tipped arrow. But for now the centaur is still speeding across the water, excitedly looking up at his prey as she looks up to the heavens with those doleful eyes that Reni made his trademark. He is holding onto her flowing dress, which billows out in every direction. There is so much pale pink, peach, red and blue that Nessus looks like he is wearing it himself. The floating drapery gives all the feeling of motion that Reni needed, but it also gives the scene an otherworldly quality suitable for a classical story. He had learnt a great deal from his teacher Carracci. Reni used his classical idealization of figures, ultimately derived from Raphael, but he tinted it with the flowing elegance of the older Mannerist ways. This combination is the first flowering of the Baroque seeds laid by Caravaggio and Carracci.

THE ARTIST Reni is one of the seventeenth-century's most influential painters. Until the nineteenth century, when the English critic John Ruskin trashed his reputation, Reni had been ranked next to Raphael. His huge studio cranked out thousands of copies of his paintings – not all were great ones, thus Ruskin's rant against him. But Reni had a massive gambling habit he needed to pay for. We know more about him than about any artist of the time. He was prim, got embarrassed by obscenities, and venerated the cult of the Virgin Mary because he was a virgin himself. It is now thought he was also a repressed homosexual. He lived with his mother, but the art historian Count Malvasia wrote that he froze up 'like marble' in front of any other woman. He was haughty, and preferred to dress and act like an aristocrat as he walked around with his servants, which must have annoyed his down-to-earth teacher Carracci. But as the highest-paid artist to date, Reni could act as he liked.

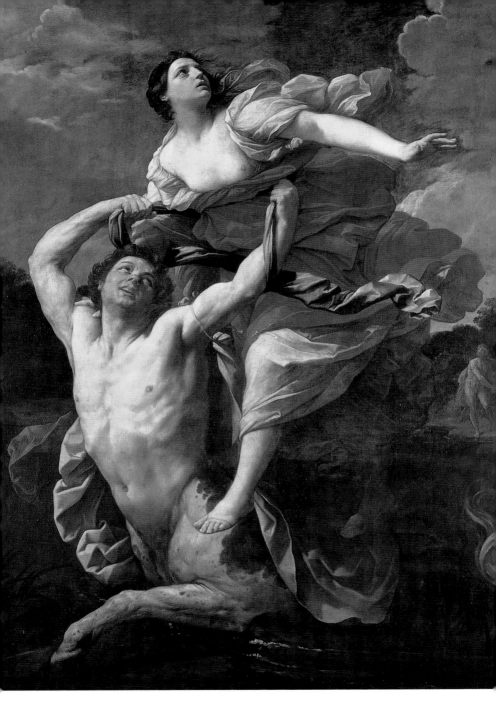

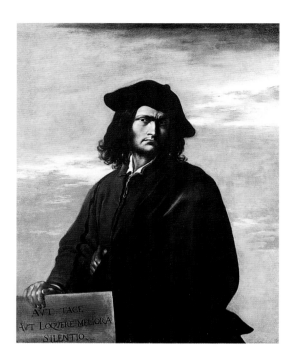

Salvator **Rosa**

b. Arenella, Naples 1615; d. Rome 1673
Self-Portrait, c.1645
Oil on canvas
116 x 94 cm (45³/4 x 37 in)
National Gallery, London

THE PAINTING Against a heroic expanse of sky, the brooding Rosa glares at us. The Latin on the plaque he holds says, 'Keep silent unless what you have to say is better than silence'. He is so self-important and serious that it is comical. He was a fiery artist, musician, poet, etcher, philosopher and actor, and that fire comes across here. He challenged everything and everyone, whether it was the artistic conventions of landscape painting, patronage or society itself. In this portrait he even seems to be challenging us. His huge British following believed he had been a bandit and a freedom fighter, trying to kick the Spanish out of Naples in 1647. This portrait helped to fuel those myths.

THE ARTIST Rosa was the first wild, romantic artist. His totally free landscapes were thrashed out in oils directly onto the canvas. Craggy ravines, mountain paths infested with bandits and dark brooding scenery filled his mind and his art. He was the first artist to reject the wishes of patrons – until then the patron had told the artist what to paint, no matter how great the artist. Rosa turned this on its head by telling the world that he was painting not for money but because he was an artist. This was revolutionary, and it meant he had to publicize himself constantly. He had one-man shows in Rome's Pantheon and sold through dealers, much like a modern-day artist. Defining himself as an individual genius, he still demands our attention.

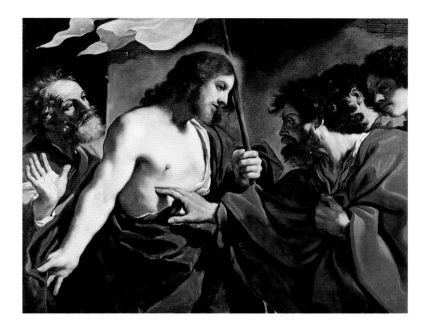

Guercino
(Giovanni Francesco Barbieri)

b. Cento 1591; d. Bologna 1666
The Incredulity of St Thomas, *c*.1621
Oil on canvas
115 x 140 cm (45½ x 55½ in)
Vatican Museums and Galleries, Vatican City

THE PAINTING Doubting Thomas does not believe that Christ has risen after death, and puts his finger to the wound left by the Roman lancer Longinus. Christ benignly invites Thomas to touch the wound for himself. Thomas' doubt turns to stunned fear as he grasps his red cloak; other disciples look on in wonder. Christ is holding the banner of the Resurrection, and around His head is a faint white saintly aura. This is one of Guercino's earlier paintings, where he is still using the vivid colours of his Venetian colourist background, and the texture of his paint is thick and richly worked like Titian's. His use of contrasting light and shade, *chiaroscuro*, is brought to life by his electric colour and deep paintwork.

THE ARTIST 'Guercino' means 'the squinter', a nickname given to him after a childhood accident when he was left with an injured eye. This did not stop him from becoming the leading Bolognese artist after Reni's death in 1642. He continued with the best traditions of Venetian *colorito*, when painting in Venice itself was on the decline, and married it up with his own dramatic lighting and strong emotional movement. The result was a fiercely colourful and powerful kind of Baroque art. But the popularity of Reni's smoother and more subdued colouring, more like Raphael than Titian, ruled the tastes of Rome and Bologna. Guercino's own style never saw the limelight, and by his later years his work became very like the painting of Reni.

Frans **Hals**

b. Antwerp 1581–85; d. Haarlem 1666
The Laughing Cavalier, 1624
Oil on canvas
86 x 69 cm (33³/₄ x 27 in)
Wallace Collection, London

THE PAINTING Hals' most famous painting shot him back to fame after 200 years of obscurity. All we know about the sitter is that he was twenty-six, and that Hals painted him in 1624. Whoever he was, he has become one of the most famous faces in paint. In 1865 the Marquis of Hertford battled with Baron Rothschild at an auction in Paris for a painting catalogued as *Portrait of a Gentleman*. Hertford walked away with *The Laughing Cavalier* after bidding the unheard of sum of 51,000 francs for it. Hals became an immediate worldwide phenomenon. Since his death he had been forgotten about and his free, painterly looking pictures, when mentioned at all, were rubbished as the unfinished sketches of a drunkard. But Hertford had seen him through mid-nineteenth-century eyes, ready for the new realism of Courbet and the free paintwork of Manet and the Impressionists. Hals was painting with both, 250 years earlier. The Cavalier is wearing rich clothes and stands above us, looking down with a grand hand-on-hip pose. But with that roguish smile Hals has burst the bubble of pomp, and shown the sitter in all his human charm.

THE ARTIST Hals was the most individual portraitist of his time, and the first great artist of the newly independent Protestant Netherlands. His genius was to capture a moment in his sitters' lives forever; he was able to take a snapshot of emotion and transfer it into paint, catching fleeting moments like no one else. This might be why he pioneered such a fast and flowing style that was even bolder than Rubens was attempting. Hals became quite famous around Haarlem, but over the years his free style fell out of favour, which only increased his lifelong debt problems. Later critics claimed his debts came from drinking, but true or not his enormous family was a bottomless money pit. He was married twice, and his second wife was often in trouble for brawling and once tried to have one of their ten children, Sara, put in a workhouse because of her 'loose morals'. Another, Pieter, was imprisoned as a public menace. Hals tried dealing paintings, buying at auction and selling privately, as well as cleaning pictures to make enough money to keep the bailiffs away, which he didn't always manage to do. He retired penniless, living on a tiny pension. Ironically he is now one of the world's most sought-after Old Masters.

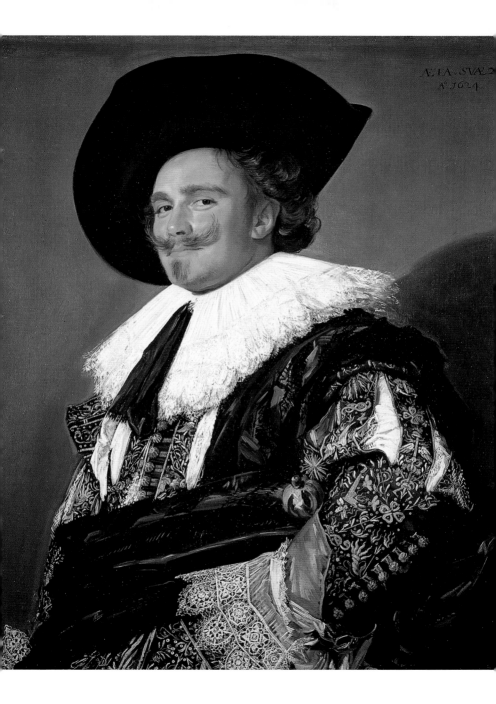

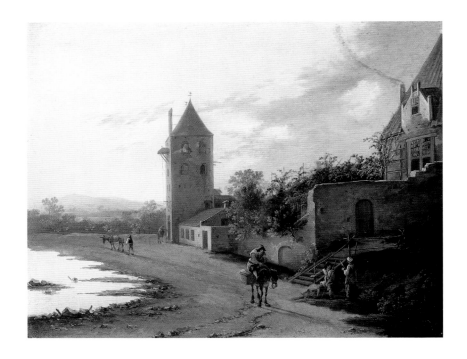

Jan **Both**

b. Utrecht *c.*1618; d. Utrecht 1652
*A Capriccio of the Plompetoren,
Utrecht*, early 17th century
Oil on panel
32.4 x 40 cm (12³/₄ x 15³/₄ in)
Private Collection

THE PAINTING This warm, late afternoon is painted with such detail that it seems like the quiet beach-front of a real place. The Dutch buildings are real (they are in Both's hometown), but there aren't any mountains in the Netherlands, and the hot sandy beach and peasants are straight out of Italy. The artist has mixed up his two loves, the Roman *campagna* (countryside) and his home country, and created a peaceful, idealized fantasy landscape that the Dutch could almost recognize as their own land. It brought to mind a free and peaceful Netherlands at a time when religious wars were raging across Europe. The contented donkey-riding man is one of Both's favourite figures, popping up in most of his pictures.

THE ARTIST After training in the Netherlands, Both went to Rome aged nineteen to live with his older brother, the artist Andries. There he teamed up with the established classical landscapist Claude, and came away with Claude's skill at pervasive yellow sunlight. But instead of following his grand style he painted the Roman *campagna* and filled it with simple farmers, rather than classical or Biblical characters. The Roman holiday ended in 1641. On a trip through Venice, Andries accidentally drowned in a canal. Both's time in Italy ended in tragedy, but he came back from there the greatest painter of the Dutch Italianate school. He nostalgically adapted the warmth and peacefulness of his Italian peasant scenes to the darker landscapes back home.

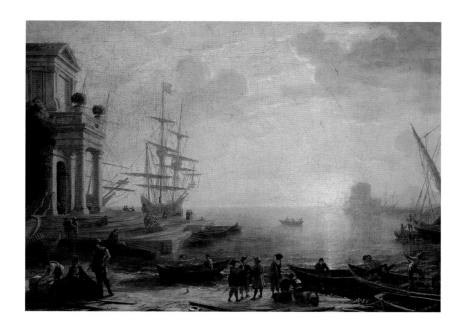

Claude Lorrain
(Claude Gallée)

b. Champagne, Lorrain 1600; d. Rome 1682
*An Italianate Harbour at Sunset, c.*1638
Oil on canvas
40.5 x 55.5 cm (16 x 22 in)
Private Collection

THE PAINTING The picturesque fantasy port of a beautiful Mediterranean coastline is one of Claude's favourite subjects. Taking up Carracci's invention of the ideal landscape, he transformed it into the ultimate picture of beauty. Here his open harbour is balanced with classical buildings on each side, and scattered boats and busy figures are everywhere. He silhouettes the masts and riggings of the men-o'-war ships against an incandescent sky. The scene recalls the classical world but it is a reflection too of what Claude knew of Italy and its Amalfi coast. His exotically dressed merchants, clearing out their boats before nightfall, have a conscious continuity about them that stretches back to antiquity.

THE ARTIST Claude was the most prized and famous landscape painter in history. Paintings like this dominated landscape art into the nineteenth century. In England, country house estates were even modelled on his paintings. Constable called him 'the most perfect landscape painter the world ever saw'. Orphaned in France, Claude worked as a pastry chef and servant, and was later a pupil of Agostino Tassi in Rome (the same Tassi who was imprisoned for raping Artemesia Gentileschi a few years earlier). Outgrowing Tassi's style, Claude learnt to paint with deep space and a misty lighting that gives his work its powerful moods. He could only paint a few of these exacting landscapes a year, and despite his fame he lived modestly and piously. His influence on landscape painting is equalled only by Poussin.

Nicolas **Poussin**

b. Les Andelys 1594; d. Rome 1665
Landscape with Polyphemus, 1648
Oil on canvas
150 x 199 cm (59 x 78¹/₄ in)
Hermitage, St Petersburg

THE PAINTING The huge one-eyed monster Polyphemus sits on the mountain playing his pipes. He is so inhuman and distant that his flesh looks like stone. Poussin loved to paint idyllic Arcadian landscapes with contented shepherds and farmers living side-by-side with gods and monsters. It is the pagan equivalent to the Garden of Eden. Looking out to the ocean, Polyphemus is playing a love song to win over the beautiful sea nymph Galatea. In the foreground three classically draped nerids, the nymphs of fresh water, are about to be ravished by two horned and hoofed satyrs, the drunk and lecherous attendants of the wine god Bacchus. But there is no real sense of threat or even eroticism in Poussin's world – it is the perfect natural order of antiquity. Poussin painted this when Galileo was finding mountains on the moon and the Milky Way; the earth was no longer the centre of the universe. For Poussin this was pure escapism from the new uncertain world. He wasn't painting religion like most artists, because to him religion was transitory. He could find eternal ethical truths in the ancient world, which is why his art is just as lively now.

THE ARTIST Founder of the French classical tradition, Poussin is France's best seventeenth-century artist. Born into a peasant family in northern France, his active mind led him to study painting and the classics. Like his friend Claude he felt most at home in the classical world of Rome, and actually spent most of his life there. After a serious illness (venereal disease according to his friend and biographer), he stopped looking for large public commissions and turned to the sort of pictures that suited him best: paintings that reflected his own feelings for the lost ancient world. He was a serious classical scholar. Where Claude's landscapes are like beautiful dreams of a hazy antique world, Poussin's are usually exacting passages from classical sources. Unlike most artists who painted pagan scenes, Poussin understood them completely. Reynolds said Poussin 'had a mind thrown back two thousand years'. He was practicing High Renaissance ideals of seriousness in a world that had moved on past Mannerism and into the Baroque. He had no worthy followers because he worked alone and no one could match his knowledge. By the end of his life he had become a hermit, immersed in ancient writings and painting.

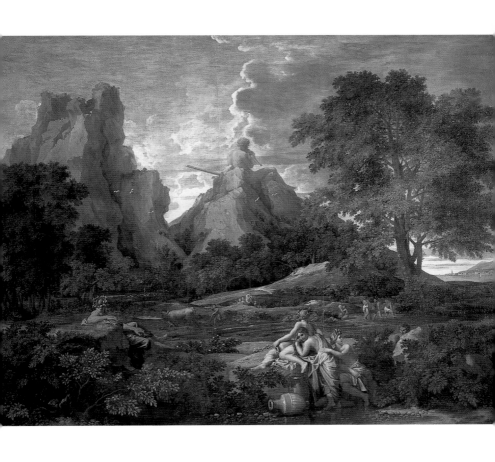

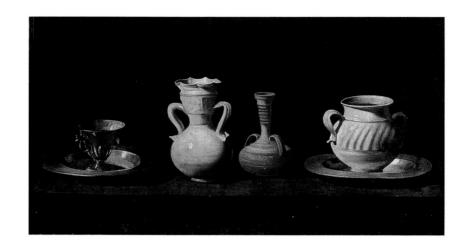

Francisco **Zurbarán**

b. Fuente de Cantos, Badajoz 1598; d. Madrid 1664
Still Life, c.1633–40
Oil on canvas
46 x 84 cm (18 x 33 in)
Prado, Madrid

THE PAINTING A simple shelf, lined with humble jugs and pewter, is the subject of Zurbarán's mastery. The warm earthenware contrasts with the cold shining pewter plates and the bronze chalice. All with little handmade imperfections, they are tied together by a soft mellow light, balanced by falling shadows. It is not how pretty the pots are themselves that matters; Zurbarán has made them beautiful because of how he has handled the paint and light. Still lifes were commonly crammed with details, like Ruysch's floral ones would be in Holland. But Zurbarán strips away all the unwanted clutter and proves that the simplest things can be handled with his honest Christian grandeur, and that anything can be painted beautifully.

THE ARTIST Zurbarán was one of the founders of Spanish painting. Caravaggio's art had reached Spain, and his deep shadow effects (*chiaroscuro*) and gritty realism were big influences on the young Spaniard. He used these new effects to capture the religious feeling of Spanish society in his day. His saints, lit dramatically in dark monastic cells, made him hugely famous and in demand. But Zurbarán had strong competition from Murillo, and soon his patrons deserted him. Though his friend Velázquez got him some royal commissions he ended up cranking out second-rate pictures for the South American colonies. Tragically his payments sank into the Atlantic after the warship they were on was destroyed. By now onto his third wife, with countless children to support, Zurbarán died in poverty.

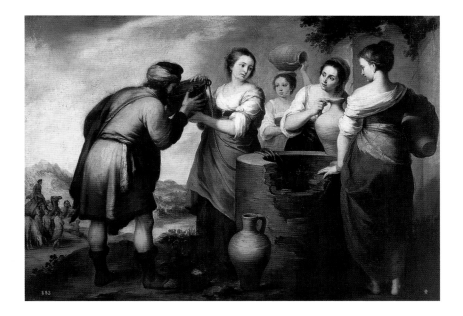

Bartolomé Esteban **Murillo**

b. Seville 1617–18, d. Seville 1682
Rebecca and Eliezer at the Well, c.1650
Oil on canvas
107 x 171 cm (41 x 67¼ in)
Prado, Madrid

THE PAINTING Eliezer has been sent out by his master Abraham to find a wife for Isaac, his son. Eliezer decides, after praying a bit for guidance, that whichever woman at the next well gives him water will be his choice for Isaac. Rebecca offers him her bucket. So she gets taken back to Canaan, meets Isaac who takes her into his mother's tent, and 'she became his wife, and he loved her'. Not our idea of love at first sight, but it did the trick in Murillo's time and most Old Masters painted the story at some point. Murillo has given it warmth, with very mellow browns. All the outlines have a softness closer to Correggio, Rubens or van Dyck than to the harsh realism that Zurbarán and the popular Caravaggesque artists were using in Spain.

THE ARTIST Murillo outstripped Zurbarán as Seville's premier artist because of this softer approach. Orphaned young with his thirteen siblings, he only found happiness, in life and art, at the time of his marriage. Of his nine children, only three outlived Murillo, and his wife also died young. These tragedies directly influenced his art. His religious paintings are full of happy floating cherubs and beautiful motherly Madonnas, idealizing his dead wife and children in heaven. His orphaned street children paintings, close to his own experiences, were 200 years ahead of their time in their sweet sentimentality. They had a huge influence on the English artists Hogarth, Gainsborough and Reynolds.

Diego Rodríguez de Silva y **Velázquez**

b. Seville 1599; d. Madrid 1660
Las Meninas (The Maids of Honour), c.1656
Oil on canvas
316 x 276 cm (124¹/₂ x 108³/₄ in)
Prado, Madrid

THE PAINTING Velázquez's greatest masterpiece is Spain's most famous picture, and one of the most discussed. As soon as we look at it, the questions start. Is it a portrait of the confident Infanta Margarita in the foreground, or the king and queen in the mirror? Is it an amusing record of what they were seeing as Velázquez painted them? But then he has shown himself to be painting this picture as he looks at us, looking at him. Is it about the status of Velázquez himself, proudly showing off his Knight of Santiago clothes, in his huge palace studio, surrounded by royal friends? Or is it a dangerous social painting where the servants have more importance than their royal employers? Velázquez painted it to ask questions, not to give answers. This fleeting, informal moment did not come about casually. It is a painting of the Baroque period where everything is carefully ordered to give effortless movement. Velázquez leans one way, his easel the other. The light from the right is curtained off by the dark room behind, but it is echoed again up the stairs which draws us to the mirror, reflecting us right back 'outside' of the painting again. It is a triumph of spatial illusion. The mirrored figures echo those in van Eyck's *Arnolfini Marriage*, hanging in the Spanish collection at the time.

THE ARTIST No other Spanish artist has ever rivalled Velázquez. Like his friend Rubens in Flanders he effortlessly rose to the top, with as much financial and social reward. But unlike him he was tied to court and only managed to escape it twice in his career. On Rubens' advice he had two year-long stints in Rome. From these trips he left an illegitimate child, and brought back a wider understanding of Italian art. His style was an original progression from Caravaggism mixed with the love of working oils that he learnt from Titian. Velázquez worked and lived in the Alcázar in Madrid, where Titian's paintings hung. The light painterly touch in *Las Meninas* ultimately comes from him. Velázquez dominated Spanish art, but Spain was an isolated place, getting poorer and desperately trying to hold on to its foreign possessions. It wasn't until the Prado Museum opened in 1819, with forty-four of Velázquez' best paintings on view, that he became known outside Spain. Within decades Manet and the Impressionists were calling him 'the painter of painters'.

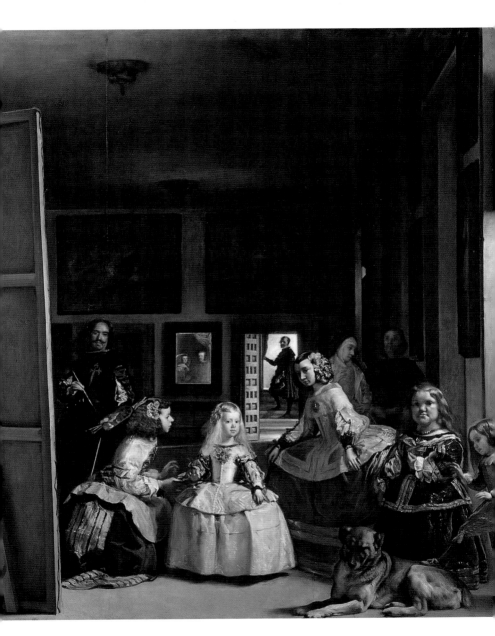

Mexican School

The Conquest of Tenochtitlan, 17th century
Oil on canvas
120 x 200 cm (47¹/₄ x 78³/₄ in)
Private Collection

THE PAINTING The Spanish *conquistador*, Hernán Cortés, wields his sword as his mount rears up heroically. The Aztecs climbing out of the reeds will clearly be no match for the Spanish leader. His disciplined European army, with their cannon ships and armour, are slaughtering the spear-toting Aztecs. The earliest conquest of the New World is ambitiously recorded with a grandeur that recalls Altdorfer. Cortés' troops swarm in from three angles, looking like a massive force of armoured knights, but in fact Cortés destroyed the Aztec Empire with a tiny band of adventurers. This painting, one of a narrative of eight scenes showing the winning of America, is from the most important historical series in Mexican art. Tenochtitlan (modern Mexico City) was the Aztec capital, and it stunned the invaders with its vast pyramids, temples, palaces and fountains. The Emperor Montezuma ruled most of what is now Mexico from the city seen here in the distance being sacked and burned, to be left in ruins like the civilization of the Aztecs themselves. The empire was now a Spanish possession. The bright gold jewellery of these accurately painted Aztecs would be taken from the dead, melted down, and shipped back to Spain to fund the further conquering of America.

THE ARTIST The Meso-Americans, like the African nations of the same date, have mainly left stone carvings and pottery behind, not painted art. Their artists, from the earliest Olmecs, through the Maya, Toltec and Mixtecs, to the later Incas and Aztecs, shared similarities of geometric stylized patterning and design. We know they continued these traits in their now lost paintings. But when Cortés repressed the Aztec's religion of human sacrifice with his victory in 1519, and broke the imperial power of the Incas in 1532, the art and culture that went with them soon died away. It was replaced by mostly unnamed Spanish colonialist artists, like the unknown artist who painted this history of the conquest for an anonymous local patron. Artists as famous as Zurbarán sent religious paintings from the new mother country back in Europe, with hundreds more local Spanish South American artists weakly reproducing the style of the exported art for centuries to come. Without surviving paintings of the Meso-American peoples, this exported European style represents American painting up to the work of the North American landscape artists of the eighteenth and nineteenth centuries, like Church.

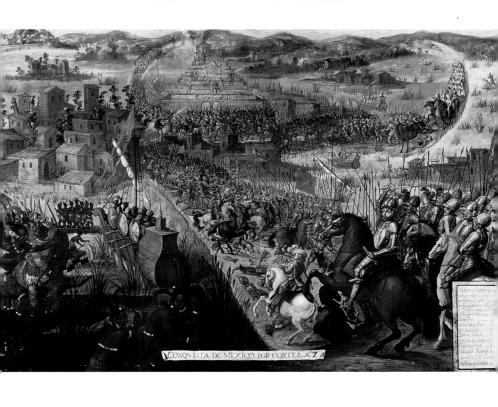

CONQVISTA DE MEXICO POR CORTES. AC 7

Basawan and Chatai

Active c.1556–1600
Akbar Tames the Savage Elephant, c.1590
Gouache on paper
34.5 x 21.7 cm (13¹/₂ x 8¹/₂)
British Museum, London

THE PAINTING Basawan's employer, the brilliant young Mughal Emperor, Akbar, is the real subject here. He is the one on the charging elephant's back. Akbar inherited his father's title at the age of fourteen, and this picture from his biography illustrates one of his most important acts of youthful heroism. Akbar mounted the famously difficult elephant Hawa'i in order to fight another elephant, in a sort of old Indian joust. The angry beast chased the second elephant, causing carnage as he went, with Akbar holding on. As the massive animals thunder across a weak pontoon bridge, boatmen fly off into the water and swim for their lives to the shore of Akbar's new Red Fort at Agra. According to his biography this was proof that, having put himself in such a dangerous situation, God had allowed Akbar to triumph. This showed that as a young man he was divinely sanctioned to spread his huge empire and to rule over man and beast. The painting is a development from Persian School art, where the outlines are drawn and then coloured in like Chinese and Japanese painting. Basawan drew this and his colourist Chatai added the bright, Hindi colours. Basawan's new feeling of space and distance was influenced by Europeans in India.

THE ARTIST Basawan revolutionized Mughal art with his action packed three-dimensional paintings. His sensitive portraits made him famous, and were imitated by generations of followers. Emperor Akbar developed the arts at his expanding court, leading the way for his grandson to build the Taj Mahal fifty years later. Basawan rose to be Akbar's best painter. An incredible leader, it is from Akbar's interest in multiculturalism that Basawan's art developed. He brought together at court artists from Persian Iran, Hindus, local Muslims and Europeans. Basawan was a rational artist who painted only what he could see; he didn't care much about the otherworldly imagery of religious artists. Because of his down-to-earth concerns, the painting of the Mughals developed into dense story-telling narratives. He painted in miniature, which was the usual format of Indian art, and over his forty years in the imperial workshops he painted for nearly all the important manuscripts that were produced. His understanding of European oil painting led him to break away from the tight outline art people were used to, and he introduced a sense of three-dimensionality that was groundbreaking in Mughal painting.

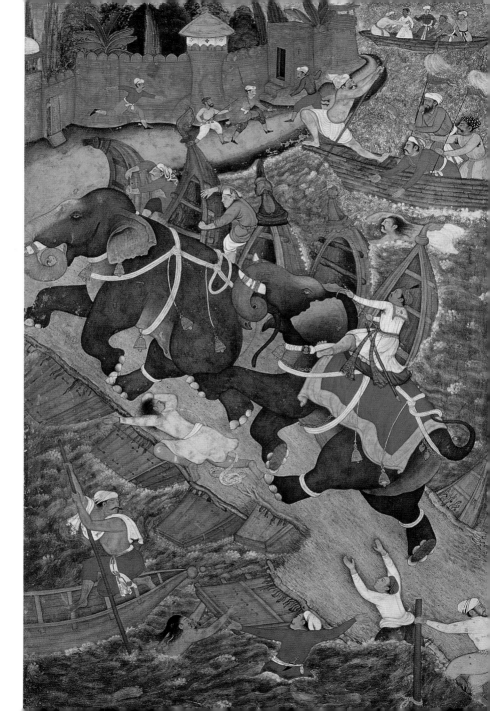

Shigehide Calligrapher and anonymous illustrator

The History of Yuzu Nenbutsu Sect, 1528
Ink and colour on paper, detail from a scroll
29.4 x 1098 cm (11¹/₂ x 432¹/₂ in) – total size
Private Collection

THE PAINTING This is a small detail from one of a pair of enormous scrolls that recorded the history of a Japanese Buddhist sect in the sixteenth century. The scroll itself is a perfect illustration of Japanese artistic culture of the time. It records the history of a religion, one powerful enough to convert the Emperor Toba, and it gives a telling insight into the place of the artist in Japanese artistic culture. The artist's name is unrecorded because it was the calligrapher's art surrounding it that was thought to be important. While calligraphy could express the subtlest thoughts of the artist's mind, a painter, though capable of great subtlety, was only seen as capable of drawing things, rather than complexities. This artist has painted an apparently casual but balanced composition of townspeople, beggars, mothers, and the elderly, all ripe for conversion by the Buddhist monk Ryoshin into his Nenbutsu sect. His self-proclaimed mission was to teach every level of society the way to salvation and eternal paradise with Buddha. Pure Land Buddhism offered an easy path to eternal happiness and had became popular. Ryoshin improved on this and

preached an even faster route. By repeating his Nenbutsu, a simple mantra, until reaching a meditative state, you could gain admission to paradise.

THE ARTIST Here the painting on the scroll is less important than the calligraphy that surrounds it, which is why the painter was not deemed worth recording, while the calligrapher proudly signed his work. The sort of naturalism that had developed in Europe by this time was still unknown to our artist in the east. In Japan, like its artistic motherland China, outline drawing in ink was the tradition that had been carried on for centuries. It would continue without the three-dimensionality or shading of Western art until into the nineteenth century. Though the Japanese were far more open to outside artistic influence than the Chinese, these western practices, when known about at all, were considered unattractive. This unknown painter, typically of Japanese figurative painters for centuries, is already pointing forward to the casual, everyday scenes of the *Ukiyo-e* (floating world) school of Japanese art that dominated from the next century until the nineteenth. Unlike his Chinese counterparts who were caught in a ever more critical academism, this artist was free to paint a casual arrangement of characters from all classes and without the need for continual reference of his work to earlier great masters.

Sir Anthony **van Dyck**

b. Antwerp 1599; d. London 1641
Lord John Stuart and his Brother Lord Bernard Stuart, c.1638
Oil on canvas
237.5 x 146 cm (93^1/$_2$ x 57^1/$_2$ in)
National Gallery, London

THE PAINTING This is van Dyck's greatest tribute to aristocratic grandeur, ego and power. The two young lords, cousins to the Stuart king Charles I, reek of haughtiness and wealth. It was painted just before their grand tour of Europe, which would polish up their artistic and cultural learning. The younger 'most gentle' brother, Bernard, is standing down a step, reflecting his lower status, but van Dyck has given him the pose, clothes and manner befitting a man in line to Charles' throne. His 'rough natured' older brother looks gormless; his flat, stupid face is about as uninteresting as his stance and dress. Otherwise van Dyck has made them almost reflections of each other, which gives the picture the dynamic tension of the Baroque period. The fanatically painted satins were amongst the specialities that helped him found the elegant courtly style that lasted in British portraiture for the next 200 years. He created such a powerful idea of nobility that these faces still look familiar today. Unfortunately in England at the time, not everyone shared the Stuarts' view of aristocratic superiority. Parliament and royalty were about to start a civil war. The boys were called home, and like their cousin the king, were killed.

THE ARTIST From Rubens' huge studio of assistants, only one artist came out to rival the master's powers – van Dyck. At the age of fourteen he was painting self-portraits, by eighteen he was Rubens' chief assistant, and at twenty he was being called the next big thing. It looked like a brilliant start to a promising career. Like all artists he visited Italy, and stayed for six years. Like Rubens and Velázquez, he came back with a feeling for the texture and possibilities of oil paint, learnt from the painterly Venetian colourists like Titian. Back in Antwerp and in huge demand, he was invited by the art-loving Charles I of England to be court painter. Van Dyck was ambitious. He knew he could only ever be second best in Antwerp, as Rubens ruled the roost, so he accepted. His court portraits reached new heights of suave and dignified grandeur, suiting his aristocratic manners as well as flattering his sitters. But in Protestant England, without religious subjects to paint, his talents were narrowly confined to portraits. Never a very healthy man, he died aged forty-two, only a year after the much older Rubens and never getting the chance to take his place.

Jan **Vermeer**

b. Delft 1632; d. Delft 1675
A Young Woman Standing at a Virginal, c.1670
Oil on canvas
52 x 45 cm (20¹/₂ x 17³/₄ in)
National Gallery, London

THE PAINTING Vermeer's women have become iconic symbols of natural beauty, from their pearl jewellery and their glowingly-lit domesticity to their hauntingly real moods. But only a few dozen paintings by him actually exist. We have just walked into the room, and the young woman catches our eye and smiles faintly. This might seem inviting, but unlike most of his other women Vermeer has given her a pale stony look, more like the Virgin in Memling's *Annunciation* than a real person. His pictures were thoughtfully crafted, and this, like everything else he produced, has a meaning. His choice of instrument, a mini harpsichord called a virginal, brings in the idea of chastity without making obvious references to it. As Shakespeare said, 'if music be the food of love, play on'. The empty chair looks as if it is waiting for her future lover to return. Behind her the painting of Cupid holding up a card is a symbol of fidelity, like the dog in van Eyck's *Arnolfini Marriage*. On the wall and the virginal are two mountainous landscapes, hinting that the lover is travelling far the from flat terrain of the Netherlands. These things might give an undercurrent of unanswered questions, but it is Vermeer's indescribably airy paint that gives it a weird sense of mystery.

THE ARTIST For 200 years Vermeer was virtually unheard of, yet now he has taken his place with Rembrandt and Hals as one of the greatest seventeenth-century Dutch artists. Like them, he died in poverty. For an artist who painted so few pictures this is a pretty big reputation. Although well regarded as an artist when he was alive, he made his real living as an innkeeper and art dealer. In 1672 the French decided that taking over his rich, new and small country was worth their while. The economic chaos that followed their occupation destroyed Vermeer's carefully balanced income. With a wife and fifteen children to support, he died aged forty-three. The Dutch critic Jan Veth later described his very individual paintwork as 'crushed pearls melted together'. He used it to paint simple domestic scenes, all heavy with symbolism, but with a feeling of frank simplicity that gave them incredible grandeur. He was rediscovered by a nineteenth-century French art critic who saw this quality and, comparing it to the political art of Courbet's Realism, hailed him as fellow socialist.

David **Teniers** the Younger

b. Antwerp 1610; d. Brussels 1690
Archduke Leopold Wilhelm in his Picture Gallery, 1653
Oil on canvas
81 x 87.6 cm (28 x 34 in)
Private Collection, formerly in the Rothschild Collection

THE PAINTING This private gallery, stuffed with works of art from all over Europe, is presided over by Teniers, holding up an inventory for the hat-wearing archduke.

Painted for two egos – royal and artist – it reflects the self-consciously 'arty' pride of the archduke alongside Teniers' pride in his high status. Teniers was the Flemish court painter, as Rubens had been previously, building up his collection with paintings bought from the dismembered collection of the executed Charles I of England. In this painting there are recognizable pictures by Titian, Reni, Bellini, Giorgione, Tintoretto, Veronese, Rubens, and others. It is a window into the new world of collecting that was developing. Royalty were competing all over Europe to outdo each other with the Old Masters they could buy.

THE ARTIST At the age of twenty-seven Teniers married Bruegel's heiress granddaughter. He was making his name by painting the sort of peasant scenes Bruegel started eighty years before. By then he was already a master at the painters' guild of St Luke, and looked to be on his way to great things. By befriending the Antwerp dealers he managed to create for himself a new kind of patronage, as they told their clients to buy his pictures from them. It was the new way to collect art, and it is still that way today. Teniers painted thousands of pictures. Like Rubens he was made a noble and bought a country estate. Art had become an established path to the top of society.

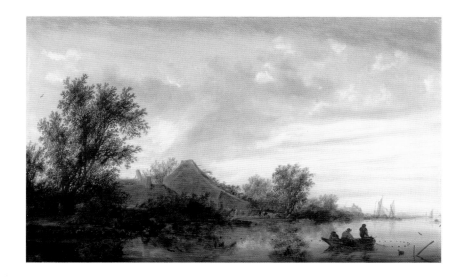

Salomon **van Ruysdael**

b. Gooiland c.1600; d. Haarlem 1670
River Landscape with Fishermen, 1644
Oil on panel
52 x 83 cm (20¹/₂ x 33 in)
Private Collection

THE PAINTING Two fishermen are trawling with their nets on the still waterway. The line of their netting arches around the boat, through the reflections of the trees and back to the shore. The tumbledown cottages seem to be growing out of the wetland like the scrubby trees and bushes around them. Ruysdael has filled three quarters of the painting with sky. It is still, with just some thin hazy clouds hanging in the air. Far in the distance there is a town, and the sails of boats recede away out of sight. Their activity doesn't break the feeling of quiet, it just continues the tone of this peaceful world as far as we can see. The colours are muted, there's nothing to distract our attention from the calm activities of man and nature harmoniously living together. This was the atmosphere of natural beauty that Ruysdael spent his life creating.

THE ARTIST Along with Jan van Goyen, Ruysdael led the way in 'tonal', atmospheric landscapes in the seventeenth-century Netherlands. He specialized in them. Like so many artists at the time he took one kind of painting and made it his own. He created countless scenes like this that have come to represent the Dutch landscape. Two hundred years later his lush waterways and country labourers were an inspiration for Constable, who grew up in a similar landscape in England. Ruysdael's nephew Jacob learnt from his quiet style but rebelled against it, creating the next phase of dramatic and heroic Dutch landscapes.

Rachel **Ruysch**

b. Amsterdam 1664; d. Amsterdam 1750
A Bouquet of Flowers, c.1695
Oil on canvas
34.4 x 27.2 cm (13½ in x 10¾ in)
Private Collection

THE PAINTING These flowers are painted with almost mind-numbing attention to detail. The Netherlandish tradition of building up perfect details couldn't be better represented than here. Ruysch's paintwork is so meticulous, fine and clear that she has bathed it in a creamy white light to soften it. The flowers are full of life. There are opening buds everywhere and the flowers are strong and vibrant. It is like a celebration of the beauty of living things. But Dutch art is rarely without symbolism. Still lifes in Italian are *natura morta*, literally 'dead nature', and in Dutch painting that symbolism is always hanging over them. Earlier *vanitas* ('all is vanity') still lifes used to have skulls, violins with broken strings and hourglasses in them, but by Ruysch's time those obvious pointers to death were clichés. Pure prettiness could do the same job, only better. A peacock-like Admiral butterfly flies by, but his brilliantly colourful life will end after just a few days. Butterflies and flowers, like us, are only alive for the shortest time. Even the flowers are already cut from their plants, so for all their beauty they are hollow echoes of real life – doubly so, as we are seeing merely an illusion of life in paint.

THE ARTIST Ruysch was one of the most gifted still life artists of the Dutch school. The tradition started there about one hundred years before she was born, and continued for another hundred after she died, but her luminous flowers set against dark shadowy backgrounds are some of the most memorable ever painted. She was the first female artist ever to become internationally famous. She was born into a rich scholarly family in Amsterdam. Her professor father was a renounced botanist and anatomist, and her mother was the daughter of a famous architect. She grew up with drawing and flowers on either side of the family. By the age of fifteen she had started painting with a still life artist, and went on to be court painter to the Elector Palatine in Germany. She travelled there with her minor portrait painter husband and an ever-increasing number of children (she had ten in total). There are only about one hundred pictures known to be by her. Praised by poets during her lifetime, she was still painting at the age of eighty-three.

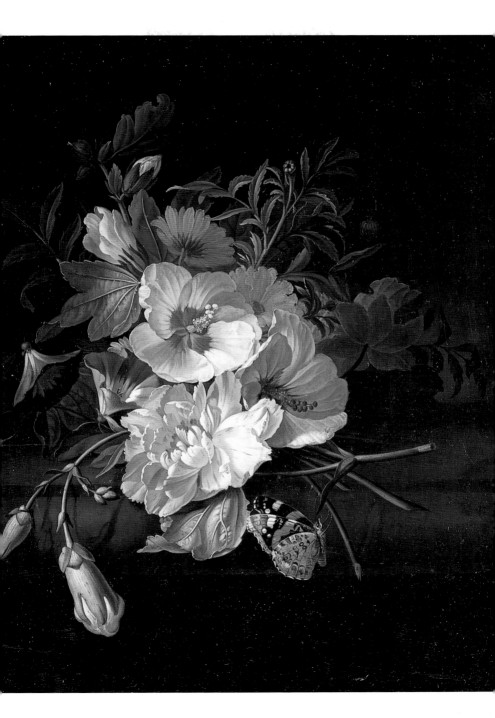

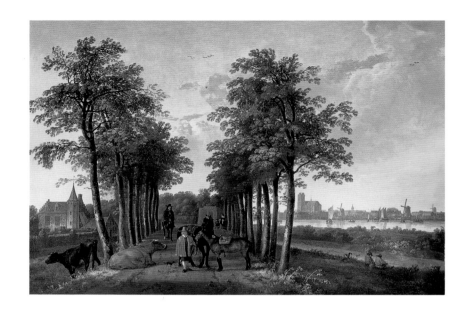

Aelbert **Cuyp**

b. Dordrecht 1620; d. Dordrecht 1691
The Avenue at Meerdevoort, Dordrecht, c.1650-52
Oil on canvas
72 x 100 cm (28¹/₄ x 39¹/₂ in)
The Wallace Collection, London

THE PAINTING The early evening sun is setting over Dordrecht, Cuyp's native town. Newly free of Spanish oppression, by 1670 the Netherlands was the world's biggest trading power; it was entering its golden age. In Cuyp's hands that phrase translated into paint, with the honey-soaked stillness of his landscapes. He was a prominent Calvinist, and underpinning his work is the Calvinist view that nature, man and commerce were unified. The high man-made path is a reminder that the Netherlands itself only exists because of man's work reclaiming it from the sea. On this land that God and Dutchmen built together, Cuyp's noble cattle, travelling merchants and fishermen play out their harmonious roles together, in the perfectly still and peaceful light of a prosperous country.

THE ARTIST Cuyp is one of the most celebrated landscape painters in western art. He rarely left his own town, and was happy painting its merchant ships gliding past or the cattle of the nearby farms silhouetted against the luminous sky. He specialized in beautiful, peaceful landscapes bathed in a soft evening or morning light. Dutch painters had used this light before – it had been learnt in Italy generations earlier – but Cuyp perfected it. After his marriage to a rich widow his painting output slowly dried up, and his reputation dwindled until the 1750s when the British discovered him. They took most of his unwanted pictures back to Britain, and his effect on the country's painting since then has been huge.

Rococo to neo-Classicism:
Watteau to David

The spirit of free painterly movement, begun by Titian in the sixteenth century and transformed into the Baroque spirit of the seventeenth century, had turned into something prettier and less imposing by the start of the eighteenth century – the Rococo. Churches all over central Europe were still being painted with saints and members of the Holy Family dramatically ascending into the heavens. But privately, away from the moralistic public face of the historic institutions, radical change was setting in. The philosophical and scientific advances into reason made earlier by René Descartes, John Locke, Isaac Newton, and in the later eighteenth century by Immanuel Kant, were all forcing the educated classes to see individual human reason as the only benchmark for knowledge rather than the teachings of the Church. Belief in religion did not dwindle, however. If anything the diversification of different Protestant sects proved how much more spiritually needy the questioning population was becoming in the face of this underlying empiricism. Membership of the educated class was growing all the time. By the second half of the century the industrial revolution had begun in Britain. Its new and rapidly increasing middle-class population was creating wealth, and with it fresh ways of seeing the world. The shift of power from the landed aristocracy to the industrialists was underway. Throughout society riches were steadily increasing due to foreign trade and the European colonization of every habitable continent around the planet.

In France the regulated official academy art of Poussin-like classicism was out of sympathy with new desires for personal freedoms. Even the Sun King himself,

Louis XIV, was demanding art that was more light-hearted. But this king, who built the magnificent and megalomaniacal palace of Versailles, died in 1715 before seeing the grand classicizing influence of his court diminish. The new Regent moved the entire camp of aristocrats out of Versailles and back into Paris, and the whole court system changed. The resulting fragmentation of the court into smaller, private, townhouse mini-palaces allowed the stiff public faces of royalty, religion and government to mellow. The house parties began and a culture of individual indulgence, free of public morals, set in. Watteau came along just in time to satisfy their needs. In a spirit that was free of academic rules and constraints he painted casual scenes of grand garden parties that sparkled with rich silks and simmered with amorous undercurrents. It was all a very new direction for painting – frivolous, sexy set-designs for a self-absorbed elite. Watteau died young while his new style was still gathering admirers, and he was immediately replaced by the fleshier and more overtly erotic art of Boucher and his pupil Fragonard. They captured the essence of the Rococo in France, creating the style as they painted. The elegant clothes of Watteau's quietly flirtatious couples came off in their hands to reveal the sensual people beneath, sometimes as gods, other times blatantly as real-life lovers. Another gifted Frenchman, working alongside this carefree erotic vein of Rococo art, was a quiet man of the very opposite kinds of sensibilities. Chardin was painting to capture the simplest objects, still lifes and servants, with as much restraint and dignity as he possessed.

At the same time, in England, the Londoner Hogarth set about launching satirical attacks on everyone around him. There wasn't a social class or situation that wasn't ripe for reducing down to its most obviously hypocritical or immoral self. The marriages of convenience between rich merchants and poor aristocrats, the gin-soaked workers in the tenements of the East End – even the fat clergy got it in the neck. By disseminating his 'low-life' moralistic tales through prints, Hogarth's judgmental, humane and amusing views of contemporary life were speaking to all classes, on something like the same level, while at the same time drawing attention to the many levels that society was splitting into.

In Italy the Rococo found its feet in different ways. From the strong and heavier Baroque style something lighter was emerging, through artists like Solimena, Ricci and Zuccarelli, until it reached its peak in the grand and assured frescos of Tiepolo in Venice. Whereas Tiepolo's opulent paintings were a little too Catholic in taste for the British, both Ricci and Zuccarelli worked in England, adapting to and influencing British style. But no one rose to the challenge of the island's cool

rationalism better than Canaletto, the greatest view-painter of the Venetian republic. In crisp, exacting daylight he painted perfect scenes of Venetian canals, with palaces of honey-hued stone rising out of the water, surrounded by the rich colours of the city's historic pageantry.

The English grand tourists who bought Canaletto's work returned home to be painted themselves by some of the finest and most subtle portrait artists who have ever lived. The eighteenth century was the golden age of British painting, and portraits were what everyone wanted. It wasn't always what artists themselves wanted to paint, and it took the greatest painters of the day, Gainsborough and Reynolds, to force artistic development on the public. Gainsborough, in his free and intuitive style, brought in the beauty of the English landscape, while Reynolds turned his sitters into historical actors on a huge scale.

Across the channel in France the century saw changes in painting that were as revolutionary as the country's politics. By the 1760s the taste for frothy sensuality, without any moral or political purpose, was running out. The age of reason and enlightenment was rejecting traditional authority and looking for a new way to express itself. That expression was found in the classical world, before Christian religions and feudal power structures developed. It seemed like a world of kindred spirits, with middle-class morals, democracy, intellectual freedom and a questioning just like they were experiencing or wanted to experience. The French were looking for heroic art to match the period's growing sense of individual power and to reflect their confidant sense of optimism. The spirit of the Ancients was being re-created in the cultures of the eighteenth century, so it was only a matter of time before that world was re-created in the neo-Classical paintings of David.

Jean-Baptiste-Siméon **Chardin**

b. Paris 1699; d. Paris 1779
Girl with a Shuttlecock, c.1737
Oil on canvas
82 x 66 cm (32¹/₄ x 26 in)
Uffizi Gallery, Florence

THE PAINTING A rosy-cheeked young girl stands motionless at a chair. Chardin has caught her in the moment she has stopped to think about something. If spoken to now, she looks as if she would turn to us, eyes still glazed, before snapping out of her reverie. Her frozen pose and wide eyes are perfectly evocative of such a delicate moment. Chardin has painted a transitory feeling, one that everyone has had, but somehow no one had ever thought to paint it before. It is the masterpiece by an artist who painted with a single-minded vision and individual integrity. His originality came directly from his own views and feelings for life. A fairly modest man, his normal field was still lifes, but when he painted other subjects he depicted the people 'below stairs' instead of the aristocrats who employed them. This little girl is a house servant, probably a seamstress by the look of the scissors and pincushion ribboned to her dress. She has been called up to the family to deliver a shuttlecock and battledore racket – the eighteenth-century version of badminton – or maybe to play with the bored children of the house. The power of the painting lies in its unpretentiousness.

THE ARTIST Chardin is one of the greatest painters of eighteenth-century France, and one of the world's finest still life and genre painters. But when he died his contemporaries took no notice, and within just a few years the French neo-Classical establishment had consigned him to obscurity. He wasn't like other artists. The followers of Watteau were painting frothy elegant parkland scenes, erotic nude allegories or grand portraits and landscapes. According to the academy of the time, Chardin was painting the lowliest sort of pictures, small still lifes of bread and pots. Not only were his subjects not grand, neither was the way he painted them. He painted with a small-scale, honest intimacy that was completely at odds with the egotistical pomp of pre-revolutionary France. Like the incredibly delicate genre pictures of servants or the bourgeois, his still lifes were simple, direct and unaffected. His thick brushwork and airy sense of space within a picture set him apart from other artists of his time. It might have been this, as well as his diligent, unpretentious character, that allowed the art establishment to brush him aside as not like them and therefore unimportant.

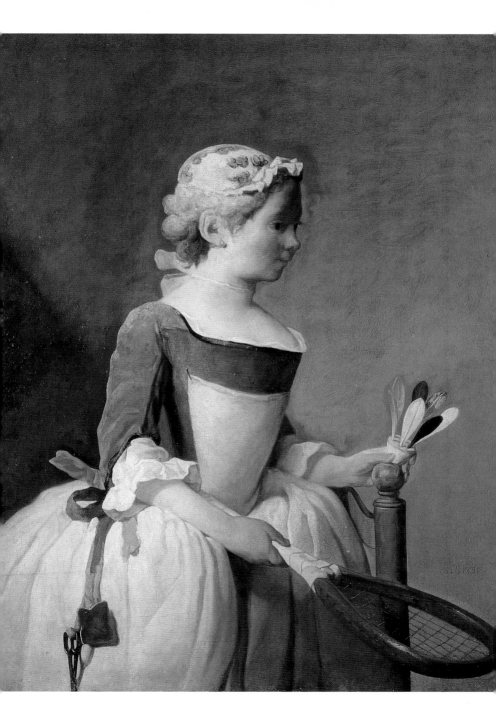

François **Boucher**

b. Paris 1703, d. Paris 1770
Odalisque, c.1745
Oil on canvas
54 x 65 cm (21 x 25¹/₂ in)
Louvre, Paris

THE PAINTING At the centre of all the crisp billowing drapery is one of Boucher's most famous nudes. Her fleshy pink body looks all the warmer sprawled over the icy blues and greens of the cloth. Pale skin and sensually reddened cheeks are the only living colours he has allowed here. In the past, artists like Cranach needed to paint classical myth when their patrons wanted naked flesh. Artist and patron didn't dare to be so crude as do anything else. Boucher was a master of these allegories himself, they were his bread and butter, but his classical scenes went beyond just painting nudes – he was painting sexuality. He broke the taboo. He allowed himself to paint sex without any coyness with the subject or even from his sitter. The plump boudoir cushions are in disarray, the carpet is pulled up at the edges, and her pearl necklace is lying on the low bed table. We don't know her name for sure, but the chances are she is one of Louis XV's mistresses that Boucher often painted in exactly this pose. Boucher's sensual skill made him the most sought-after decorative artist in France.

THE ARTIST Boucher stands out in total contrast to his subtle, quiet contemporary Chardin. After Watteau's death, Boucher became the defining artist of eighteenth-century France. Incredibly popular, he was the most famous painter of his day. Louis XV made him King's Painter and head of the painting Académie Royale. In return Boucher painted his mistresses and even taught the power behind the throne, Madame de Pompadour, how to paint. He knew what the French wanted after Watteau, and he painted it for them. He gave the eighteenth century all it wanted to know about sex but had been afraid to ask for from Watteau. But after 1,000 paintings and 10,000 drawings, the wit who said he didn't like nature because it was 'too green and badly lit' was getting out of touch. Boucher's one-liner art was starting to bore the public. There were just too many amorous couples and nude women – people began to want moral depth. The king still liked it, but then as the 1789 Revolution proved, royal taste wasn't that of the people. The neo-Classicists of Napoleon's time attacked Boucher's decadence, but his excellent draughtsmanship and fleshy sensuality have since been prized again. With Fragonard, he is seen as the international leader of the Rococo.

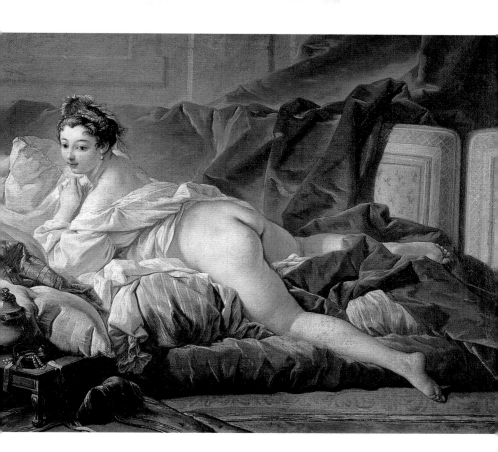

William **Hogarth**

b. London 1697; d. London 1764
The Rake's Progress: III,
The Rake at the Rose-Tavern, 1733
Oil on canvas
62.2 x 75 cm (24¹/₂ x 29¹/₂ in)
Sir John Soane's Museum, London

THE PAINTING Tom Rakewell, the 'hero' of Hogarth's series of eight moralizing paintings, inherits his miser father's wealth and literally goes mad blowing the cash. By the time of this third scene, he is already on his way to ruin. He is being groped by a prostitute he has brought back to the notorious Rose-Tavern in London's Drury Lane. On the way there they have had a prankish run-in with a night-watchman – his staff and lantern are at Tom's feet. Tom's shirt is undone and his sword is tellingly 'unsheathed'. It is 3am (we know because a girl is stealing his watch). At the table one prostitute spits at another who pulls a dagger, while an angry pimp threatens another girl who tries seduction to win him over. Next to the undressing stripper a chamber pot is spilling onto a plate of food. Her minder at the door holds the pewter dish that she dances on, and next to him a band plays under the defaced paintings of Roman emperors. This is an orgy after all. The only portrait left intact is of Nero, watching over the room while a girl accidentally sets fire to a map of the world.

THE ARTIST Hogarth was the most internationally important British artist of his time. His middle-class morals, unconnected with the old power structures of the Church or aristocracy, made his art very influential across a changing Europe. His famous 'low life' pictures were a social revolution. Etched in their thousands, they proved that artists could be independent of rich patrons. This five-foot tall, pugnacious little cockney was part of the new London middle class, and to him everyone was ripe for ridicule. His mistrust of foreigners, including their Old Masters, led him to found an art school, which in turn partly led to the foundation of Britain's Royal Academy. Despite his dislike of foreigners his painting technique comes from Europe. His Rococo style comes out of France, but Hogarth turned it into a bawdy laugh of his own making. His study of the seedier side of life affected him. He was a founding governor of the first orphanage, and painted some of his best work for its walls, for free. But he failed in his real ambition, to paint grand history pictures. His talents just didn't suit this sort of scale. After public slanging matches with most of the art establishment, he died embittered.

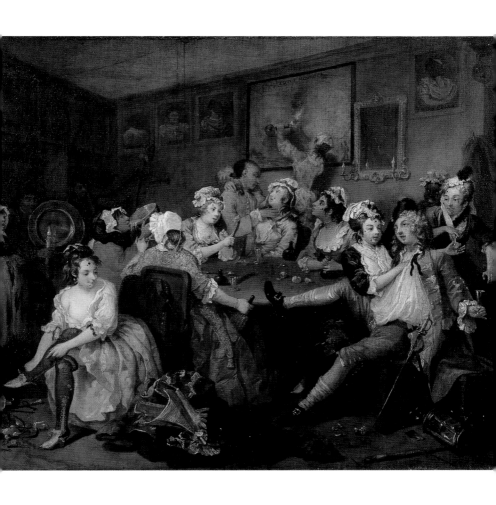

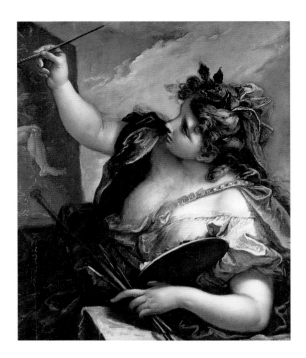

Sebastiano **Ricci**

b. Belluno 1659; d. Venice 1734
Personification of Painting, c.1700-10
Oil on canvas
76 x 63.5 cm (30 x 25 in)
Private Collection

THE PAINTING This is the living embodiment of painting itself. Ricci turns what he does with a brush into something godly. The figure's classical robes, bare chest and laurel wreath hint that she is a Muse. The classical world never got round to creating a Muse of painting – only poetry, history and music were important enough to the Ancient Greeks to have goddesses – so Ricci invented one. Her crumpled golden drapery is balanced out by the moody sky swirling in the background. Ricci's colours and the free and easy way he handled paint were typical of the greatest Venetian artists like Titian and Veronese, but he also brought in the softness of Correggio, creating his own personal style.

THE ARITST Ricci was one of the most colourful characters of his time, not just because his vibrant handling and atmospheric lighting were loved everywhere. His many dangerous liaisons around Europe meant he often had to run for his life to other countries. The Duke of Parma saved him from the death penalty after one of these affairs. Ricci is one of the founders of the light and airy Rococo style in Italy, and his work leads to Tiepolo and the rebirth of Venetian art in the eighteenth century. He was one of the foreign artists working in England that Hogarth hated so much. After Hogarth's father-in-law, Sir James Thornhill, beat him to the best commissions at Hampton Court and St Paul's Cathedral, Ricci returned to work in Venice.

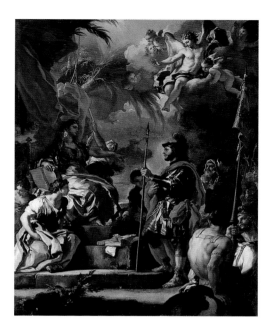

Francesco **Solimena**

b. Calale di Serino 1657; d. Barra 1747
Deborah and Barak, 18th century
Oil on canvas
128 x 102 cm (50^1/$_2$ x 40 in)
Private Collection

THE PAINTING Dramatic light and colour in an uneven but balanced composition give Solimena's picture a Baroque sense of tense action. The scene is taken from the Old Testament story about a prophetess called Deborah. She lived under a palm tree, doling out sage sayings and judging arguments for the Israelites. During one of these sessions she sent for Barak and told him to raise an army of 10,000 to retake Israel. Solimena has glorified the dusty meeting under a tree and turned it into an enthroned queen passing on the word of God to a mightily armoured hero. Deborah is one of the few powerful female figures of divine intervention in the Old Testament, so Solimena has given her the presence of an enthroned Madonna or even of a quasi-pagan deity like Veronese's *Venice Enthroned*.

THE ARTIST Solimena was one of the eighteenth century's most famous and well-paid artists. After his predecessor, Luca Giordano, Solimena was the leader of Neapolitan art in the first half of the eighteenth century. His pictures are full of puffy clouds, solid, floating angels and asymmetrically laid-out compositions full of colourful action. His classic but complicated draughtsmanship, inherited from Raphael, made him one of the century's most imitated Baroque artists. He fed the massive demand for his work in Naples with the help of an enormous studio. Naples was ruled by both the Spanish and the Austrians in Solimena's lifetime – and both needed art to glorify their regimes.

Giovanni Battista **Tiepolo**

b. Venice 1696; d. Madrid 1770
Cleopatra's Banquet, c.1747
Fresco detail
Palazzo Labia, Venice

THE PAINTING Filling the vast room of a Venetian palace, Tiepolo's Cleopatra frescoes are his best and most spectacular work. This huge wall painting is set between two actual doors, so the painted steps give the illusion of leading to real action in another room. Tiepolo hired an architectural painter to help him with this typically grand Rococo trick. Both are in the painting, standing at the left of the banquet. Still peering out over the feast 250 years later, Tiepolo is in the middle with his collaborator Mengozzi-Colonna to his left. Cleopatra's extravagance and hospitality were legendary. When Antony was invited to her fabulous palace, he was overawed by the luxury she lived in for a provincial Egyptian. To counter Antony's vulgar thoughts about money, Cleopatra took off her earring, a famous rare pearl, and dropped it into a glass of vinegar. As it dissolved she drank it, showing her ambivalence to mere wealth. It is the story of riches to end all stories of riches, and its setting here does everything to heighten the effect. It summed up the splendour of Tiepolo's art so well that he painted it more than any other subject.

THE ARTIST During his life Tiepolo was thought of as the greatest Venetian painter alive, and now he is seen as eighteenth-century Italy's most inventive Rococo artist. He was the last great fresco artist, ending a tradition that went back 400 years to Giotto. His biggest inspiration was his fellow Venetian Veronese, whose grand Renaissance decorations had a similar purpose and feel to those of Tiepolo's – so much so that Tiepolo was called the new Veronese. But Veronese's monumental solidity was transformed into the light airiness of the Rococo that Tiepolo perfected. With pale, translucent colours he transformed the flat ceilings of churches and palaces, turning them into three-dimensional openings to heaven, filled with flying chariots, gods and saints. Correggio had invented that illusionism 200 years earlier in Parma, and kick-started the Baroque with it. Now Tiepolo brought it to its perfect, floating conclusion. At the invitation of Charles III he spent the last eight years of his life painting in Madrid with his two sons. But after his death his altarpieces were thrown out for new ones by his jealous rival in Spain, Anton Raphael Mengs. Story has it that Mengs even tried to pay some heavies to beat up the old man.

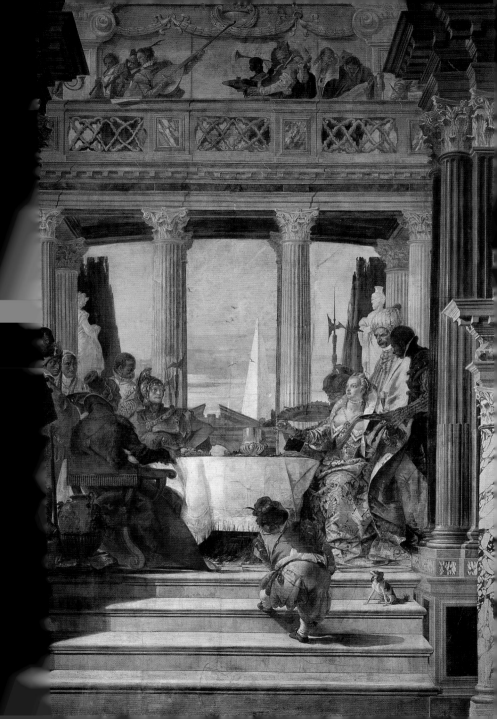

Canaletto
(Giovanni Antonio Canal)

b. Venice 1697; d. Venice 1768
Regatta on the Grand Canal (detail), *c*.1735
Oil on canvas
218.4 x 149.8 cm (86 x 54 in)
Bowes Museum, Barnard Castle, Durham

THE PAINTING The power and splendour of Venice with its carnivals, festivals and regattas is Canaletto's subject. Every year since it was decreed in 1315 there has been a regatta on the Grand Canal. It used to be held on 2 February, when this picture is set. It is evening, with the light falling from the west over Ca' Foscari and lighting up the honey coloured stones of Venice. One of the grandest of the boats takes up Canaletto's foreground; it is one of the two barges that were built every year in the great military shipbuilding yard, the Arsenal, especially for the regatta. Just to the left is part of the *macchina della regatta*, the incredibly elaborate pavilion built for Venice's elected monarch, the Doge, to hand out prize flags to the winners. The building with the flag-draped balcony is the Palazzo Balbi, built for an owner that died surveying the building work. It is the same balcony that Napoleon was to stand on sixty years later when he came to watch the regatta, his regatta by then. The once great power became just another of Napoleon's possessions, and Venice never again regained its independence.

THE ARTIST After following his father into stage design, painting backdrops for Vivaldi's concerts, Canaletto went to Rome aged twenty-three and started sketching the ruins. It inspired him to do the same back home. Other artists like Guardi painted Venice in a free, more 'Venetian' way, but Canaletto's atmosphere of cool rationality was achieved through precision. To do this he used a camera obscura. This was a kind of basic camera that reflected an image, known since Archimedes' time 2,000 years earlier. A hundred years before Canaletto, Vermeer had used one. Canaletto traced over reflections of Venice, and painted up the finished thing in oils. Selling much of his work to the English nobility, more than half of his signed paintings are still in Britain today (the Royal Collection has the world's greatest number). As the Austrian War of Succession (1740–48) raged across the continent, Canaletto headed for the safety of his biggest market, and stayed painting country houses and London views for ten years. But his brilliance began to slip and he was accused of being an imposter, not the famous Canaletto at all. He returned home to a similarly lukewarm reception and died, still painting, without his earlier fame or fortune.

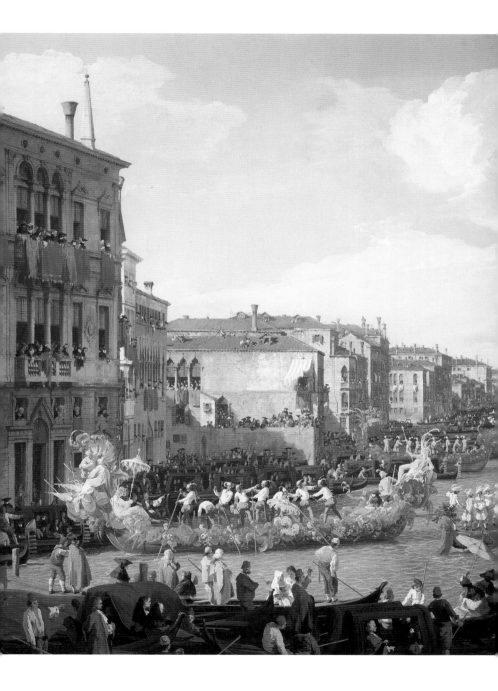

Giovanni Paolo **Panini**

b. Piacenza 1691–92, d. Rome 1765
The Interior of the Pantheon, Rome, 1732
Oil on canvas
119 x 98.4 cm (47 x 38¹/₄ in)
Private Collection

THE PAINTING What Canaletto was doing for Venice, Panini was doing in a completely different way for the eternal city, Rome. His Pantheon is a fairly faithful recording of Europe's greatest surviving ancient monument, but details like the gently crumbling frieze under the coffered dome are Panini's own. So are the small sprigs of vegetation growing out around the thirty-feet wide opening in the roof. But Panini was in the business of picturesque ancient monuments; having this one looking as pristine as it did when it was built in AD 125 did not help his purpose. After the Eastern Roman emperor gave the building to the pope in AD 608, it was converted from a pagan temple dedicated to all the gods to a Christian church dedicated to all the martyrs. In a typical Roman way the pagan gods were simply replaced by their Christian counterparts. All that changed was the statues in the alcoves. Characteristic Panini details are the monks, priests and worshippers scattered everywhere, and the tiny man looking down from the roof. On the right there is a Swiss Guard from the Vatican with his pike, by chance kneeling near the tomb of Raphael, walled up here in 1520. At the time that this was painted, no one knew where exactly Rapahel was buried.

THE ARTIST In Rome Panini created what are called *capriccio* – fantasy paintings full of real and imagined places stuck together in a way that best suited the artist's composition. Like Canaletto he started designing stage-sets and was inspired by the ruins of Rome. But unlike him Panini wasn't interested in painting things as he saw them. His views are made on the canvas. The Colosseum, Trajan's Column and the Roman Forum jostle together with famous classical sculptures. He was putting the best of the classical world together in one painting. It was pure showmanship and people loved its contrast to the more exacting views. The grand tourists in Rome, like van Dyck's Lord Stuart brothers, wanted to go home with a Panini, so he built up a studio of assistants to meet the demand. After marrying a Frenchwoman he became Head of Perspective at the French Academy in Rome. His ideas filtered into French art. But it was one of his own assistants, the young Frenchman Robert, who went on to develop Panini's theatrical style and influence a new generation of French art.

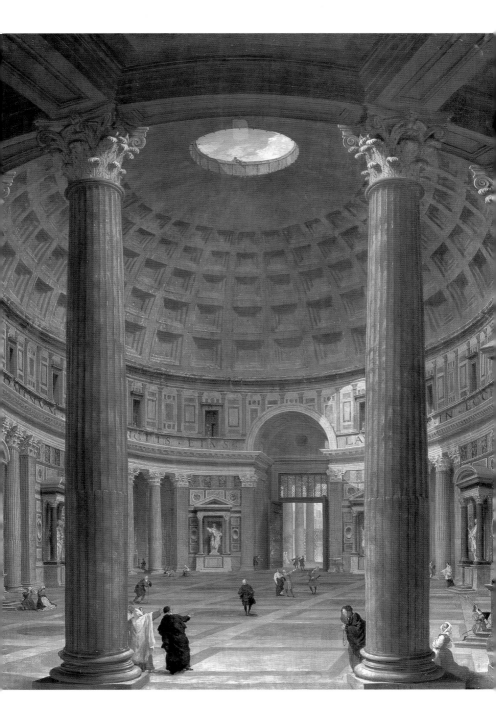

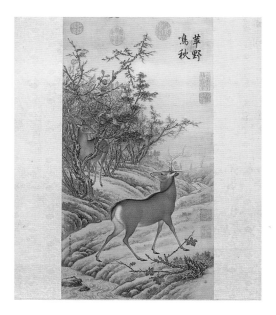

Guiseppe **Castiglione**
(Lang Shih-Ning)

b. Milan 1688; d. Beijing 1766
Autumn Cries on the Artemesia Plain, mid-18th century
Ink and colour on silk
72 x 31 cm (28¹/₂ x 12 in)
Private Collection

THE PAINTING This painting represents the brief melding of Asian and European art. It is a Sino-Italian hybrid. The landscape comes out of the Sung Dynasty traditions of Xu Xi, and Castiglione continues the line drawing and fine brushwork of Emperor Huizong and the Shigehide artist. But he has added European three-dimensionality by giving the landscape a linear perspective, and adding solidity to the deer with shadows. This was one of Emperor Quinlong's prized paintings. To his eyes the deer and doe represented two things – the eternal struggle of sexual domination, and the proud and ancient traditions of stag hunting by the Emperor's nomadic ancestors. He had just revived the hunt and filled his Summer Palace gardens with deer to chase.

THE ARTIST Castiglione was a Jesuit artist who, after ten years of painting in Italy and Portugal, headed out to Macao in 1714 to convert the locals. Keen to learn the language and etiquette it didn't take him long to get introduced to the emperor. He became a court favourite and was made an official, a Mandarin, and so wore a peacock-decorated silk gown with a sapphire-studded hat. He painted as a Chinese-European for three emperors, at a time when they were most interested in learning about western culture. Unfortunately civil war and colonialism pecked away at China's international goodwill until the West was rejected completely, culminating in war, when the Summer Palace was sacked and this painting was taken to Scotland.

Francesco **Zuccarelli**

b. Pitigliano 1702; d. Florence 1788
The Rape of Europa, mid-18th century
Oil on canvas
135 x 153 cm (53 x 60 in)
Private Collection

THE PAINTING Correggio's *Jupiter and Io* tells the tale of one of Jupiter's infatuations. The insatiable god assumed many shapes to ravish unsuspecting mortals, not always female. Here he is, at it again. The popularity of these obscure myths was not entirely due to their sexual content. In medieval times the classical myths were translated into Christian terms in the *Moralized Ovid*. This one was read as Christ transformed into a bull to plod off up to heaven carrying a human soul on his back. This perhaps was not an obvious subject for a painting, but at least it *could* have been read as a Christian image if, for instance, the local bishop was coming over. Zuccarelli's light, pale landscape is a minor backdrop here for his plump cherubs and maidens – all colourful Rococo decorations in a scene that only really needs Europa and a bull.

THE ARTIST Zuccarelli was a Rococo landscape painter and one of the eighteenth century's most influential. The English liked him most, as they did Canaletto. It was Canaletto's dealer, Joseph Smith, who introduced Zuccarelli to his English clients and changed the course of his career. Perhaps it was because he took the grand classicism of Claude and the wildness of Rosa, both English favourites, and combined them with his own lighter and sweeter decorative taste that he went down so well. He worked in England for sixteen years, leaving a huge influence on British landscape painting. He was one of the founder members of the Royal Academy.

Francesco **Guardi**

b. Venice 1712; d. Venice 1793
A Venetian Capriccio, late 18th century
Oil on canvas
55.5 x 41.5 cm (22 x 16¼ in)
Private Collection

THE PAINTING Guardi is a quintessentially Venetian artist. While the older Canaletto usually painted exacting copies of Venetian views, Guardi was sloshing thick paint around and creating work of real imagination. Like most of his paintings, here he has included as much swirling sky as possible. Through two triangles of colour, one dusky blue, the other dusty brown, he flings some sunlight. It catches some cloud here and a Gothic church pinnacle there. Where all the sunlight is coming from is not obvious, but then it is not supposed to be. Everything is mysteriously unreal. The men playing dice look real enough, but look a little closer and you see that they are actually just a few brilliantly executed dashes of colour. They are all paint rather than flesh and bone. The view looks convincing enough as some little-known Venetian back street, but it isn't. It consists of bits and pieces of reality that Guardi has mixed together to create his own fantasy. The outlines of the warm, flesh-toned buildings melt in the evening sun. It is a wispy fantasy of Venice, an impression of what it was really like, without Canaletto's rational details to get in the way.

THE ARTIST Guardi was the best-known member of a family of Venetian painters, and Tiepolo's brother-in-law. But he died in poverty, forgotten. His cityscapes were never thought a match for Canaletto's. At the age of forty Guardi was even reduced to taking work in his studio as an assistant. Seeing how the English tourists snapped up Canaletto's style, Guardi tried his hand at it. He got himself a camera obscura, which projected an image to trace, and painted the rest as Canaletto did. These paintings went down very well, but unfortunately he never signed them so we don't know where they are or what they looked like. They probably have Canaletto labels on them now. But Guardi didn't stick to this, as he much preferred his own free style. Everything in his paintings shimmers. The reflected water and sky takes over from the buildings as the main attraction. In his waterway paintings he used so much sparkling blue water and sky that it can be hard to see where the canal ends and the horizon starts. If you are lucky there might be a tiny gondolier there to guide you. It took the age of Impressionism to dawn before Guardi's Venetian impressions were fully valued.

Thomas **Gainsborough**

b. Sudbury 1727; d. London 1788
The Painter's Daughters with a Cat, c.1760-1
Oil on canvas
75.6 x 63 cm (29³/4 x 24¹/2 in)
National Gallery, London

THE PAINTING This is one of the subtlest and most moving portraits Gainsborough ever painted. It has all the informality and emotion of Rubens' portrait of his own daughter. Gainsborough had inherited Rubens' free painterly style. It comes through in the swirling background landscape, there to frame the girls' silky beauty rather than to distract us by being real. But instead of flicked into being, like in Rubens' portrait, here the girls' hair is finer and more realistic. Their faces have a deep opaque solidity that has more to do with Gainsborough's complex painting techniques than just shadow or light. There is nothing sentimental about these girls, which there so easily could have been. The deep look of the older sister and the bored, attention-loving look of the younger one make this a most engaging portrait. It is a private family picture, which might explain why he never finished it. You can see the ghostly outlines of a hissing cat, which would have taken the painting in a very different direction. But it seems he was happiest concentrating on the sisterly embrace. Their expressions added all he wanted.

THE ARTIST 'Gainsborough will be transmitted to posterity, in the history of art, among the very first…' So said his greatest rival, Reynolds, when he died – twelve years after the American Revolution – as one of the eighteenth century's most original and natural artists. The two had been in lifelong competition, and artistically disagreed about everything. Reynolds was the intellectual artist, Gainsborough the intuitive one. Aged thirteen he left his small-town merchant roots and became a painter's apprentice in London. His love of landscape came from Dutch and Flemish pictures, as well as from Watteau, while his love of shimmering drapery came from van Dyck. Landscapes were his calling, but in England clients wanted portraits, so he ingeniously combined the two when he could. His *Mr and Mrs Andrews*, painted in their country estate, shows off their status and Gainsborough's landscape talents. He painted every part of his 700 pictures himself, without the usual help of apprentices, painting into the night by candlelight. With what Reynolds called 'those odd scratches and marks', he would impressionistically brush people onto the canvas. His inventiveness did not fit with the rules and teaching methods of the new Royal Academy, although he was a founder member. He quit, and set up his own exhibitions.

Sir Joshua **Reynolds**

b. Plympton 1723; d. London 1792
Colonel John Dyke Acland
and Thomas Townshend, Viscount Sydney, 1769
Oil on canvas
239 x 184 cm (94 x 72 1/2 cm)
Private Collection

THE PAINTING This is a heroic double portrait. Acland and Townshend are like eighteenth-century Robin Hoods, dashing through the forest with hair flowing in the wind and taut bows about to fire at their kill. Reynolds has made the two friends the epitome of elegant hunter-gatherers. He puts them in tight-fitting clothes to show off their manly, stretching physiques, but still manages to give them the flowing drapery of a classical hunting scene. The green and brown material shimmers with gold thread, putting them in place as natural champions of the forest. They are both noblemen of nature and successes at the hunt, with their kill of the day piled up behind them. Once you accept the fact that Reynolds paid local boys to dress up and stand in those positions for hours, in order to paint this action snapshot, then it does start to look pretty impressive. He transformed the stale portraiture of England into dynamic, classically allusive allegory with this sort of painting. He has made the two look like dashing, energetic supermen and loyal friends. The truth wasn't so prosaic. They quarrelled before it was finished, and both refused to pay or take it away.

THE ARTIST As the dominant figure in eighteenth-century English painting, Reynolds died having founded a distinctly British school. More than anyone he elevated art and the status of the artist in Britain. In his time Old Masters were bought-up on grand tours, while homegrown artists painted portraits. Reynolds wanted to change all that. So he married portraiture with the grand style of allegory and history painting, building his artistic reputation on suiting historic imagery to the personalities of his sitters. He was the first president of the new Royal Academy in 1768. Here he delivered his fifteen *Discourses on Art*, spelling out, in his Devon accent, the academic grandeur of painting. His father had been an Oxford don and Reynolds' friends were literary types, the opposite of his more intuitive rival Gainsborough who 'detested reading'. Samuel Boswell even dedicated his famous *Life of Johnson* to Reynolds. With 150 portraits a year he needed assistants to carry out the much of the work, like Rubens had done. His funeral proved how far he had changed the standing of artists in Britain – three dukes, two marquises, three earls, a viscount and a baron carried his coffin to St Paul's Cathedral.

Benjamin **West**

b. Swarthmore, Pennsylvania 1738, d. London 1820
The Death of General Wolfe, c.1771
Oil on canvas
43 x 61 cm (17 x 24 in)
Private Collection

THE PAINTING Having won the battle for Quebec in 1759, ending the French presence in Canada, General Wolfe lies dying in the arms of his men. Wolfe had kept North America British, but by the time this was painted, colonial revolution was in the air. West brought his American revolutionary spirit to London with this work, a turning point in art. History paintings like this had always been in classical, everlasting costume. West not only painted the characters as they actually looked, but painted them as portraits too. It is a real battlefield. There are no allegories of victory with laurel crowns. But the poses are as grandly classical as any allegory had been. The picture caused an uproar, but it made him History Painter to the king.

THE ARTIST West is the father of American painting. Born to Pennsylvanian Quakers, he went to Rome to learn to paint. By 1763 he was painting in London, and became a founder member of the Royal Academy in 1768. After he showed a version of *The Death of General Wolfe* in the Royal Academy's 1771 exhibition, his reputation as an ingenious American was set. His London studio became a mecca for American artists, who returned home influenced by his style. They all made the pilgrimage to the old world to take its new art back with them. West took over from Reynolds as President of the Royal Academy, and during his twenty-eight years in office helped see in the Romantic movement.

George **Stubbs**

b. Liverpool 1724; d. London 1806
Tristram Shandy, c.1762
Oil on canvas
102 × 127 cm (40 × 50 in)
Private Collection

THE PAINTING A perfectly studied racehorse is all Stubbs wants us to see. Its owner Viscount Bolingbroke had divorced his wife, Lady Diana Spencer, for adultery and wanted a portrait of his new love, his racehorse. The springtime landscape is as uncluttered and undiverting as possible, making the dark horse a silhouette against it. Every muscle is caught under the sunlit coat. The light green field is like a manicured lawn, and the parkland vista is a fashionable bit of landscaping. From the perfectly bred racehorse to the sculpted countryside, this painting is as much about man's control of nature as it is about the anatomy of this animal. Even the groom is turned away from us so as not to attract our attention. All eyes are on Stubbs' perfect racehorse.

THE ARTIST Stubbs did for animal painting what Leonardo and the Renaissance had done for human figure painting. His life's work was based on a full understanding of the anatomy of animals. Born into a poor Liverpool family, he worked with his father in the family shop. By the age of sixteen he was teaching himself how to paint, and dissecting horses and dogs. He lectured in anatomy at York Hospital and etched for medical manuals, until he had made enough money to visit Italy. He said the trip proved to him that 'nature is superior to art'. His book *The Anatomy of the Horse*, published in 1766, shot him to fame and commissions to paint horses came rolling in.

Hubert **Robert**

b. Paris 1733, d. Paris 1808
Egyptian Fantasy, 1760
Oil on canvas
63.5 x 95cm (25 x 37½ in)
Private Collection

THE PAINTING The epic scale of the pyramids is exaggerated beyond reality in Robert's ancient fantasy. He had never been to Egypt, and he didn't need to. A shaft of sunlight hits the centre ground, but blackened clouds cast the shadows of night everywhere else. Vast flights of stairs, massed with figures involved in torch-lit rituals, wind around the building which soars through the clouds like some Tower of Babel. The fallen obelisk in the foreground shows it is not even Ancient Egypt anymore. Robert is hinting at some more sinister post-Pharaoh, pre-Islamic, indeterminate world. His brushwork is free, the figures are single dabs of colour, and the floating clouds are smeared on over a chunk of dark paint that hints at the grandeur of the monument.

THE ARTIST Having spent eleven years in Rome, sketching the ruins with Panini and Fragonard in the French Academy, Robert developed his semi-real grand fantasies. Continuing Claude's Franco-Roman tradition of idealized landscapes, Robert added grand ruins just when Rococo frivolity wanted to see them. Nothing was serious, or exactly real, it was evocative and picturesque. Louis XVI put him in charge of opening a museum in the Louvre Palace – one year before the French Revolution. Robert found himself in jail waiting to be beheaded, like the king. Somehow they set him free and beheaded someone else with the same name by mistake. He continued to paint into his 80s until, as his friend Vigée-Lebrun said, 'he died brush in hand'.

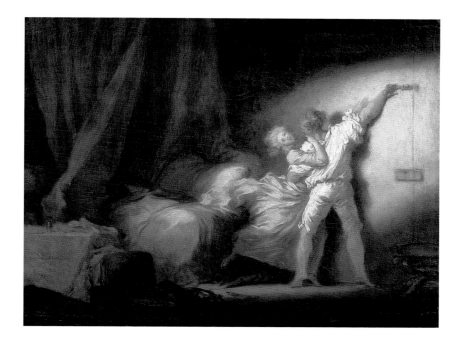

Jean-Honoré **Fragonard**

b. Grasse 1732; d. Paris 1806
The Bolt, c.1778
Oil on panel
26 × 32.5 cm (10¹/₄ × 12³/₄ in)
Private Collection

THE PAINTING The seething sensuality and eroticism of this picture make it one of the French Rococo's most powerful. From the cavernous dishevelled bed, the woman desperately leaps for the door, knocking over a chair. But she is restrained by the man, who envelops her with one arm while bolting the door with the other hand. Sexuality and domination could only be painted this blatantly in eighteenth-century France. This painting was taken from the collection of Robert's patron, the treasurer of France, after his beheading during the French Revolution. Its fast energetic sketchiness gives movement and feeling. Fragonard painted a more finished version, but the thrust of his erotic paintings is in their free and urgent brushwork. In its content and handling this leap-frogs David's neo-Classicism and looks right into Romanticism.

THE ARTIST After a brief training with Chardin, an artist with opposite views in life and art, Fragonard became Boucher's star pupil. Together they gave France a generation of erotic Rococo art, that Fragonard painted with Gainsborough-like naturalness. But when Louis XVI's mistress Madame du Barry rejected Fragonard's *Progress of Love*, which she had commissioned, it left his reputation in tatters. Taste was shifting away to neo-Classicism, and by the 1789 Revolution Fragonard's aristocratic sensuality was intolerable. He gave up painting altogether. David got him a job in the newly opened Louvre Museum, and by 1795 he was running it. After overseeing the stolen European artworks that Napoleon was daily shipping into Paris, Fragonard left, to die in obscurity.

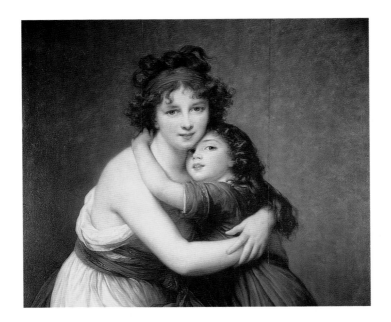

Élizabeth Louise **Vigée-Lebrun**

b. Paris 1755; d. Paris 1842
Self-Portrait of the Artist and her Daughter, 1789
Oil on canvas
130 x 94 cm (51¼ x 37 in)
Louvre, Paris

THE PAINTING Vigée-Lebrun was a famous beauty and wit who held society parties for the doomed French *ancien régime*. As the ideas of the noble simplicity of Ancient Greece were coming into art through David and through Vigée-Lebrun herself, she was walking around Paris dressed in classical robes and holding salons *à la Grecque*. And this is how she has painted herself here, wrapped in drapery with her hair tied up in the way it would have been seen in antique sculpture. But this isn't a portrait just to show off her fashionablity. Her nine-year-old daughter Jeanne is wrapped around her neck with all the softness and sentimentality of the children of Murillo or Gainsborough. Like David's *The Death of Marat*, the background is an austere block of colour but the unremitting triangle in the centre is a soft one.

THE ARTIST During her hugely successful career Vigée-Lebrun befriended Queen Marie-Antoinette and painted her dozens of times. She was a famously charming socialite who specialized in soft, pretty paintings of women and children from her social circle. When the Revolution came and the queen was beheaded, Vigée-Lebrun and her daughter left France, and an unhappy marriage, behind. She spent the next fifteen years painting the great and the good in capitals all over Europe. She finally resettled in France after Napoleon's exile and wrote her three-volume memoirs, where she sums up her resolute character: 'the day my daughter was born I never left my studio...I went on working'.

The Birth
of the Modern World:
Romanticism to the Pre-Raphaelites, Goya to Millais

Bliss was it in that dawn to be alive,
But to be young was very heaven!

That's what the English romantic poet William Wordsworth had to say about the participants of the 1789 French Revolution. The old orders were being blown apart, and the fires ignited by the American War of Independence were catching on across the world. Continental Europe was in a constant state of war and revolution. The secure rationalism driving the eighteenth century didn't seem so secure anymore, and the lights of the Enlightenment were dimming. Religious questioning and upheavals had always been around, but now the very basis of religion was being shaken by science and philosophy. By the 1830s Darwin was collecting evidence that swept away the old certainties of existence. The more that was being learnt about the world, the less people recognized it. The beliefs that supported the coherent artistic world of Reynolds or Fragonard couldn't survive the onslaught of change brought on by the painful birth of the modern world. The old order supported the collective consciousness of society, with the individual giving himself up for the greater good. But the new world was different. An age of ego was awakening, while people were dealing with the difficult questions that the world was now throwing at them. Art reflected this new subjectivity, and was changing faster than at any other time between the Renaissance and the twentieth century. Artists were again beginning to

paint their artistic theories and express their emotions, rather than simply painting pictures. It was the new beginning of a fundamental shift from craft to ideas-based art.

Traditional patronage continued in many countries, but the middle classes were on the rise and with them came radical changes in artistic creation. The very idea of what it was to be an artist was in turmoil. New classes of patrons willing to question established ideas were giving credence to the artist as a visionary. The artist was no longer a producer of religious or edifying images on request, but was being seen as an individual who could transcend the experiences of his audience and enlighten them with his vision.

The word 'romantic' was only used later to try and label this staggered move away from the authoritarian aspect of the eighteenth century, with its shared judgements and ideals, and toward a rising sense of the individual. Romanticism wasn't one artistic movement – it was more like a collection of individuals who each rejected the old shared order. The great differences between Goya, Blake, Turner, Friedrich and Delacroix show how each was answering his own personal artistic calling. Goya, the first artist of the modern world, expressed the inner anxieties of humanity in art for the first time. Independently, Blake used art to mirror his deepest personal feelings and thoughts, without caring about the established rules of representation. Turner, Friedrich and Delacroix, in their separate ways, brought the craft of painting into the service of their emotions with stunning new effect.

The industrialization of Britain and the West made a lot of rich new patrons, but it also caused the upheaval of communities, the creation of a large urban proletariat, and the mechanization of traditional crafts. In reaction, nostalgia was felt for a simpler, idealized medieval time of country pursuits and honest dignified labour. Constable's love for the simplicity and beauty of the English landscape (not unmotivated by the new threats it faced) brought a new kind of realism, much like his French contemporary Millet, whose idealization of peasant life has inspired generations artistically and politically. But while Constable tried to paint his local landscape exactly as it was, the younger French artist Corot never wanted to lose the emotion he was feeling at the time. This brought his melancholy 'impressions of nature' closer to the ideas of the Impressionists. In America, the emotional brilliance of Turner and Constable's love of local landscape are united in Church's new world landscapes. The realism of Courbet's politically charged peasant scenes was rooted less in nostalgia and more in the turbulence of nineteenth-century French politics. Meanwhile the Pre-Raphaelite Brotherhood of Millais' circle in Britain rejected the

slickness and sentimentality of the establishment, and tried to explode their decadent practices of painting affected beauty. Instead they created scenes of minute detail, inspired by the truth and seriousness of the early Renaissance.

From this revolutionary time emerged our view of the artist as a romantic visionary, freed of the constraints of patronage. Art for the first time had begun to reflect human emotions fully, to express the soul. In a period when everything was open to question, answers were being sought, and found, in the work of its great artists.

Francisco José de **Goya** y Lucientes

b. Fuendetodos 1746; d. Bordeaux 1828
Colossus, c.1808
Oil on canvas
116 x 105 cm (45^1/$_2$ x 41^1/$_4$ in)
Prado, Madrid

THE PAINTING *Colossus* thunders out of Goya's nightmare and into the world. The titanic naked body of this giant, miles from us, seems as if it could turn and destroy us at any moment. Towering above the sky, he reduces our world to one of insects. People and animals scatter in all directions, seized by blind fear and confusion as the muscular savage, arms raised in aggression, puts an end to civilization. Is this the apocalypse? Or a manifestation of our deepest fears, fears that gripped Goya's Europe during the Napoleonic wars? Whatever his vision, this vast, dark monster is destructive, indiscriminate, evil and as pointless as the horrors Goya had seen in those wars. Reality is lent to this nightmare by the movement and panic in the free dabs of paint that make up the scattering hordes, while the hazy sky has patchy clouds scraped on with a palette-knife. Goya hasn't laboured with details. This is fast, immediate and real.

THE ARTIST Some of the most original images of a generation were brought into being by the torment that Goya endured during the early nineteenth century. As witness to hellish visions of destruction and cruelty, begun by Napoleon's forces and perpetuated by various Spanish regimes, Goya progressed from his light and frothy Rococo painting, inspired by Watteau and Tiepolo, into being a dark and personal artist. His highly individual portraits, though heirs of Velázquez and with a textural beauty like Gainsborough's, are almost naïvely charming and hauntingly elegant. But in 1794 illness took his hearing, and with it his optimism. With only his sight and imagination for inspiration he became broody and reflective. But it was the onslaught of the Napoleonic forces in 1808 that triggered Goya's deepest visions and anxieties, forcing him to express his imagination on canvas. This was groundbreaking. Not since the High Renaissance had an artist followed his mind alone, ignoring all those around him; his paintings reflect no patron's wishes but proclaim the artist as a visionary, as all artists since have echoed. Goya began as a Rococo painter and developed an individual, new style of portraiture while on his way to introducing ideals of Romanticism to art. He is both the last of the Old Masters, and the very first artist of the modern world.

The Birth of the Modern World

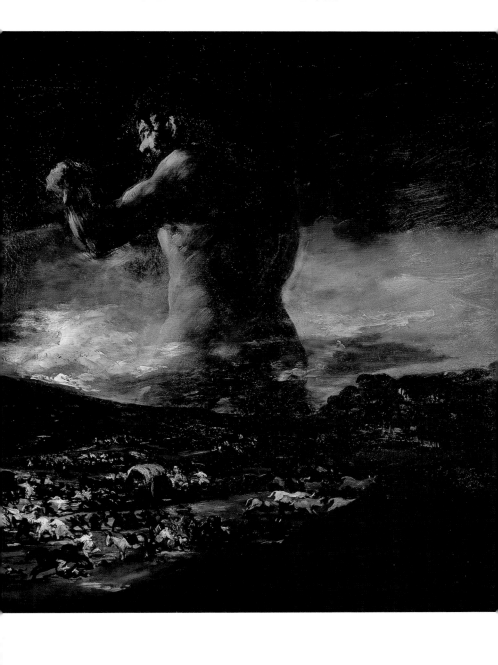

John **Constable**

b. East Bergholt 1776; d. Hampstead 1837
The White Horse, c.1817–19
Oil on canvas
61 x 52 cm (24 x 20¹/₂ in)
Private Collection

THE PAINTING Constable's English landscapes have typified England for people all over the world. His paintings have been reproduced so often that he is probably the defining artist of the twee 'chocolate-box' cover. But it is not his finished paintings that are always the most interesting. He wanted to paint nature as it really was, not to use the tricks that artists used to imitate leaves or earth. He literally wanted to transfer his native countryside on to canvas, without faking a composition or changing its colours to suit people's views about what 'proper' landscapes were. This is why sketches like this one are so forceful. It is Constable at his most honest. He painted exactly what he saw, then made a bigger, more finished painting later in his studio. The sketch is the real impression he had, and has so much more life because of it. It shows the River Stour where he grew up. His father's mill is just upriver, and the thatched boathouse and cottages were his childhood haunts. There is nothing contrived about this. Nature, plain and simple, is painted with incredible boldness for the time.

THE ARTIST With Turner, Constable is the most important landscape painter in British history. Born in the year of the American Revolution, by the banks of this river, he moved to London to study painting at the Royal Academy, but he always went home to paint the landscape he loved. His passion for trying to capture nature as it really looked had something to do with his belief that God was in nature. Where Friedrich makes up a beautiful landscape to show his beliefs about life and death, Constable takes himself out of his painting, shows us real nature, and lets it speak for itself. Though he looked back to Dutch painters like Ruysdael and Both, who'd painted in a similar landscape in Holland, he was painting for a different reason – love of the landscape in all its forms. In sketches like this his passion comes straight through. It was that energy and honesty as much as his freely handled painting that had such an influence on French Romantics like Delacroix and Géricault. He was more of a success in France than he was in his lifetime in Britain. Aged fifty-three, he was finally voted a member of the Royal Academy, grudgingly by a margin of one vote.

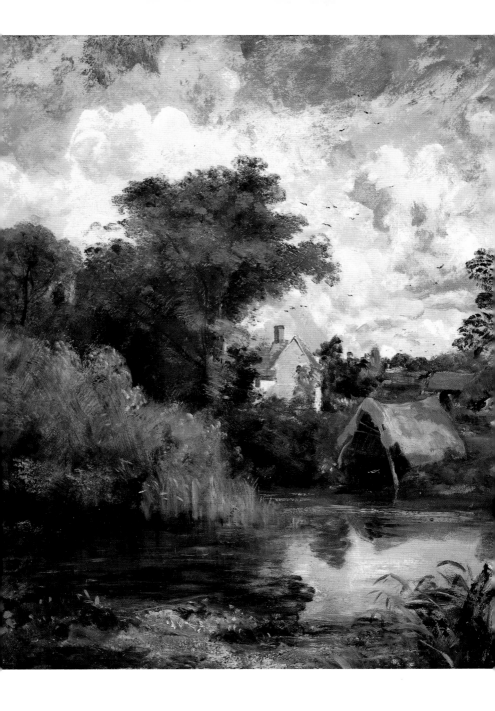

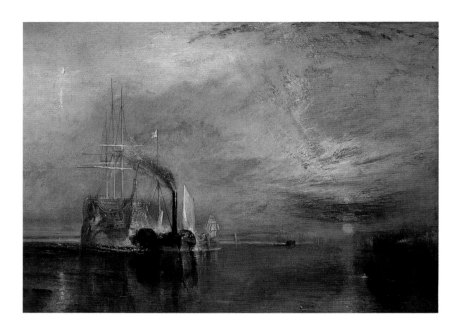

Joseph Mallord William **Turner**

b. London 1775; d. Chelsea (now in London) 1851
The Fighting Téméraire
Tugged to her Last Berth to be Broken up, 1838
Oil on canvas
90.8 x 121.9 cm (35³/₄ x 48 in)
National Gallery, London

THE PAINTING The *Téméraire* is being dragged away to die, tugged by a dark, graceless harbinger of the modern world. The burning crimson of the dying sun has the grandeur of a classical seascape by Claude, but this is something very different. This fire is fuelled by the introspection of the Romantic age. The *Téméraire* meant something to Turner, and he believed its passing should be saluted by the nation. He had painted it before, in his 1808 *Battle of Trafalgar*, fighting gallantly beside Admiral Nelson's HMS *Victory*. Thirty years later he saw the old boat being towed, impotent and forgotten, to its Valhalla. The painting captures Turner's shift into more violent colours and impressionistic feeling for forms, its sense of pathos and loss making it a landmark in pure Romantic landscape.

THE ARTIST Expressive colours like these and the painterly way Turner pasted them on the canvas were very new in the nineteenth century. They were so ahead of their time that it took the Impressionists, the Expressionists and finally the Futurists to rediscover his advances. In this way Turner is like Goya and Blake, an isolated genius not fully appreciated in his lifetime. Unlike them, however, he was at the centre of the art world all his life. At twenty-seven he was the youngest member of the Royal Academy, and later became its president. He wanted to equal Claude's views, but somewhere along the line his love of painting and landscape combined to create something much better.

The Birth of the Modern World

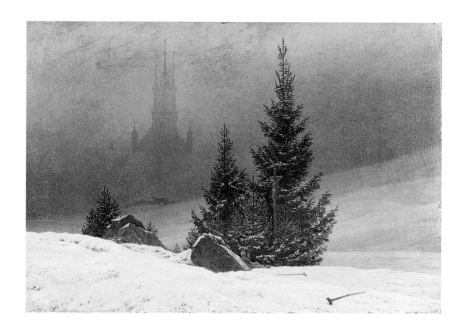

Caspar David **Friedrich**

b. Greifswald 1774; d. Dresden 1840
Winter Landscape, 1811
Oil on canvas
32 x 45 cm (12¹/₂ x 17³/₄ in)
National Gallery, London

THE PAINTING An otherworldly church spire floats above the mists of this snowy hillside, its shape echoed in the upward-growing natural beauty of the pine tree. Friedrich uses the symbolism of winter and twilight as metaphors for death, but wraps it up with popular German nationalism. Gothic architecture and hillside pine forests were pan-German at a time when the German kingdoms were separate. But politics wasn't what Friedrich cared about; he was obsessed with spirituality and death. In this painting a cripple has reached the living beauty of the Christ of the tree and has thrown his crutches away to pray. In the sister painting to this the same cripple is in a desolate, dead wood, with no church or life in sight.

THE ARTIST Friedrich was the leader of the German Romantic movement and is nineteenth-century Germany's greatest landscape artist. But he was forgotten after just fifteen years of painting, until the twentieth century. Romanticism in Germany was created by and for a tiny elite; most Germans had never heard of it, nor of Friedrich. It was tied up with the politics of nationalism, republicanism and protestantism, alongside movements in philosophy, poetry and music. The powerful emotions in his pictures make him one of the greatest painters of Romanticism. In Friedrich's own words, 'Just as the pious man prays without speaking a word and the Almighty hearkens unto him, so the artist with true feelings paints and the sensitive man understands and recognizes it'.

Jean-Auguste-Dominique **Ingres**

b. Montauban 1780; d. Paris 1867
The Turkish Bath, 1863
Oil canvas
108 cm diameter
Louvre, Paris

THE PAINTING This is the greatest work of Ingres' later life. Painted when he was eighty-two years old, the radical composition is a sensual riot of nude female flesh. The mass of intertwined bodies has one simple message – sex. This picture is about sensuality and the female form. Ingres boldly throws out the respectable device of classical mythology and uses instead the mid-nineteenth-century vogue for the East, with its steam baths and tales of harems. But even though this was a private commission, from Prince Napoleon, France was not ready for such blatant sexuality and, maybe unsurprisingly, the painting ended up in the collection of a rich Turk. The bodies are a roll-call of Ingres' lifelong nude studies. The guitar player is his most famous nude. She is straight out of his masterpiece of 1808, *The Bather of Valpincon*, while the plump reclining figure on the right is ultimately borrowed from Titian's *Bacchanal of the Andrians*, where she personified sensual pleasure. Ingres was the ultimate draughtsman, yet here he purposefully bends the female form out of its natural proportions to suit his desire to create the perfect painting, regardless of reality. The coolly refined Raphael-like figures stand out against the fleshy and erotic atmosphere, making the overall effect even more powerful.

THE ARTIST In an age intoxicated by Romanticism, Ingres was the leader and staunchest upholder of the French neo-Classical tradition, a style of austere high seriousness and draughtsmanship. Even though his work was dogged by criticism, sometimes seen as too radical, other times as too old-fashioned, he managed to become the epitome of the successful and intransigent establishment art figure. Pitting his tight draughtsmanship head-to-head against the free-handed, painterly methods of Delacroix and the rising Romantic movement, he even went so far as to forbid his students to look at pictures by Rubens, in case the free emotional style infected them with any leanings towards Romanticism. Instead he demanded that they draw with 'the profound study that the great purity of form demands', and that the 'animal part of art', colour and emotion, be subservient to draughtsmanship. But this authoritarian image hid his deep self-doubt. He was thrown from self-confidence and pride in his work to crises that meant he sometimes reworked or repainted already finished pictures. A portrait from Ingres could take up to seven years to be finished, if he finished it at all.

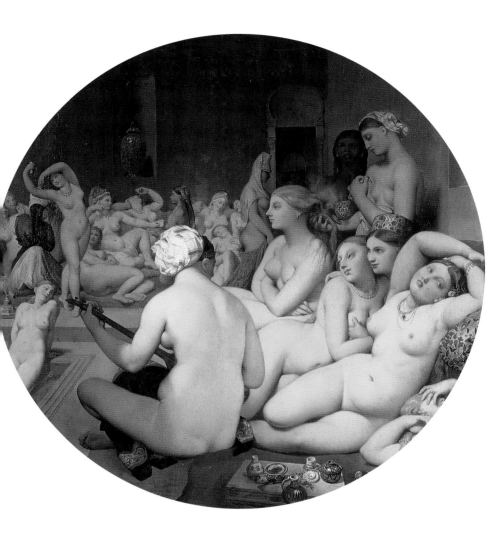

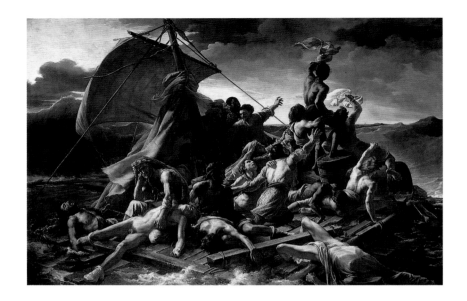

Théodore **Géricault**

b. Rouen 1791; d. Paris 1824
The Raft of the Medusa, 1819
Oil on canvas
491 x 716 cm (192 x 282 in)
Louvre, Paris

THE PAINTING Géricault's most famous picture is the first great painting of French Romanticism. When the frigate *Medusa* ran aground in 1816 with 150 people onboard, the crew took the only lifeboat, leaving the rest to drift. Only fifteen were found alive a month later. Rather than religious death with hope, or grand nationalistic death with honour, the painting shows this scandalous death, with its real despair and suffering. The canvas is the size used for heroic epics, but the raft doesn't have a hero on it. An old man holding his dead son stares out with blank disbelief, another clutches his head, while others wave in mad hope. By mixing this unheroic reality with heroic elements like the vast scale, grand triangular composition and unrealistically perfect bodies, Géricault was deliberately challenging traditional, comfortable perceptions of death.

THE ARTIST Before he painted this, Géricault copied Rubens and Velázquez paintings, and came back from Rome with a love of Michelangelo and the Baroque. All this is reflected in *The Raft of the Medusa*. The bodies are modern Michelangelo, the movement has the energy of Rubens, and the crammed detailed composition is from the Baroque. Géricault took all this and used it to rebel against the classicism of David and Ingres. His wild brushwork and sinister colouring were all about expressing emotion. The fast, noble romance of horses was his favourite subject – his passion for them ended when a riding accident killed him at the age of thirty-two.

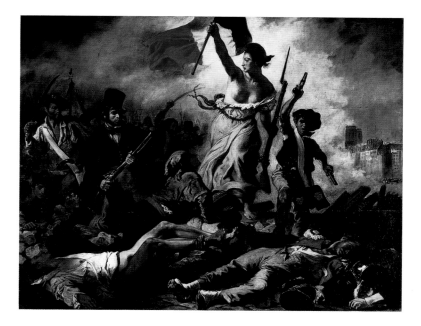

Eugène **Delacroix**

b. Charenton-Saint-Maurice, nr Paris 1798; d. Paris 1863
Liberty Leading the People, 1830
Oil on canvas
260 x 325 cm (102¹/₂ x 128 in)
Louvre, Paris

THE PAINTING Liberty leads the workers and the bourgeoisie to victory in the 1830 French Revolution. With youth by her side, and deified by a luminous cloud, she tramples over broken barricades holding a rifle and a tricolour. But she is charging over the stripped bodies of the dead too – this heroic, noble Liberty is the ragged leader of a mob massacre. It is at once a triumph of classical allegory, history painting and real life; a romantic historical epic painted from contemporary events. Louis-Philippe, the new king, bought it from the Salon exhibition in 1831 and hid it for thirty years so it wouldn't ignite another revolution (it briefly came out after the Revolution of 1848). A testament to how powerful a painting can be, it is still the most potent image of any revolution.

THE ARTIST Delacroix was the uncontested leader of the French Romantic movement. In Britain and Germany the movement had come about through literature and philosophy; Delacroix transformed and developed it in France as the main force in painting. The poet Baudelaire said that Delacroix was 'passionately in love with passion'. He put that passion onto canvas with bold colour and free, energetic painting, taken from the examples of Titian and Rubens. This was very unlike the tight Raphael-like classicism of his dignified rival Ingres, with whom he had a public rivalry. A caricature of the time shows them duelling, Ingres with the draughtsman's pencil, Delacroix with the painterly brush.

Gustave **Courbet**

b. Ornans, Franche-Comté 1819;
d. La Tour-de-Peilz, nr Vevey, 1877
Bonjour Monsieur Courbet, 1854
Oil on canvas
129 x 149 cm (51 x 58¹/₂ in)
Musée Fabre, Montpellier

THE PAINTING Courbet has been described as the bull in the china shop of polite art. It might look harmless enough now, but paintings like this gave him that reputation. Courbet paints himself walking up a path to meet his patron, Alfred Bruyas. This was not the formal studio with top-hatted gents viewing paintings on easels, with classical statues and other props lying around that made artists look grand and intelligent. Courbet looks like a homeless tramp casually meeting some men on a dusty track, and by the intensity of the bright sun, probably a pretty sweaty tramp too. This sort of gritty realism was shocking. Official art was grand, formal and in Courbet's eyes, clichéd and a sell-out to honest artistic ideas. Caravaggio had done the same thing 250 years before, painting gods with dirty fingernails. The French middle classes did not like the look of Courbet's vulgar realism. This was one reason why he painted as he did – to shock the bourgeois. This is nineteenth-century shock art. The colours are pale under the realistically harsh sun, and despite his tramp overtones he has consciously borrowed the look of the Wandering Jew, the rejected wise man. He has stripped away the trappings of the artist but replaced them with the much more powerful idea of the lone genius-artist, full of unbreakably honest ideas.

THE ARTIST Courbet was a genuine revolutionary and not just in art. He hated authority in the art world, in society and in the government. He went to prison for blowing up the Vendôme Column during the 1870 Paris Commune; he then had to flee to Switzerland when they tried to make him pay for the building of a new one. But before this end to his French career he had founded the whole school called Realism. Typically, he did this by staging a one-man show in opposition to the Paris International Exhibition in 1855. His catalogue proclaimed he wanted 'to create a living art', to paint life as it really was. He painted, in perfect detail, ordinary people and peasants doing everyday things, but he painted them with a compassion and empathy that were calculated to unsettle the middle classes. As a die-hard socialist he was using the beauty of his images to re-define the balance of power, in society and in art – with himself, rather egotistically, as its charismatic leader.

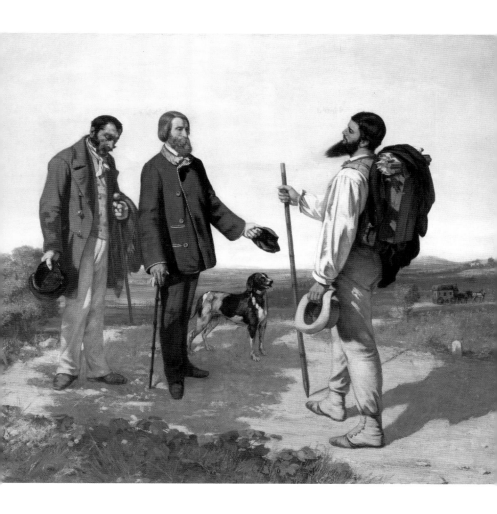

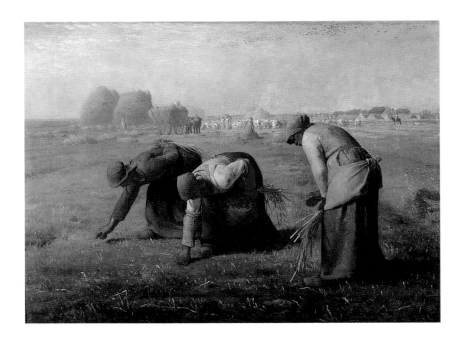

Jean-François **Millet**

b. Gruchy, nr Gréville 1814; d. Barbizon 1875
The Gleaners, 1857
Oil on canvas
83 x 110 cm (32³/4 x 43¹/4 in)
Musée d'Orsay, Paris

THE PAINTING There is nothing elegant in the mute labour of these stocky peasant women. They are intent on picking the remains of wheat too paltry for the reapers to collect. But this simple act has been lent more dignity and honest nobility than anyone had seen before. It might look like a casual arrangement of figures, but these fully rounded, solid women have nothing around them to distract us, just pale, hard fields. Their work with nature is left to consume the picture. In the politically charged France of communes and revolutions some saw it as a powerful socialist statement. Millet didn't believe in any of that, he just had a deep regard for humanity and a melancholy spirit. He said, 'it is the treatment of the human condition which touches me most... I never see the joyous side'.

THE ARTIST A farmer by birth, Millet studied painting in his local town before moving to Paris for ten years to study and work as a portraitist. His roots in the countryside drew him back, and by 1849 he had moved for good to the artist colony of Barbizon. His calling was to paint peasant life as it really was – not the comic yokels of the seventeenth-century Dutch tradition or the idealized, scenic peasants of the eighteenth, but real people, faces that we still recognize today. The moral intensity that flowed onto his canvases connected with the late nineteenth century, and Millet became the most reproduced artist in history.

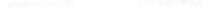

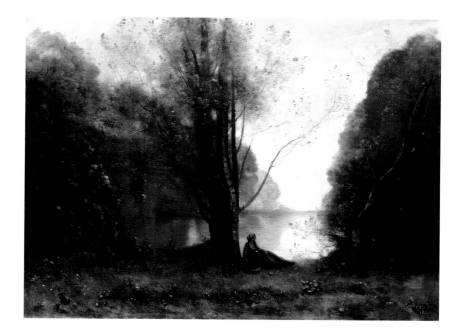

Jean-Baptiste-Camille **Corot**

b. Paris 1796; d. Paris 1875
La Solitude, Souvenir de Vigen, 1866
Oil on canvas
37.4 x 51.2 cm (95 x 130 in)
Private Collection

THE PAINTING Corot pointed the way to Impressionism with paintings like this. There is no detailed Realism here, it is all about atmosphere. This emotional impression of the landscape, created through use of light and dark, subtle changes in colour, is not necessarily a real one. The mysterious vision is of a girl sitting alone in quiet solitude, balanced between three shadowy groups of trees. The dim colours express a sad stillness, but there is hope too. The girl looks out across the silver lake and to the dazzling white sky. This is a timeless image of solitude and contemplation where the strength of the message is in the atmosphere, not the detail. As Corot said, 'If we have truly been moved, the sincerity of our emotion will be transmitted to others'.

THE ARTIST Corot is an individual genius who belonged to no school of painting. Forced to learn drawing in secret from his forbidding family, and with a total lack of interest in old paintings, he freely developed his own ethereal, haunting instincts. His individuality was so ahead of his time that it took the Impressionists until the 1860s to develop his belief that 'beauty in art is truth steeped in impression'. To capture these impressions Corot went out and painted in the open air (*plein air*). Artistic integrity and individuality paid off, and he became so sought after that he couldn't keep up with demand. The result was that Corot became, and remains, the world's most forged painter.

Frederick Edwin **Church**

b. Hartford 1826; d. Hartford 1900
Cotopaxi, 1862
Oil on canvas
122 x 216 cm (48 x 85 in)
Detroit Institute of Arts

THE PAINTING This is pure American Romanticism. The deep orange reds of the setting sun, just breaking through the thick cloud, are reflected across the volcanic lake. The foreground trees show that the area is full of life, but it is still unknown to man. In the centre a waterfall smashes down through the rocks below, while the receding horizon off to the left helps give the whole thing a biblical sense of scale and newness. This fantastical landscape is a conscious rejection of the small, old world of Europe for the magnificence of the American continent. Church was from a tradition of East Coast painters called the Hudson River School, who painted the native landscape in all its grandeur. As their new leader, Church visited the icebergs of Canada and the rain forests of South America. This view is high in the Andes of Ecuador where he had made oil sketches a few years earlier, and back in his studio he labouriously re-created the details. Combining the grandeur of landscapes by Claude and the introspective vision of Turner, he adds his own American pride to make a picture of epic proportions. The country was in the second year of bloody civil war, and differing ideas of what it meant to be American were all around. But Church's views hadn't changed with politics. America was unspoilt, grand, beautiful, and with the spiritualism he conjured up in his landscapes he was showing it to be God's own country.

THE ARTIST Church was in the second generation of the Hudson River School of landscape painters. English-born Thomas Cole, the founder of American landscape painting, started the group, but Church carried it into full-blown Romanticism. His optimistic-feeling landscapes focused the imaginations of a country that was expanding further westwards every day. With minutely detailed foregrounds and long vistas leading off into the distance, he brought the viewer right into the landscape and then pushed them out into the country's untouched vastness. Church was painting views that had never been painted before, charting the new continent and praising its beauty as he did so. But fashion changed. American painting became more international, and Church died unknown by the young and thought of as a provincial artist by his countrymen. It wasn't until the 1960s that he began to be recognized again as one of America's greatest and most characteristic artists.

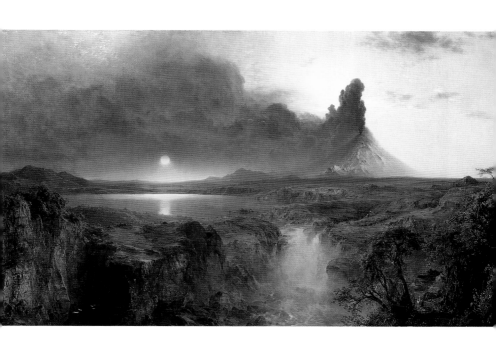

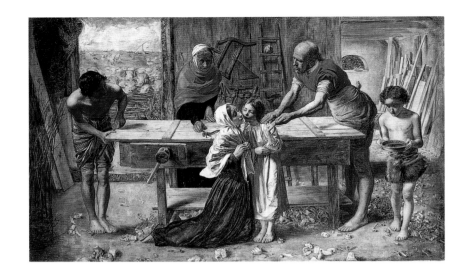

Sir John Everett **Millais**

b. Southampton 1829; d. London 1896
Christ in the House of His Parents, 1863
Oil on canvas
38 x 61 cm (15 x 24 in)
Private Collection

THE PAINTING Charles Dickens called this painting 'mean, odious, revolting and repulsive', and led a campaign against Millais and his circle. It took Britain's most famous art critic, John Ruskin, to salvage Millais' reputation. It seems a bit extreme for a picture of the young Christ, but Dickens was standing up for the 300 years of tradition that Millais and his Pre-Raphaelite Brotherhood were trying to derail. The highly detailed gritty realism looks a bit like Courbet. The Pre-Raphaelites hated the pretentiousness of current art just like he did, but they painted this way for different reasons. They saw the early Italian painters' honesty and desire to paint as things really were as a truer form of art. Millais' brilliantly lit oil is perfectly balanced and labouriously painted, but it was done as a statement rejecting the official painting of the art academies that had spread across Europe since Raphael.

THE ARTIST Millais was a fantastic success story. He was the youngest student of the Royal Academy at the age of eleven, and then ironically as an anti-Academy Pre-Raphaelite he went on to become its president in 1896. He was given a hereditary knighthood, unknown for artists, and became one of the richest Victorian painters by selling hundreds of thousands of prints of his most sentimental paintings (like *Bubbles*, the Pears Soap girl that is still used in their advertising). This gave him the unfair reputation of an artist who sold out to the public's poor taste.

Impressionism to Post-Impressionism:
Monet to Cézanne

It is common to look at Impressionist pictures with a sense of awe at the seemingly massive leap these people made in painting. It's true that over the previous four millennia no artistic movement attempted to do what they did, but even though they might seem to have been painting in a vacuum, they did not come out of nowhere. The assortment of late nineteenth-century French characters that make up the Impressionists were the natural heirs to a long line of artists who loved to work freely with thick oil paint. Titian, Tintoretto, El Greco, Rubens, Velázquez, Hals, Rembrandt and Goya are all forerunners. In the Impressionists' own century Delacroix and Corot also pushed the frontiers of figurative painting further toward impressions of nature, as did Constable and Turner in England. The Impressionists could be seen as the logical culmination of these influences. But it wasn't just freedom of paintwork that they saw to its conclusion. Painting, for the Realist Courbet, was 'essentially a concrete art, and must be applied to real and existing things'. The Impressionists, though using radically different methods from his meticulous, near photographic painting, also brought Courbet's Realism to another, different conclusion. What could be more 'real and existing' than the mental imprint of a casual scene quickly painted outdoors, rather than one highly worked slowly in a studio? The Impressionists, like the Realists before them, wanted to capture the instant of a transitory moment – as photography was beginning to do – rather than the unreal allegories and staged views of battles or classical stories that were praised by the old academy hierarchy. These painters were throwing out the hierarchical

Claude **Monet**

b. Paris 1840; d. Giverny 1926
Les Nymphéas (The Waterlilies), 1906
Oil on canvas
89.5 x 93 cm (35¹/₄ x 36¹/₂ in)
Private Collection

THE PAINTING The paint is so thick in places that it casts its own shadows. Scraped on with knives, it has then been flicked and pushed along the canvas. Blues, greens and the reflections of shimmering light skip from one lily patch to another as they stretch out into the distance. This never-ending patchwork impression of water, plant and sunlight filled Monet's mind for thirty years. This was the theme that the French prime minister asked him to paint as a gift to the nation in 1918. In 1890 Monet bought a country house in Giverny, and he revelled in the beauty of the natural landscape he created there. The garden was filled with exotic plants and flowers, and in the lake he grew these waterlilies. The series of waterlily paintings came out of his love of the colours, shifting shapes, reflections of sky and water and the ever-changing nature of the lake-top plants. He painted the same scene over and over again to catch different moods and lights, as he had done with Rouen Cathedral (which he painted twenty times in two years). Each lily painting is one version, one impression, of an ever-shifting subject.

THE ARTIST It was from Monet's *Impression: Sunrise* that the term Impressionism was derisively coined in 1874. He was the leading member of the most radical and influential art movement since Titian. But his early career was a bohemian one of desperate poverty, being helped out by artist friends and sporadically by his family. His time in Paris was interrupted by a year of military service in Algeria. On his return he met Pissarro and Renoir, who became a lifelong friend. Within a few years he had a son with his lover Camille, partly lost sight in one eye due to stress, and escaped the 1870 Franco-Prussian War in Paris by going to London with Pissarro. There the paintings of Constable and Turner had a big influence, and his interest in Japanese prints began. By 1874 he was showing work in the first of eight annual Impressionist exhibitions. When the informal group broke up in the 1880s, it was Monet who carried on painting to the original principles, right up until his death. In later canvases his feelings were more visible in his brushwork than in his subjects, which had an influence on the Abstract Expressionists in New York.

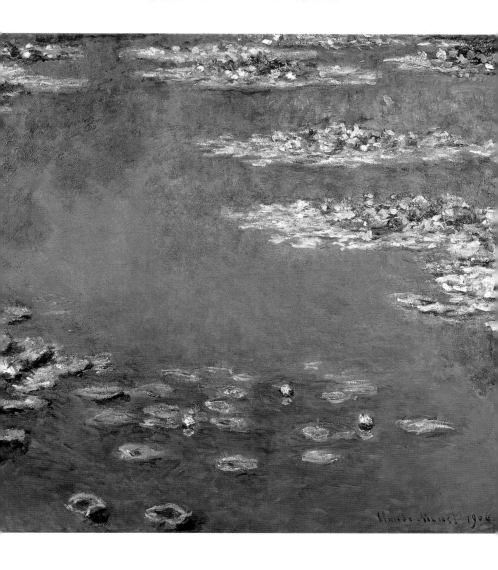

Édouard **Manet**

b. Paris 1832; d. Paris 1883
The Balcony, 1868–69
Oil on canvas
170 x 124.5 cm (67 x 48 in)
Musée d'Orsay, Paris

THE PAINTING In *The Balcony* Manet challenged the most basic things about western art teaching. It might look like nineteenth-century bourgeois prettiness, but only at first glance. The translucent white lace dresses stand out in front of a darkened room, where we can just make out a servant. This is Manet's social world. The woman sitting down is his sister-in-law, the artist Berthe Morisot. Unlike the Impressionists he was associated with, Manet was solidly bourgeois. But he isn't painting for established tastes. Influenced by Spanish art, the composition came from Goya, but Manet's intention was very different. He wanted to paint this scene the way it would really look on a bright sunny day. There is no depth to his background. In daylight there wouldn't be. The room would seem veiled off, not full of perspective. The faces seem almost two-dimensional. In bright daylight not everything is seen with the infinite gradations of light and shade that all western artists were trained to paint with. The thick streaky brushwork seems Impressionist, but it is just as much a reflection of Manet's reverence for past masters such as Hals than for his friends' work.

THE ARTIST Although Manet has been seen as a founder of Impressionism, he is actually more of a Realist. Rebelling against his establishment family, he started painting. From the beginning he wanted to free art from narrow-mindedness. When he complained that 'We have been perverted by the recipes of painting . . . Who will deliver us from all this prissiness?' he answered with his own work, blowing apart accepted views of Old Masters. The first outcry was caused by his *Déjeuner sur l'Herbe*, which showed dressed men and naked women picnicking together. It was an affront to morality. Actually it was a new take on Giorgione's masterpiece that hung in the Louvre. Next he took Titian's *Venus*, mimicking the clichéd pose. Where it had been interpreted as acceptable 'classic' nudity, Manet reinvigorated it. He brought back the shock of sex that the original would have had by making her a prostitute in a brothel, ready for business and looking us directly in the eye. He broke the shackles of moral, religious and historical allusions. It was as a visual rebel that the Impressionists saw him as a senior figure. He broke with the formulas of three-dimensionality in search of reality. Though the Impressionists and Manet mutually influenced each other, he never exhibited with them.

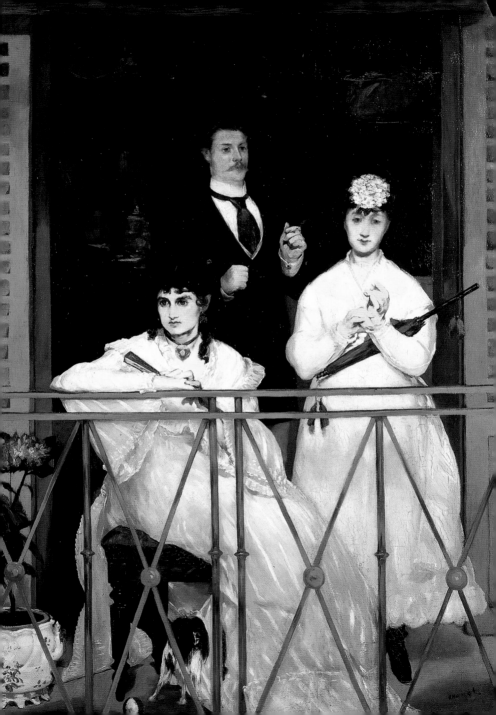

Camille **Pissarro**

b. Charlotte Amalie, St Thomas,
Danish Virgin Islands 1830; d. Paris 1903
*Le Boulevard Montmartre, Temps de Pluie,
Après-Midi*, 1897
Oil on canvas
52.5 x 66 cm (20¾ x 26 in)
Private Collection

THE PAINTING Pissarro's Impressionism was always more formalized than that of the others in the group. This warm, rain-soaked boulevard combines Pissarro's traditional, structured landscape with his fervently avant-garde techniques. The street has all the melting dabs of colour, pushed and pulled into place on the canvas, that were the glory of the movement. But his early influence had been Corot, and the formal elements of that generation stayed with him. It comes through in this choice of an angular boulevard receding with strict perspective into the distance. What is most typical of Pissarro is the way he handles the effects of nature with the solidity of the man-made world. Through his hotel room window, with failing eyesight, he has brought harmony between the two. Haziness after a shower, combined with the movement of an active sky over twiggy autumn trees, seem completely at home in one of Paris' busiest streets. It is an almost religious harmony between the working man in his built environment and nature, like Cuyp had done 200 years earlier. Pissarro had moved through blurry 'romantic' Impressionism into the 'scientific' neo-Impressionism of Seurat's Pointillism. Calculated points of colour marked out these two movements, but Pissarro combined the two techniques in this fluid, individual, spot-dash brushwork.

THE ARTIST Pissarro was seen as the father of Impressionism and was the teacher of the Post-Impressionists Gauguin and Cézanne. After leaving his family grocery business in the Caribbean he settled in Paris aged twenty-five. Following the style of Corot and the left-wing views of Courbet, he focused on working peasants rather than leisured gentry in his country landscapes. When the Germans took Paris in 1870 he fled to London, like Monet, and like him was influenced by Turner and Constable. Unlike Courbet he didn't get involved in the violence of the resulting Paris Commune. With seven children and a lover driven to a suicide attempt through poverty, the anarchist was too poor for activism. His finances became even worse when he returned from London to find the occupying Germans had destroyed the hundreds of canvases he had left behind. Part of Impressionism from the beginning, with Monet, he was already aged forty-four by the first Impressionist exhibition and is the only member of the group to have shown work at all eight exhibitions. He also diversified into neo-Impressionism when he exhibited Pointillist paintings with Seurat. Despite all of this, he spent his life in poverty.

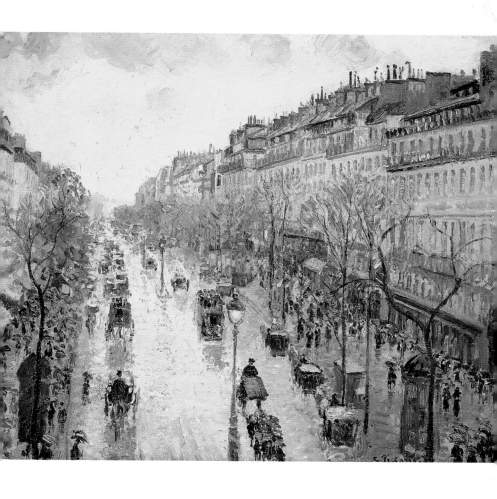

Katsushika **Hokusai**

b. Edo (now Tokyo) 1760; d. Edo 1849
The Well of the Great Wave of Kanagawa, c.1823–29
Polychrome woodblock print
25.5 cm x 37.5 cm (10 x 14³/4 in)
Victoria and Albert Museum, London

THE PAINTING This is probably the most famous image of the sacred Mount Fuji, yet the most powerful Japanese symbol is hardly visible in Hokusai's inventive view. The picture is part of his famous work, *Thirty-six views of Mount Fuji*. Though this is a print made from a drawing rather than being a painting, it is included here because Hokusai was the most popular figure in late Japanese art. He changed the visual arts of the East, and with Japan opening up to trade in 1854 he changed those of the West too, especially influencing the Impressionists. This vision of the much-venerated Mount Fuji comes straight from his imagination. A small, snow-capped triangle in the distance, the same colour as the pounding waves, it has become incidental to the action. This sort of eccentric visualization showed Manet, Van Gogh, Whistler and others just how far they had to go if they wanted to shed themselves of the clichés of western art. Hokusai's boats are at the mercy of the sea. Waves grab at them with white crests, like Asian dragon claws. His outlines are totally original; the bold curving forms and colours prove his position as the most dynamic and individual Japanese artist.

THE ARTIST Hokusai became the most gifted member of the Ukiyo-e, the 'floating world' school of Japanese art which reflected commonplace things, people going about their normal lives, without any idealization. Hokusai made an incredible 30,000 drawings, mostly printed as book illustrations. Not all of them were printed under his assumed name of Hokusai. He used different personas for each of the varied classes of drawings – Actors, Birds, Calendars, Women, Erotic, Landscape. He was a famous eccentric and a cunning self-publicist. Once setting out 600 square feet of paper, he ran around it with a broom dripping with ink, making a vast painting spectacle. Infamously, during a drawing competition, he dipped a chicken's feet in red paint and set it to trot around a piece of blue paper. He titled the resulting image *Maple Leaves on a River*. He said that he drew nothing of any value before he was seventy, and that when he reached a hundred and ten 'each line shall surely possess a life of its own'. He died before he could see that happen, at the age of eighty-nine. He left a huge school of followers.

Impressionism to Post-Impressionism

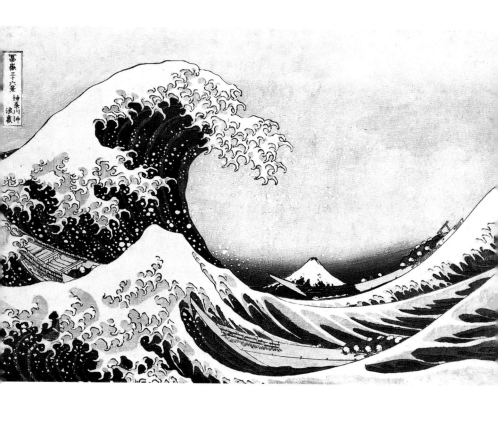

James Abbott McNeill **Whistler**

b. Lowell, Massachusetts 1834; d. London 1903
Harmony in Grey – Chelsea in Ice, 1864
Oil on canvas
45 x 61 cm (17³/₄ x 24 in)
Private Collection

THE PAINTING This was painted ten years before the first Impressionist exhibition in Paris, 1874. Whistler painted it when he was drawing London's River Thames for a series of etchings. The title says everything that Whistler wanted with this painting. It is totally un-cluttered, in composition, colour and in association with anything other than the frozen river. It was dramatically reduced to its most basic elements, impressionistically, long before the term had been thought up. But Whistler's pared-down clarity came from further afield than France. Its Japanese influence runs right through this painting. Hokusai and the Japanese were influencing the Impressionists, but Whistler was one of the few artists to understand Japanese painting fully, and to imitate it. In some of his pictures he adds Japanese fans or vases, which was just a fashion for *Japonisme* at the time. But in *Harmony in Grey* the gentle lines of eastern painting and printmaking are running across his river and the formless rolling horizon. Without the steamboat in the distance it could almost seem like meaningless washes of colour. It is an abstract grouping of icy greys, with only one smeared blob of yellow allowing colour into its world.

THE ARTIST Whistler's early life in America and Russia was followed by a disastrous attempt to follow his parents' wishes and enter West Point Military Academy. By the age of nineteen he had moved to Paris to be an artist. He fell in with Courbet's Realism and borrowed an idea from the poet Baudelaire that stayed with him all his life: 'Painting is an evocation, a magical operation...' With his fellow wit and dandy Oscar Wilde, Whistler became one of the most vocal believers in art for art's sake – aestheticism – where art is unconnected with morals, religion, historicism or anything else. Manet was trying to shake up these associations, but Whistler was trying to ban them. He called his paintings 'arrangements' and 'harmonies' to point out that they should be seen in the same way that music is heard, 'independent of all claptrap'. In an infamous libel case where the critic Ruskin attacked him for charging 200 guineas for two days of painting, Whistler came up with the most memorable defence of modern art. He said he didn't expect payment for the time it took to paint, but for the lifetime of knowledge it took to paint it. The courtroom stood in applause.

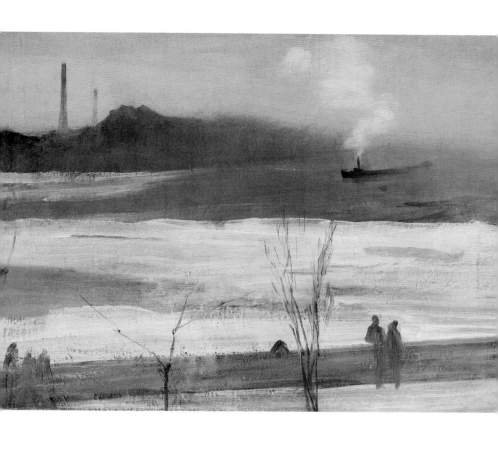

Pierre-Auguste **Renoir**

b. Limoges 1841; d. Cagnes-sur-Mer 1919
Young Girl Bathing, 1888
Oil on canvas
81 x 65.4 cm (32 x 25³/₄ in)
Private Collection

THE PAINTING Renoir said, 'I never think I have finished a nude until I think I can pinch it'. Pinchable or not this nude is one of Renoir's most developed, and captures all the interests of his long career. Earlier he had suffered a crisis of confidence: 'I had travelled as far as Impressionism could take me and I realized the fact that I could neither paint nor draw'. He reacted by experimenting with a much tighter, outline style inspired by draughtsmen like Raphael and Ingres. Life-drawing led him to this next obsession, the young female nude. This bather's modest but formal pose is from the ancient *Venus Pudica* sculpture that Botticelli had used. The curvaceous girl's pearly, opalescent skin provides a cool and human contrast to the rainbow of colours around her. With this painting Renoir came back to the Impressionist focus on the effects of light on the eye. The water ripples out from her, catching the colours of the bank-side plants and the blue sky. Typically for Renoir, he used bright colours because he liked their descriptive emotional effect – there's no natural reason for this vividness.

THE ARTIST Renoir was a leader of the Impressionists, but was the first to turn his back on it. From a poor family, he started painting porcelain in a factory aged thirteen (rather than going to art school). Years later he had saved enough to paint full time, and met Monet. In these early years of studying paintings in the Louvre, he was attracted to the voluptuous and colourful figures in the Rococo art of Watteau, Boucher and Fragonard. Their influence stayed with him. By the 1870s he had started to make money by painting society portraits, and gradually turned away from the subjective uncertainties of the Impressionists, refusing to exhibit with them for a while. He called it his 'sour manner'. His fluorescent colours and fluid wetness dried up, but his new harsh outlines weren't liked by anyone. Finally he agreed with his critics and returned to Impressionism, but with a more formal structure. *Young Girl Bathing* is from this new productive and successful phase. At the end of his life, crippled with rheumatism, he painted with brushes tied to his arms and directed assistants to be his 'hands' sculpting. Summing up his art he said, 'Why shouldn't art be pretty? There are enough unpleasant things in the world.'

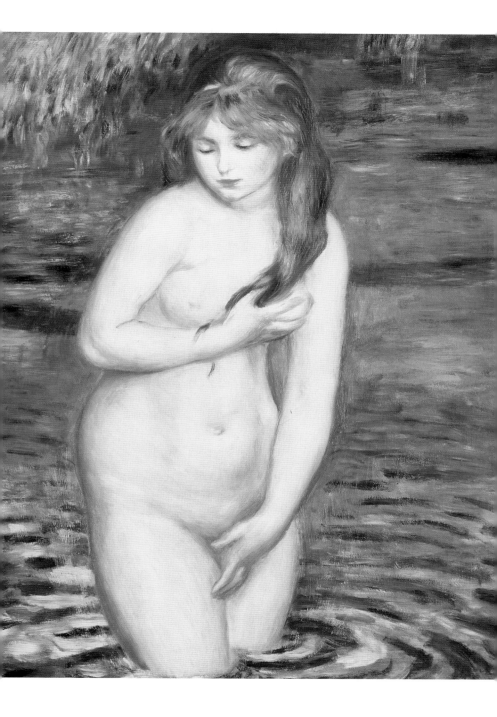

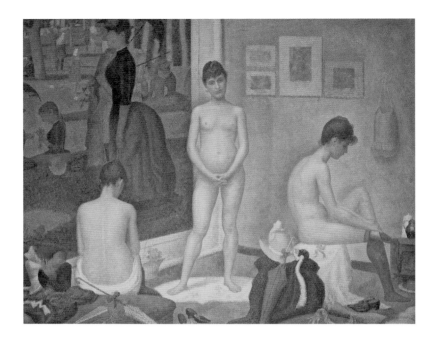

Georges **Seurat**

b. Paris 1859; d. Paris 1891
Les Poseuses, 1886–88
Oil on canvas
200 x 250 cm (78³/₄ x 98¹/₂ in)
Barnes Foundation, Pennsylvania

THE PAINTING Three nude models undress in different poses in Seurat's studio. Behind them, in what looks like a window, is Seurat's famous park painting *La Grande Jatte* (the second to use his new dot technique called Pointillism). The contrast between the two paintings gives an edgy, unexplained commentary on public and private life. 'Outside' the woman stands on a shadowy circle; the white rug beneath one of the nude models mirrors it. Horizontal lines for Seurat created calmness. Here there are none, just the happiness and sadness of his verticals and diagonals. Using points of pure colour instead of brushstrokes, he created an optical illusion where you need to pull back to focus on the painting. The vibrating but stiff effect of his 'scientific' Impressionism is completely different from the painterly 'romantic' Impressionists.

THE ARTIST In his reaction against the Impressionists, Seurat led those looking for more than a solution to capturing a fleeting impression. From Ingres he took classical form, from Delacroix colour, and from the Impressionists their interest in pure unmixed colour and the problems of perception. To this he added his own interest in science. The result was Pointillism. He broke colours down into dots, before the viewer had a chance to do this automatically in the brain. Pure colours were placed together on the canvas; it was thought that the result would be vibrant and luminous. He died aged thirty-one, from 'overwork'. He was so private that his friends didn't know he had a lover and son.

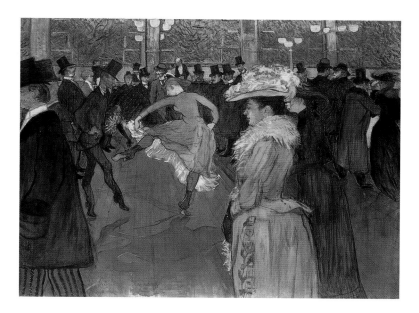

Henri de **Toulouse-Lautrec**

b. Albi 1864; d. Château de Malromé,
nr Langon, Gironde 1901
Dressage des Nouvelles, par Valentin le Désossé, 1890
Oil on canvas
116 x 150 cm (45³/₄ x 59 in)
Philadelphia Museum of Art, Pennsylvania

THE PAINTING The dubious world of the Moulin Rouge was Lautrec's favourite haunt. The famous dancehall in Paris' Montmartre district was a regular for nineteenth-century gentlemen like the Prince of Wales. They openly lived the French brothel lifestyle, dancing and drinking absinthe with prostitutes. A spindly man – Valentin (the boneless wonder) de Désossé, quiet lawyer by day and jigging-fool by night – is dancing with an equally rubber lady in a tipsy, heated dance. They don't care who's there, and the crowd doesn't care to look at them. In the seedy world that Lautrec paints, everyone seems to scuttle about guiltily, pale, cold and intoxicated. Only the bright dress of an unusually refined lady breaks the suffocating atmosphere.

THE ARTIST Lautrec is one of the most interesting characters in late nineteenth-century Paris. Influenced by Degas and Japanese prints, his paintings, posters and lithographs defined the bohemianism of the times. An aristocrat deformed by inherited illness and riding accidents, it was his deformity that made him to feel at home with society's outcasts. His friends were the prostitutes, dancers, actors and generally unorthodox characters that gathered in gaslit Paris nightlife. Living in brothels for weeks at a time, where he would come across his eccentric father the Count, he would paint the girls without sentimentality or moralization, but with the melancholy of the dejected. Detached disillusionment fills his shadowy world, dark but always human. He died of alcoholism and syphilis aged thirty-six.

Vincent **van Gogh**

b. Zundert 1853; d. Auvers-sur-Oise 1890
Dr Gachet, 1890
Oil on canvas
66 x 57 cm (26 x 22^1/$_2$ in)
Private Collection

THE PAINTING Dr Gachet took care of van Gogh at the end of his life, and this portrait of him is one of van Gogh's most powerful and emotive paintings. The whole composition is strong and complex, with the intensity of vivid colour that characterizes his work. He used colour to express his feelings, and here it breaks down into simple, but incredible blocks of colour – rolling calm blues, a shock of red hair, green-leaved bluebells and a red and green tablecloth. The movement in Gachet's slouched position is mirrored in the swirling flicks of paint, which give it a buzzing intensity. His doleful eyes and weary manner seem to confirm his worry for van Gogh, who by this time had been in and out of a mental asylum. An argument with Gauguin ended in a seizure of madness that led van Gogh to sever his ear and give it to a prostitute. Later that year he ended his torments with a bullet to the chest. Van Gogh sold only one painting in his lifetime. When *Dr Gachet* was auctioned in 1990 for $83,000,000 it became the most expensive painting in history, surpassed only in 2004 by a Picasso for $104,000,000.

THE ARTIST Van Gogh's life is more than merely famous, it changed the public view about the artist and the genius. His extreme poverty, visionary belief in his art, eventual madness and suicide have given him iconic status as the tortured artist. Along with Cézanne and Gauguin he is the leader of the Post-Impressionists. He began by working for his uncle's art dealership in London, but was so badly affected by unrequited love for his landlady's daughter that he was fired. After this his life changed. He turned to religion and became a preacher in Belgium and England. Again he was fired for being overzealous. Then in 1880, only eleven years before his death, he suddenly decided that art would be the channel for his passion for humanity. For ten years his brother Theo, an art dealer's assistant, sent him the paint, canvases and money he needed to survive. During a stay with him in Paris, already influenced by the lines and colours of Japanese prints, he met the Impressionists and Seurat and tried out their ideas. They weren't enough for him. The pure force of emotion in colour took over in thick swirls and filled his canvases.

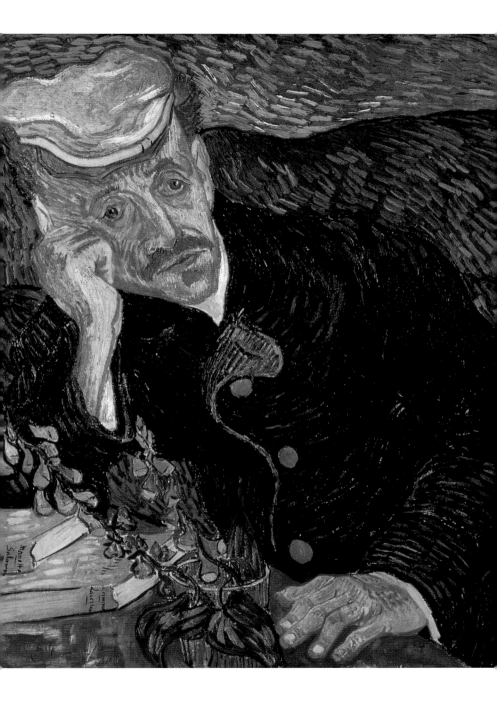

Paul **Gauguin**

b. Paris 1848; d. Dominica, Marquesas Islands 1903
Young Breton Woman, 1889
Oil on canvas
46 x 38 cm (18 x 15 in)
Private Collection

THE PAINTING Through the deeply pallid face of this young girl, Gauguin is silently transmitting his hatred of conventionality. His blocks of unnatural colours don't give any sign of the feelings of life, excitement, wonder or happiness of his later work, when it became free from all European conventions of form, society or religion. This cold blue, 'civilized' subject did not deserve the free explosion of sensuous colour that his naked Tahitians enjoyed in their simple, superior world. The sitter's long drooping chest and shoulders, under that restrictive collar, suggest an unhealthy sort of woman. Her pretty face is dulled and saddened, her hair tied back. She is the opposite of the pert-breasted, smiling, primitive carving behind her with free-flowing hair. She is locked into an unhappy, developed, world. The beautiful natural landscape behind her is shut out, boxing her in like the horizontal lines behind her long vertical body. Gauguin had come to the agricultural region of Brittany in the hope of getting closer to primitive values. It didn't impress him. He left Europe the next year.

THE ARTIST Gauguin was interested in the Impressionists, but soon found their obsession with the fleeting moment to be an artistic dead end. Like Cézanne he was a Post-Impressionist who wanted to paint something deeper and more important. He abandoned his stockbroking career, his wife and his five children, and went to South America and Martinique looking for simplicity. But poverty and disease forced him back to France. Van Gogh invited him to Arles to help start an artists' colony, but the plan fell apart spectacularly when they fought over where the art should come from. Gauguin painted straight from the imagination. Van Gogh, clinging to reality as best he could, wanted to paint what he physically saw but infused with the emotion of his mind. His violent outburst sent Gauguin fleeing back to Paris for safety. From there he left the West for good. His next twelve years in Tahiti, broken by occasional, failed trips to Paris to sell his work, were a time of reflection on the true elements of humanity. Without 'the disease of civilization' he explored primitive representation. However his own disease, syphilis, combined with artistic neglect and extreme poverty, killed him in 1903. His bold blocks of colour and new ways of symbolizing actions and emotions led to Fauvism and Symbolism.

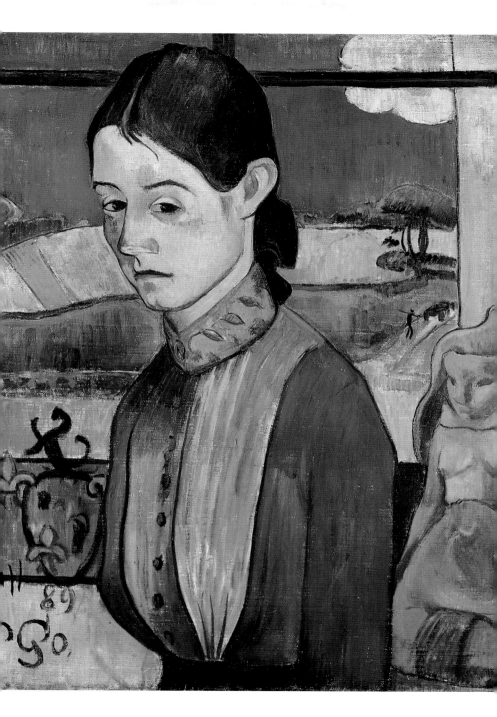

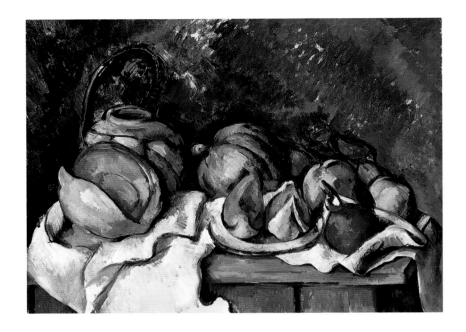

Paul **Cézanne**

b. Aix-en-Provence 1839; d. Aix-en-Provence 1906
Nature Morte aux Fruits et Pot de Gingembre, *c*.1895
Oil on canvas
46 x 61 cm (18 x 24 in)
Private Collection

THE PAINTING Until the Impressionists, still lifes were painted along realistic lines like Zurbarán's. This still life is about 'realizing' (as Cézanne called it) all the three-dimensionality that real things had, into the flat surface of a canvas. He would sit staring at fruit for weeks, using wax fruit when it had rotted, trying to understand it spatially. These fruits do not look like real ones, but they have a solidity and 'reality' far greater than other paintings. Without losing the leaps into colour made by the Impressionists, Cézanne wanted to 'make something solid and enduring'. He does just that with these bold, fervent colours. He doesn't use conventional perspective, but there is great sense of depth and solidity.

THE ARTIST Cézanne is the most central figure in the development of twentieth-century art, but he spent most of his life working alone. He struggled unsuccessfully as an artist until he inherited his father's country estate, when he immersed himself in the structure of painting. The solid form was what he wanted to paint. Impressionism was all about light and surface effects on the eye. Cézanne thought this had no substance, no solidity or depth. It was only in the last ten years of his life that his friend Pissarro convinced him to exhibit in Paris. But his single-minded study had made him an icon to younger artists. His huge importance was only appreciated after his death. The Cubists, Picasso, Matisse, Duchamp and countless others were inspired by him.

Modernism and the Contemporary World:

Munch to Hirst

It is tempting, comforting even, to think that the history of painting is one long and intertwined process of action and reaction. Up until the end of the nineteenth century this was the case, but all that changed. There was no single artist or painting that created the break, it happened in stages. First the Impressionists and then more importantly the Post-Impressionists shifted art's goalposts irrevocably. There was a parting of the ways in painting, between the old and the new. With the advent of photography, painting's descriptive role was taken away, while modern ideas about what painting is, and what it is for, started to form. All the developments in figurative art since Giotto in the fourteenth century were being thrown out of serious painting. The long, continuous history of art was breaking apart and by the end of the nineteenth century naturalism in painting was dead. At the beginning of that century Goya had used painting to record his tormented visions privately, but now artists were using painting to voice their feelings for the public at large. The expressiveness of van Gogh and Gauguin, with their emotional colours and forms, spelt the end of traditional academic art. Gauguin's search for the deeply primitive and van Gogh's spiritual outpourings in paint were the sort of things that painting was concerning itself with now. More was being asked for from art than had ever even been thought of before. Writers of the time, like André Gide and Arthur Rimbaud, were calling for more spiritualism in art. Painters were becoming the public's new preachers, the new poets and philosophers.

The new belief in painting as a vehicle for emotion and ideas was spelled out in the poet Jean Moréas' *Symbolist Manifesto* of 1886, where it said that painting was

there 'to clothe the idea in sensuous form'. Ideas were the point of art now, not technical skill like it had been historically. Munch closed off the century with a painting that summed up this new art. In *The Scream* all the disillusionment and angst of *fin-de-siècle* Europe echoes out from this deeply personal but completely universal statement of panicked torment, simply rendered. Strong Symbolism like this closed the door on naturalistic art for good

From this death of naturalism came an explosion of movements, often pulling in contradictory directions, which explored the new possibilities that an art without limits could throw up. The beginning of the twentieth century was a time of continuous revolutions and diversification in a quest for newness and significance. In 1909 the Italian Futurists called for a total rejection of the past and a glorification of the modern world. Some artists were less confrontational but were just as revolutionary. Matisse and the Fauves attempted to find beauty through harmony of form and colour, unrestrained by historical conventions. They played blocks of vivid, pure colour off against each other to give a vibrancy without the emotional symbolism of van Gogh. It was just the beauty of the forms that concerned them.

At the same time, in Vienna, Klimt was developing the international Art Nouveau style with incredible individuality. He took its flowing sense of beauty and tried to use it to create a style that might bring together the diversity of the new movements into one. Expressive colour and form, as well as figurative representation, were combined in an attempt to reunify painting. But he was a lone voice. Artists were thinking up radical new ways of painting and carrying them through on different paths. Picasso was following on from Cézanne's experiments with three-dimensionality when, along with his friend Georges Braque, he created a new way of painting that was easily the most important leap of the twentieth century – Cubism. By painting his subjects from more than one angle Picasso allowed the viewer to construct the three-dimensionality of his objects by themselves. Volume was reduced to a flat, painted surface. It was a total break from western art practice. The painting no longer had to be a window onto the world. It became a compilation of ingredients upon which the viewer exercises his or her own subjective ideas to create their own mental image.

But not everyone was interested in making representations of real things. Abstract art, like Mondrian's, took figurative representation out of painting altogether. Mondrian was looking to create a painted guide to the underlying reality of the universe. By cutting out any recognizable forms and only allowing himself primary colours and grid patterns he hoped to create the right contemplative prompts to

understand objective reality, beyond the problems of perception and subjectivity. Kandinsky was tackling the same problem, that of underlying reality, and for him abstraction also seemed the way to do it, but with swirls of brilliant colour. They were so emotionally charged that they led directly to the emotionalism of the Abstract Expressionists, Pollock and Rothko in post-war New York. Rothko floated blocks of complementary colour together in regular, calming balance, intended to allow the sensitivities of the viewer to engage with the colours. Pollock, a much more volatile man, thrashed about with streaks of colour on huge sheets of paper, flinging paint in all directions to make something without top or bottom, beginning or end. The way he put paint to canvas was itself the art form; the action of expressively painting was more important than the finished canvas. Action also influenced artists from Fontana, who slashed open his canvases to comment on the nature of space, to Gilbert and George who, as well as making art images, are themselves self-styled living sculptures.

Contemporary art has thrown up countless movements and 'isms', not all of which rest easily within the category of painting in the traditional sense. Richter has merged photography and paint so fully that it becomes meaningless to try to disentangle them, while Hirst's colour spot paintings are rarely even painted by the artist himself. Instead you buy a license from Hirst for one of his assistants to paint his designs for you. Art has overgrown its historic limitations and the definition of painting has expanded along with it. Paint now shares its once dominant position as the medium of expression with other forms, like sculpture, video, sound, photography, installation and performance art, but its horizons have never been more exciting.

Gustav **Klimt**

b. Baumgarten, nr Vienna, 1862; d. Vienna 1918
The Kiss, 1907–08
Oil and gold on canvas
180 x 180 cm (70³/₄ x 70³/₄ in)
Österreichische Gallery, Vienna

THE PAINTING Klimt's *Kiss* is one of the most powerfully painted expressions of Art Nouveau. This life-sized square of flat, textured gold holds one of the most enduringly appealing images of tender eroticism. But the incised gold ground was not his invention. Byzantine in origin (like Cimabue's use of gold), it had been seen in German religious paintings for centuries. With this metallic and unnatural medium, covered in abstract geometric patterns, Klimt has managed to create an overwhelmingly warm and sensual painting. The woman clings to her lover and is literally enveloped by his masculinity. Her delicate features and arching hands are draped over his thick, domineering body. Four abstract blocks of bright colour are defined by gently rolling lines. The middle one is made of his tall, strong, rectangular sectioned cloak, her organic stylized flowers and the swirls of gold behind her. Is it her hair, his cloak or a decorative aura balancing them? We don't know and we don't need to. Klimt hasn't filled this with symbolism. It is a visually stunning piece of decoration. He subtly extends the underlying sexual current by combining the patterns of the woman's dress with those covering the man from the waist down.

THE ARTIST Klimt is the leading painter of the international Art Nouveau movement. Its origins partly lay in the English Arts and Crafts movement, and it sprouted up in different forms all over America and Europe (particularly in France and Belgium), known as Sezessionismus in Vienna Jugendstil in Germany, Stile Liberty in Italy and Modernismo in Spain. The movement's art was based on organic outlines, decorated with stylized flower buds or female motifs, partly inspired by Japanese prints and Celtic design. Klimt was already a successful artist of the old school in Vienna, when he gathered together like-minded artists from their conservative academy to form a new group, the Vienna Sezession (secession). He was president. His favourite theme wasn't just the female nude but her sexuality; female masturbation was the most common theme in his erotic drawings. The first major commission in his new style was attacked as pornographic, and questions were even raised in parliament. This was his decorative cycle for Vienna University, destroyed in World War II. He never got a public commission again, but private commissions kept flooding in. His style was so personal that he had no artistic followers. He did however leave fourteen children – few with the same mother.

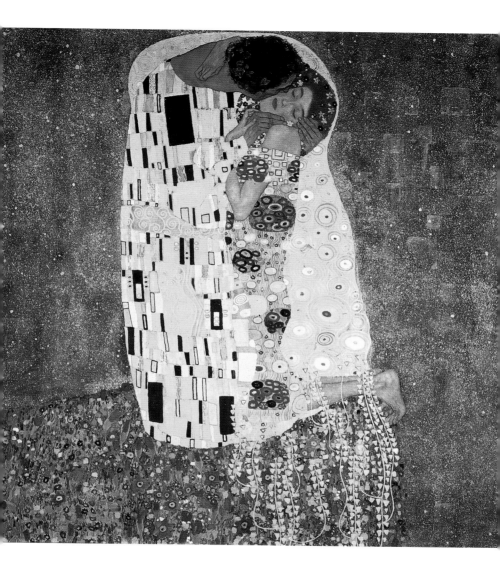

Frederick Childe **Hassam**

b. Dorchester, Massachusetts 1859;
d. East Hampton 1935
Flags, Afternoon on the Avenue, 1917
Oil on canvas
91.5 x 61 cm (36 x 24 in)
Private Collection

THE PAINTING This is one of Hassam's famous series of flag paintings. Fifth Avenue, in New York City, is seen through his misty brushwork. It looks like a typical American celebration, a St Patrick's Day parade maybe. The impressionism of the view gives the scene even more sparkling light and a party atmosphere. Monet had painted a flag-decked Parisian festival in 1878, and when Hassam was in Paris in 1911 he painted the Bastille Day celebrations. Both paintings brought him closer to this one. But this is not a celebration. Painted the year America joined World War I, this painting was all about patriotic encouragement. When Hassam painted this from his window in 1917 the street was being called the Avenue of the Allies, with all the flags of the USA, Britain, Italy and others fluttering down the ravine-like Manhattan street. Anglo-American patriotism is on show, out of the windows and on the roofs of the skyline. It is a balmy New York day humming with life, but under the flags of war. The cityscape is strongly structural, closer to Pissarro than any of the other French Impressionists. While Hassam's firm vertical composition gives it an underlying strength and purpose, the buzz of activity in the streets below gives a certain human hope. That hope is also hinted at by the mellow opal sky opening up down the street. It focuses our gaze through the noise and upward to peace.

THE ARTIST The Bostonian Hassam is the leading figure of American Impressionism. He came to the movement long after others had pushed the boundaries out into neo-Impressionism and Post-Impressionism, but his expression of light and air continued to have a huge following in North America. His early American pictures were street scenes, where the tonal differences between areas are emphasized to give atmosphere. Travelling throughout England and France, he finally settled in Paris with his wife in 1886, where his paintings came closer to the Impressionists, especially the work of Monet. As he developed into an Impressionist style he kept his earlier, solid human figures, usually in strongly laid-out streets or urban settings. It is these remnants of solidity that single him out from European Impressionists and helped to give American Impressionism a more solid feel. He didn't like to call himself an Impressionist; he preferred to be seen as a simple painter of 'light and air'.

Modernism and the Contemporary World

Henri **Matisse**

b. Picardy 1869; d. Nice 1954
Harmonie Jaune, 1927–28
Oil on canvas
88 x 88 cm (34^1/$_2$ x 34^1/$_2$ in)
Private Collection

THE PAINTING Matisse has made a space of completely unnatural colours and content. He has no interest in showing us a room with a girl and a table in it. It is the colour and the design that matter here. Unlike Cézanne, who was desperately trying to re-create real space in the canvas, Matisse was interested in the value and qualities of pure colour and line on his canvas. The chessboard is defiantly two-dimensional; he's deliberately showing contempt for the old systems of representation. The colours are as fantastically lurid as possible, and the patterned wall is like an eastern carpet, magnified and luminous. The girl on the couch is dressed in black, but with fluorescent yellow outlines harmonizing her with the wall and table. Matisse's choice of colours and forms is independent of any real things that might have been used as props in his studio. The painting is not representational of anything other than the harmony and beauty of the design. There are no symbolic meanings hiding anywhere to distract you from the brilliant colours and overall design. Matisse wanted art to 'comfort the soul, something like a good armchair'.

THE ARTIST Along with Picasso, Matisse stood as one of the twentieth century's giants who redefined the language of painting. Having given up his law job, he started painting while recuperating from an operation. Within a few years he was in Paris, painting first as an Impressionist and then as a post-impressionistic Pointillist. But by 1905 he had become the leader of a group of artists who were doing something brand new. Taking inspiration from the vivid colours of van Gogh and Gauguin, the group developed ideas of colour for its own sake. They held an exhibition, which was attacked by one critic as 'an orgy of pure colour'; he called the group a bunch of Fauves (wild beasts). The term of abuse stuck. Matisse was breaking away from colour signifying anything other than itself. It wasn't emotionally charged or weakly imitating real life. But as rebellious as his 'wild beast' tag seems, Matisse was strangely conservative and homely. It is true that he slept with most of his models, but he was keen to be seen as a family man. During World War II he carried on painting in unoccupied Nice, finally taking his views on pure colour to an almost abstract level by using cut-outs of coloured paper.

Marc **Chagall**

b. Vitebsk 1887; d. Saint-Paul-de-Vence 1985
Above the Town, 1915
Oil on board
48.5 x 70.5 cm (19 x 27³/₄ in)
Private Collection

THE PAINTING In this dreamworld two lovers soar through the sky, high over the little town below. Their happiness has taken them out of reality and up above everyone else. It is a simple, almost child-like, image of love. Chagall ignores the Cubist and Abstract art that he knew in France and Russia, and expresses his eternal theme of love in a folksy and simplistic way. He wanted to use uncomplicated colour and design to express his memories, his mystical world of childhood. As a Jewish Belarussian, he is painting his cultural roots of fairy tales and story-telling. The ramshackle wooden town is tidy and ordered, respectable but poor, and the couple are just as respectable. From the full-length skirt to the buttoned-up shirts, these lovers don't hint at sex. His hand is over her breast but there is no eroticism, nothing to draw us out of the child-like innocence of fantasy. It is simple, honest and colourful, and it sentimentally captures his joy. Chagall had been seeing Bella Rosenfeld, whose family disapproved of his lowly background and odd job. The year he painted this he had finally married her, and here they are, floating away on love.

THE ARTIST With his cheerful, emotionally colourful and folksy paintings, Chagall has become one of the most popular artists of the century. Born one of eight children in a poor Jewish family in Belarus, his artistic development and early life mirrored the turbulent times he lived in. He moved to St Petersburg to study with various teachers, so poor that he was sharing rooms and even beds with strangers. After four years in Paris he developed his style in the community of expatriate artists, like Foujita from Japan, called the École de Paris. His colourful and dreamy figurative paintings had a poetic expressionism that went down very well in Germany. His 1914 one-man show there was a huge success, and he returned home to visit Bella a famous man. But World War I broke out, trapping him in Russia for eight years. Under the Bolshevik government he set up an art school, but intolerance was becoming official. Only Constructivism was seen as an appropriate art form to serve the state, so he fled to France. In 1937 he got French citizenship, but by 1940 the Nazis had taken over the country. As a Jew his citizenship was revoked, so he fled again, to America.

Vasily **Kandinsky**

b. Moscow 1866; d. Neuilly-sur-Seine 1944
Angel of the Last Judgement, 1911
Oil on paper on panel
64.7 x 50.5 cm (25½ x 20 in)
Private Collection

THE PAINTING This is a swirling, stained-glass like painting of acid strong colours. The prompt in this picture is the hint of angel wings, ascending in a vortex of light and colour. Full of emotional colour and non-meaningful form, it is the start of Abstract Expressionism. In 1908 Kandinsky had a life-changing moment. He caught a glimpse of a painting that he thought was 'of indescribable beauty, imbued with an inner flame'. He saw 'only forms and colours whose meaning was incomprehensible'. He then realized it was one of his own, turned upside down. Kandinsky was interested in expressing spirituality, and felt that subjects were ruining his art. Painting without a subject brought him closer to a 'pure' form of expression. In 1911, the year he painted this, he founded the Blaue Reiter group. This painting is the expression of their non-figurative and spiritual views. His instinct was for brilliant colour, and here he uses it not just to fill in the areas of his design, but actually to be the design. Like Picasso's Cubism, Kandinsky was freeing the painting from the confines of representing anything. This painting is autonomous from the artist. Our emotional response to it is its meaning, rather than anything actually painted.

THE ARTIST Kandinsky is the central figure of Abstract art, and led to the Abstract Expressionism of Pollock and Rothko in America. He was a successful lawyer who couldn't bring himself to quit to become a painter until he was thirty. But after seeing one of Monet's pictures, and also being struck by the folklore and 'vivid, primitive' colours of the Russian peasantry, he moved to Munich to study art. After eight years of teaching and studying in Dresden, Venice, Paris and Moscow, he turned to Abstract art. Fauve-like bright colour and line were all he wanted to use to express his inner, spiritual self. He believed that representational art was just a diversion from painting the true emotions that art should be about. He was the central figure in the Blaue Reiter group, formed to express the 'pure' art of 'inner and essential' feelings. After working under the Soviet government he realized that state-sponsored socialist art was limited, and like Chagall he left. He took up a post in the influential Bauhaus School in Germany until the Nazis closed it down as degenerate. In 1933 he left Nazi Germany and worked in Paris.

Gino **Severini**

b. Cortona 1883; d. Paris 1966
*Simultanéité de Groupes Centrifuges
et Centripètes (donna alla finestra)*, 1914
Oil on canvas
106 x 88.2 cm (41³/₄ x 34³/₄ in)
Private Collection

THE PAINTING This cracked, intertwined arrangement of colours looks like it could be under the influence of Kandinsky's Abstract Expressionism. But Severini was doing something very different from the emotional reflections of that group. When the Italian poet Marinetti wrote his Futurist Manifesto in 1909 he was trying to incite a revolution. He called for a total rejection of the past (the reverence for the classical art of Italy in particular), saying things like 'Burn the museums! Drain the canals of Venice!'. Movement, speed and everything urban and mechanical were to be revered now. Severini painted this image as a reflection of the most famous phrase of the Futurists – 'a racing car is more beautiful than the *Victory of Samothrace*'. The greatest classical statue was no longer the summit of civilization. Mechanical speed was more beautiful. Severini has taken the multi-dimensional ideas of Cubism and translated them into the Futurist love of motion. The broken perspective is a perfect vehicle for the ideas of dynamic speed. This is the fast movement of a centrifuge machine pushing and pulling. It shows the beauty of the modern world with no reference to anything but modernity.

THE ARTIST Severini was part of a wave of pre-World War I Italian artists, like Giacomo Balla and Umberto Boccioni, who brought the revolution of Futurism to the attention of the world. He was born into a poor family in Tuscany. With no proper school nearby he was sent to live with his grandfather. Aged fifteen he was expelled, not just from the school but also from the entire Italian school system, for stealing exam papers. Penniless, he moved to Rome and got clerical jobs while studying art in the evenings. He managed to convince a Vatican official, whose family were the local nobles from his birthplace in Tuscany, to sponsor him to study art for two years. By appealing to the Renaissance spirit of enlightened patronage he became an artist, but went on to reject everything that cultural heritage had given him. He quickly gained a reputation as a revolutionary. By 1906 he was in the centre of the art world, Paris, where he befriended the Cubists who influenced his emerging Futurist style. Like Picasso he was drawn away from the avant-garde and back to classicism by the 1920s. This brought him official commissions from Mussolini's government, wanting to re-create past glories for fascism.

Ernst Ludwig **Kirchner**

b. Aschaffenburg 1880; d. Frauenkirch 1938
Strassenszene (Street Scene), 1913
Oil on canvas
70 x 48 cm (27¹/₂ x 19 in)
Private Collection

THE PAINTING This street scene is one of Kirchner's most toxic. It was painted during the high point of his career in 1913, when the streets of Berlin represented everything that he found smothering, alienating and de-individualizing. The intense claustrophobia of the individual in an increasingly systematized world found an outlet in the Expressionism of Munch's *Scream*. Kirchner's picture was painted twenty years later, a direct heir to Munch's art, but for a world that had become even more tense, crowded, and impenetrable to the needs of the individual. Kirchner used intensely unnatural colours and distorted figures to express the alienation of man in his environment. The nervousness of the brushwork gives the feeling of anxious tension in a city only months away from the brink of the most catastrophic war Europe had ever seen. In this crowded street there is no sense of depth. The two prostitutes stare blankly out, waiting for their anonymous clients. In man's new world the most fundamental exchange of life is reduced to a hollow function of machines. Everything is cold and impersonal, anxious and claustrophobic. The 'wild beast' colours that the Fauves used in the service of beauty are used here by Kirchner to isolate us in this sick and lonely world.

THE ARTIST Kirchner is one of the most important Expressionists, but his life is one of the most tragic in twentieth-century art. In 1905 he graduated as an architect, founded the art group Die Brücke (the bridge), and left architecture behind. The name of the group represented their ambition to be the link between art of the past and great art of the future. The colour and lines of van Gogh and the Fauves, and the expressionism of Gauguin and Munch, had influenced him and the group. He wanted to express his feelings with colour, like Kandinsky, but through figurative painting. For the next six years he painted in Dresden, so poor he lived in an unfurnished old butcher's shop. Success came quickly when he moved to Berlin, culminating in his street paintings, a high point of German Expressionism. Unfortunately he was drafted into World War I the next year, then hit by a car. Both experiences left him dependent on drugs and led to his breakdown. When the Nazis included his work in their Degenerate art exhibition in 1937 it proved too much for him, and he shot himself.

Piet **Mondrian**

b. Amersfoort 1872; d. New York 1944
Composition in White, Blue and Yellow: C, 1936
Oil on canvas
70.5 x 68.5 cm (27¹/₄ x 27 in)
Private Collection

THE PAINTING Stripped of everything representational, *Composition in White, Blue and Yellow: C* provides us with a blueprint for the eternal laws of the universe, or so the theory goes. Mondrian developed this exceptionally harsh system of painting over many years of paring down the natural, symbolic, or anything that was in any way representational. The only pictorial language he ended up using consisted of the three primary colours (blue, yellow and red) and the non-colours (white, black and grey). These could only be arranged in strict verticals and horizontals, allowing for rectangular shapes but nothing else, including curves. This choice was idiosyncratic. He left the De Stijl movement, which he had founded with Theo van Doesburg, on a matter of principle – that there should be no diagonal lines. This canvas has no recognizable subject. To Mondrian the material things in the world are in a continual state of change. He wanted his art to capture the essential, constant and pure reality that exists behind everything, invisible to us. This metaphysical belief united Mondrian's ideas of mysticism with his strict, ascetic Calvinist youth. This painting is a prompt to consider what he called 'pure, constant reality'.

THE ARTIST Mondrian is one of the most important figures in Abstract art, but he spent almost his entire life in poverty. Born into a Calvinist family, he spent his early life trying to free himself from his domineering parents. After very slow progress as a figurative artist in the Netherlands, he moved to Paris aged forty-one. There he developed his own variation on Cubism. Everything stopped for World War II, and he went back to Holland. This proved to be his turning point. He met Theo van Doesburg and together they formed the *De Stijl* magazine, which was concerned with discovering the 'laws of universal equilibrium' that would reshape the society of the future. At the time, Abstract, Constructivist and Bauhaus artists shared the De Stijl view that a utopia was going to develop and that they needed to define the arts and crafts most suited to the people. Art and society seemed to be on the threshold of fundamental change. Technology equalled progress. Utopian beliefs like communism were common everywhere, and to the deeply religious and mystical Mondrian it seemed that art, spirituality and social progress could be brought together. His paintings point the way to this eternal, harmonious order.

Marcel **Duchamp**

b. Blainville 1887; d. Neuilly-sur-Seine 1968
The Bride Stripped Bare by Her Bachelors, Even, 1915–23
Oil on lead foil between glass
277.5 x 175.6 cm (109¼ x 69 in)
Philadelphia Museum of Art, Pennsylvania

THE PAINTING More than a painting, this is one of the twentieth century's greatest art enigmas. After eleven years work Duchamp abandoned it, unfinished. It was only when it was accidentally smashed that he declared his masterpiece complete. When you view the paint between the two sheets of glass, the world you can see through the glass, together with your reflection, becomes part of the work. In this way it is always changing – it is only in photographs that it becomes a static 'painting'. It is obsessively erotic and sexual, typical of Duchamp. In his notes he describes the upper section as the bride, whose desire for the nine bachelors below swells their 'malic' (male, phallic) bodies with 'illuminating gas'. This creates the trickle of an imaginary waterfall that powers their machine, in turn spinning the 'chocolate grinder' in the centre. It is a bio-mechanical sex machine, in a male/female world separated into two sections. The immobile machine hints at a perpetual lack of fulfilment. Is it just there to confuse? Duchamp said, 'There is no solution, because there is no problem'. This ever-changing work set in motion an endless series of questions and thoughts.

THE ARTIST A leader of Dadaism, Duchamp was a stimulating intellectual. He redefined art as thought, not craft. The Dadaists wanted to take art out of its lofty ivory tower, imprisoned there by the middle classes. This was to be done by destroying the pretentious assumptions that hemmed it in, such as skilled craft, market values, individual genius or traditional beauty. Duchamp's ready-mades did all this and more. His 1917 ready-made sculpture, *Fountain*, was an industrially manufactured urinal that he had signed. The craft of traditional art was swept away in one move, and replaced by the idea. Duchamp had chosen what he wanted to use and for us to think about. It didn't matter who actually made the object, Duchamp was the one who gave it its artistic definition. He created it as an artwork. Duchamp rarely made works. His last took twenty years to complete and was done in secret. He spent most of his life between New York and Paris, playing chess – he was one of France's best players. It dominated his life so much that after a week of marriage, his new wife glued his chess pieces to the board and divorced him. He was a huge influence on Conceptual, Minimal, Pop, Kinetic and Surrealist art.

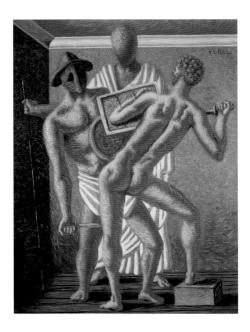

Giorgio **de Chirico**

b. Vólos 1888; d. Rome 1978
Gladiatori, 1928
Oil on canvas
130 x 97 cm (51¹/₄ x 38¹/₄ in)
Private Collection

THE PAINTING Two gladiators with little shields and daggers are fighting with what looks like a philosopher/judge behind them. Or are they standing, frozen in action like posing models? Perspective in the room is disjointed, and the faceless figures all have unnatural bodies. The two fighters are arching away from each other on impossible legs. It is not a real scene, but neither is it quite a surreal one. The philosopher Nietzsche had strengthened de Chirico's beliefs in a parallel reality, more true and eternal than the weak, changing one we live in. Here he uses these unreal symbols of the Greek myths and memories of his childhood to incite the feelings that might bring us closer to this other reality.

THE ARTIST From his wartime hospital bed, where he was recovering from a breakdown, de Chirico came up with the name Metaphysical painting for his visions of a deeper reality. Born into an Italian family in Greece, the memories of an ancient and mysterious world fuelled his thoughts. Aged eighteen he moved to Munich to study art, and was influenced away from naturalistic representations by Symbolism. He tried to pare down visual reality to exclude as many unwanted associations as possible, without becoming abstract. He was defining this 'real' reality like Mondrian was doing in the Netherlands. Humans became faceless tailors' dummies and common things were put in uncommon places. This was to provoke thoughts about the nature of the reality of the things themselves.

Modernism and the Contemporary World

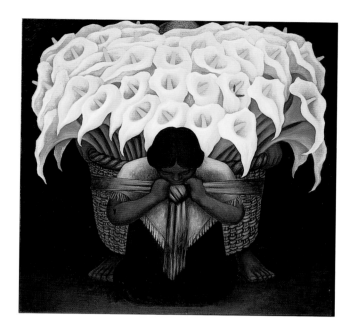

Diego **Rivera**

b. Guanajuato 1886; d. Mexico City 1957
The Flower Seller, 1942
Oil on masonite
122 x 122 cm (48 x 48 in)
Private Collection

THE PAINTING The enormous basket of gigantic yellow flowers is like a silently exploding volcano of colour over the woman's head. The deep contrast of the black background and the brilliant yellows of the natural, simple flowers heightens their beauty and draws attention to them as a bounty of nature. The native Indian woman is the epitome of the good honest worker, with head down, carrying the earth's natural products to sell. Behind her, for comic effect, are the hands, feet and balding head of her husband. A visually vibrant and exciting thing to look at, it is also there to glorify the working classes. Rivera was a lifelong communist, and his painting is a glorification of workers everywhere.

THE ARTIST Rivera was the leader of the Mexican Muralists, the first major movement in modern art that started outside Europe. From a liberal family in a Mexican silver mining town, he was a natural socialist. Aged sixteen he was thrown out of art school for starting a student strike. With a scholarship to Spain he travelled around Europe's art capitals. A giant man, his affairs and illegitimate children made him a larger-than-life character in Parisian art circles. Returning to Mexico he had a huge impact, both there and in the USA. At New York's Museum of Modern Art (MOMA), his one-man show broke attendance records. His rise in communist circles led to his wife having an affair with Trotsky, and Rivera being investigated for Trotsky's assassination in Mexico City.

Salvador **Dalí**

b. Figueres 1904; d. Figueres 1989
Assumpta Corpuscularia Lapislazulina, 1952
Oil on canvas
230 x 144 cm (90^{1}/$_{2}$ x 56^{3}/$_{4}$ in)
Private Collection

THE PAINTING This larger than life painting is one of Dalí's 'hand-painted dream photographs'. With some deference to the Madonnas of his countryman Murillo, Dalí has created a real devotional image for the modern world in this Ascension of the Virgin. Despite Dalí's famous irregularities, he was a practicing Catholic, from his Christian Brother schooldays to his church marriage a few years after this was painted. In the best traditions of Surrealism the Virgin's flowing drapery whips around the sky, while she is invisible except for her bust-like head and hands. Her twentieth-century head, looking like his future wife Gala, is at the centre of a lapis blue sky, radiating out like a disco ball. There is an altar over her 'life-giving' organs. Above is a real, shadow-casting Christ in three-dimensional relief, his hands nailed to her breasts. The horizon, yellow sky and blue disco heaven disjointedly hold up this 'real' Christ. Dalí's Surrealism is an attempt to bring together the conscious mind (what we think is real), and the unconscious mind of what we assume isn't real. Freud's psychoanalytical theories underpin Surrealist work, giving rise to Dalí's famous drooping clocks being dream images of his fear of impotence.

THE ARTIST Dalí is the most famous member of the Surrealists, but he courted so much controversy they expelled him. Born in Spain, the attention-seeking boy went to Madrid's Academy of Fine Arts in 1921. Bored by its slow pace he was thrown out twice, the second time for telling his examination committee they were too stupid to grade him. After being imprisoned for his part in an anarchist demonstration, success came fast. By 1929 he had naturally developed through Cubism, Futurism and Metaphysical painting into a Surrealist. His eccentric dress and manners were getting attention. A born showman, he famously delivered a speech wearing an old-fashioned diving suit. The mask jammed and he almost suffocated. Publicity stunts were guaranteeing him fame and fortune. When a shop window that he designed was changed without his consent, he angrily went in and came smashing out through the window riding a bathtub from the display. The media loved him. Gala, the woman who later became his wife and manager, organized his production into a moneymaking machine and the little fisherman's hut they bought together was built up over the years into a fantasy castle. After her death Dalí became one of the world's most famous recluses.

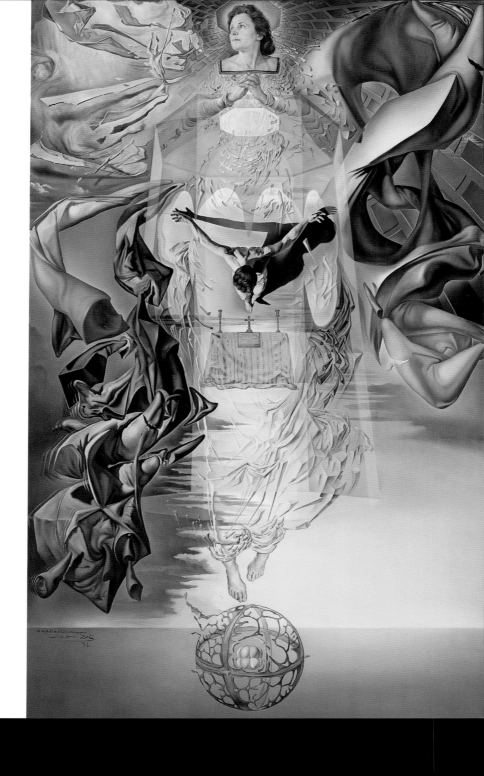

René **Magritte**

b. Lessines Hainaut 1898;
d. Schaerbeek, Brussels 1967
The Son of Man, 1964
Oil on canvas
116 x 89 cm (45³/₄ x 35 in)
Private Collection

THE PAINTING Magritte's bowler-hatted man is one of the most recognizable images of twentieth-century art. The most banal character who filled the streets of bourgeois Brussels in the middle of the century, he is Magritte's everyman. But it is also Magritte himself, a self-portrait of an artist who despite huge popularity, second only to Dalí's in the Surrealist movement, was as outwardly boring and conventional as this. But what are the apple and the title 'The Son of Man' supposed to mean? Magritte only used the barest of accurately painted details in his pictures, like in this life-sized one. It is this economy and his jokey word play that have made him so memorable and popular. Instead of looking for shocking incongruities between imagery like other Surrealists, Magritte found hidden affinities and played them off each other. The apple is the symbol of man's fall from grace. All the other associations that might come from the image and the title spring from here – man's vision is obscured by his original corruption by the apple, leading to a sense of the limitations of humanity. The grandeur of creation and the sky are pitched against the humdrum ordinariness of the bowler-hatted man.

THE ARTIST Magritte created some of the most idiosyncratic and memorable imagery of Surrealism. Born in Belgium, he was thirteen when his mother drowned herself. It was around this time that he started to see painting as an almost magical activity. He convinced his father to let him study art, but it wasn't until he first saw the metaphysical paintings of de Chirico that he knew painting was his calling. Through Cubism and Futurism he developed his Surrealist style and subjects, and kept with them all his life. He only deviated from his meticulous realism during World War II. When the Nazis occupied Belgium he said he could no longer paint in the same way. The war made him feel that charm mattered more than the anxiety he had been painting. His calm, edgily dull manner shifted toward an impressionistic, Renoir-type of painting. His admirers were shocked, but he replied, 'I live in a very disagreeable world, and my work is meant as a counter-offensive'. But the public, and his wife, preferred the sturdier style that suited his deadpan humour. He returned to his style of unforced illogicality, and stayed with it until the end.

Modernism and the Contemporary World

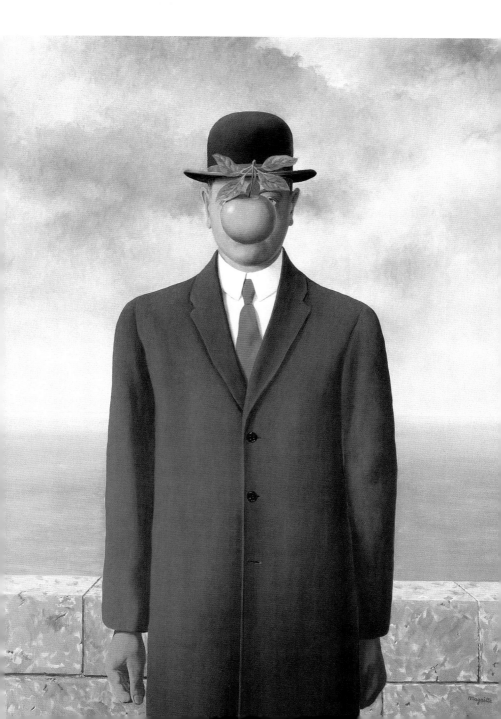

Francis **Bacon**

b. Dublin, 1909; d. Madrid 1992
Portrait of George Dyer Talking, 1966
Oil on canvas
198 x 147 cm (78 x 58 in)
Private Collection

THE PAINTING George Dyer had been Bacon's lover for two years when this was painted. Dyer's naked body is almost slug-like, writhing and contorted on his chair. His flesh is flushed with red, or coolly reflects light against its seemingly wet surface. The limbs have no beginning and no end, no hands or feet. He's just a swirling mass of meat with a craning head wanting our attention. It seems as if he is tied to the chair, bound and gagged, under a bare light bulb. His body is exploding with a message that he is just not getting out. There is a violent tension. Papers fly across the blood-red floor and the light string swings against the purple wall. As inquisitor or as uneasy spectator we are in this harsh cylindrical room with him. It arcs around us too, we have to watch Dyer's painful animalistic struggle in front of us. Bacon was affected by the existentialist thinkers like Jean-Paul Sartre, for whom real communication between individuals was impossible. Despite the closeness of their relationship, Dyer and Bacon are as eternally separated, as humanity must be. This theme is recurrent in Bacon's work. Ultimately we are just chunks of meat containing tragically isolated souls.

THE ARTIST Bacon is thought by many to be the most important figurative painter of the twentieth century. Born into an Anglo-Irish family in Dublin, he was descended from the seventeenth-century philosopher, scientist and statesman Sir Francis Bacon. Sandbagged into his grandmother's house against IRA attack in the early 1920s, he rarely managed to attend school. At fourteen he left Ireland for good, going first to London and then the hedonistic Berlin of the late 1920s. It was the beginning of a legendary life of rampant homosexuality, gambling and alcohol binges. By 1945 he was painting full-time, and exhibited *Three Studies for Figures at the Base of a Crucifixion*. It made him the most controversial painter in Europe. The style and concerns that continued throughout his career were already evident, including his single figures caught in moments of high despair or isolation, often looking like putrid carcasses or slugs, and his twisted faces and ill-defined bodies made of meat rather than living flesh. Ideas of human isolation and universal pointlessness pervade these figures. His unnervingly unambiguous paintings of this human dilemma, his 'game without reason', made him one of the most discussed painters.

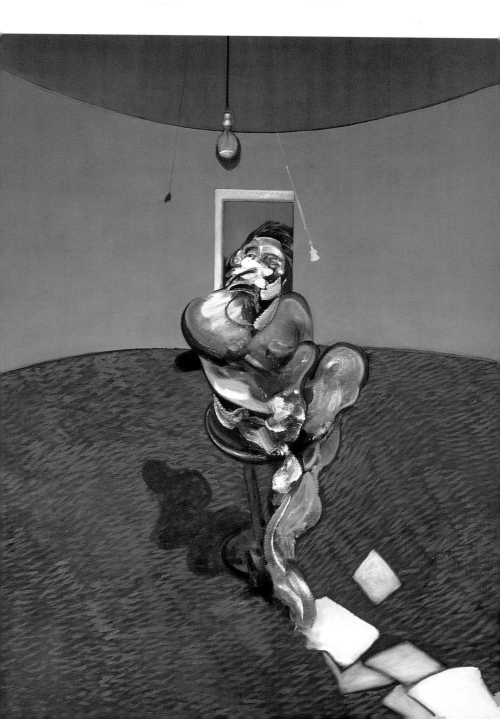

Jackson **Pollock**

b. Cody 1912; d. East Hampton 1956
Number 22, 1949
Oil on paper
70.8 x 58 cm (28 x 23 in)
Private Collection

THE PAINTING 'I want to express my feelings, not illustrate them'. Pollock's words show that it was the act of painting, the expression of his creative instinct, which was the artwork. The painting is almost a by-product, so all forms of representation are irrelevant. *Number 22* is a record of Pollock's action when he flung strips of paint at the paper; it's the pure and abstract expression of his mind. Its roots are with the Surrealists, who wanted to paint the contents of the subconscious mind. Pollock followed this idea through. He said that when he was 'inside' his paintings he didn't know what he was doing. The act of creating the paintings was a form of release of his subconscious in paint. He swirled, flung, dripped and pushed household paint around with sticks, knives or anything that he felt like. Small-scale easel painting didn't suffice for his violent actions, so here he has used paper laid on the floor, coming at it from all directions so that the painting no longer has any traditional beginning or end, no points of compositional reference. The thick colours and forms of the paint are all that Pollock used, forcing the viewers to create their own meanings.

THE ARTIST Pollock is seen as the most important and influential painter of the mid-twentieth century. He was the leader of American Abstract Expressionism and the country's most significant painter. He consciously broke all the links with art of the past and opened up a whole new direction for painting. Born in a Midwest town named after Buffalo Bill Cody, he grew up travelling between California and Arizona and liked to play up to his image as a hard-drinking, macho cowboy. But by the time he was twenty-eight he was living in New York, working under the influence of the Surrealists, Picasso and the Mexican Muralists. When his 'action paintings' became known, he was thrown into the limelight as the first superstar of American art. His work between 1947 and 1952 revolutionized painting. He became the archetype of the new twentieth-century artist, wild, drunk, and creating art that was seemingly brilliant but totally impenetrable to a mass American audience that was used to representational imagery. Travelling home one night in Long Island, drunk with his mistress, Pollock drove off the road and into the trees, killing himself instantly.

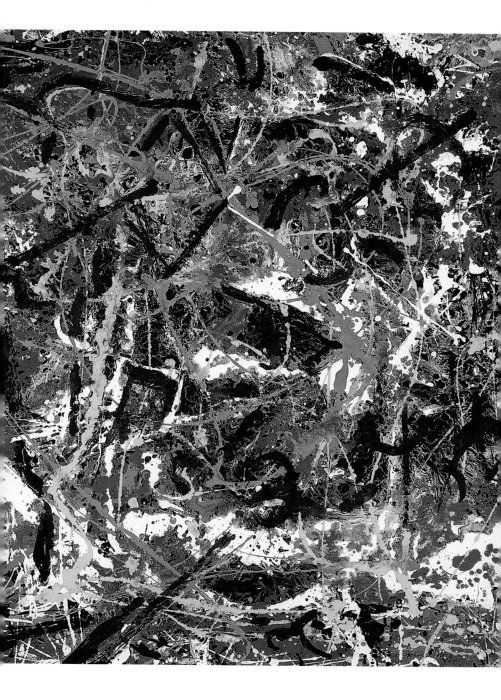

Mark **Rothko**

b. Dvinsk 1903; d. New York 1970
Brown and Black in Reds, 1957
Oil on canvas
231 x 152.4 cm (91 x 60 in)
Private Collection

THE PAINTING This huge canvas with floating blocks of colour melting together is not an abstract painting. Rothko said, 'I'm not an abstract artist...I'm not interested in the relationship of colour or form or anything else. I'm interested only in expressing basic human emotions'. Mondrian had claimed to be painting a deeper, truer reality with his abstract grids of limited colour. With all the pictures of his mature period, like this one, Rothko was making a claim to painting the deepest emotional reality, within himself and the viewer, instigating those deepest eternal feelings of tragedy, doom, ecstasy, love and pain through his expressionist colour. As time and Rothko's terminal depression progressed, so his colours got deeper, darker and more malevolent. These fiery reds blend into dried browns and a gritty charcoal black, hovering together in a hazy balance of luminous colour, as dark blocks hanging in space. Its imposing size is intended to envelop the viewer, to help them to have an immediate connection with the picture. As Rothko said, 'The people who weep before my pictures are having the same religious experience as I had when I painted them'.

THE ARTIST Rothko is one of the most important figures in Abstract Expressionism, but lived almost his entire working life in poverty and severe depression, before slashing his veins in his studio aged sixty-seven. Born into a poor Jewish Russian family, he moved to America when he was ten. His father died almost as soon as they got there, so he had to work to educate himself. After losing his scholarship to Yale (possibly through anti-Semitic feeling within the university), he abandoned being taught, for teaching. He instructed at art classes for thirty years, during which time he had a failed marriage and started drinking. His own feelings of artistic self-worth became clear when success finally came his way with Abstract Expressionist works like this one, started in 1947. Refusing to sell his works to a gallery he called a 'junk shop', his difficult character alienated him from other artists like Pollock and from some curators. His second marriage degenerated into continual drunken brawling, and in the final year of his life, addicted to alcohol and anti-depressants, he painted his darkest pictures: blacks on greys, reflecting the last depths of his suicidal mind.

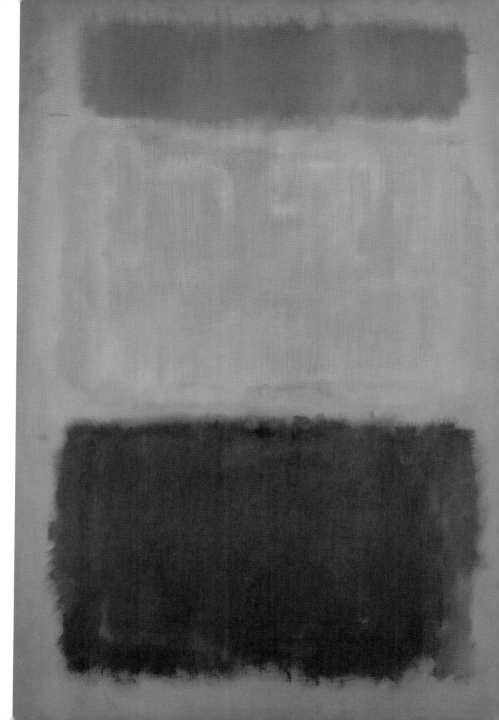

Jean **Dubuffet**

b. Le Havre 1901; d. Paris 1985
Pese Cheveu, 1962
Oil on canvas
193 x 149 cm (76 x 58³/4 in)
Private Collection

THE PAINTING In this picture Dubuffet stripped out every artistic convention and every cultural norm of beauty, taste or decorum. It is a vivid colour blur of faces, people, graffiti and movement, representing the most pared down artistic response to his surroundings. He has simplified everything down to its most essential, instinctual elements. With something like the anti-history views of the Futurists and the Dadaists, as well as the expressionism of the Abstract Expressionists and the Art Informel movement, Dubuffet rejected everything that could not be made by the 'common man'. He saw the art establishment and culture as a stifling influence on natural creativity. This painting is as close to a reflection of his culture-free self as he could get, and is painted with a non-intellectual and non-art culture primitivism. The graffiti here is another facet of this kind of pure, uncomplicated expression. In wartime Paris Dubuffet was struck by the expressions of resistance and anger focused against the Germans that were being daubed around the city. These sorts of free outbursts, uncomplicated by convention or social context, had the Art Brut spirit that he wanted in his paintings.

THE ARTIST He only turned to art full time at the age of forty-four, but Dubuffet's naturally rebellious temperament had a lasting effect on twentieth-century art and culture. His rejection of authority ultimately led to his anti-culturalism and primitivism. Born into a rich wine merchant family, he left his father's overbearing household to study art in Paris. But his rebellion from the bourgeoisie to the art community wasn't all that he hoped. It seemed to him that artists, poor or not, were treated as a privileged class. So he took off to Argentina to work with 'the common man' in a factory. He was soon back, working for his father and married to a suitable bourgeois girl – but it wasn't the life he had been looking for. He divorced and tried again to paint. Duty in World War II intervened but he was quickly imprisoned for not saluting his officers. By 1942 he had thrown himself into art fully. He gathered a huge collection of images made by the mentally ill and by children, people who were expressing themselves outside the norms of culture, 'springing from pure invention'. He called it Art Brut, and took its naturalness as his inspiration for a hugely productive career that went on to influence twentieth-century anti-historicism.

Tsugouhara **Foujita**

b. Tokyo 1886; d. Zurich 1968
Young Girl in the Park, 1957
Oil on canvas
50.8 x 65.4 cm (20 x 25³/₄ in)
Private Collection

THE PAINTING Using the fine, black ink outline drawing of the Japanese tradition, Foujita has painted a slightly unnerving image. He seems to waver between the saccharine innocence and prettiness of the girl, and an eerie weirdness. It seems very nostalgic and sweet, with the happiness of the park-goers clear in the background. But the sophisticated stare of the girl, with oddly gnarled fingers, might suggest something more. She is standing in the centre of the rose bush, within the railings, and holding a cat with a demented and twisted expression. Nabokov had published his incredibly successful novel of child love, *Lolita*, two years earlier. The picture's delicate style is completely individual, combining Japanese and French influences.

THE ARTIST Foujita was the most successful Japanese artist in Europe since Hokusai. His linear art came straight from the Chinese and Japanese traditions, but his subjects were mostly western; this cultural dichotomy affected Foujita's whole life. After graduating from the Tokyo School of Fine Arts in 1910 he moved to France in 1913 where, like his friends Rivera and Chagall, he was part of the expatriate community of artists in France called the École de Paris. He returned to Japan in 1933 where he ended up seeing out World War II as a painter of war zones in South-East Asia. By 1950 he was back in Paris, taking up French nationality and converting to Catholicism. He spent the remainder of his life decorating a Catholic chapel he had built in Reims.

Sir Sidney **Nolan**

b. Melbourne 1917; d. London 1992
Ned Kelly, 1955
Oil on board
77.5 x 63.5 cm (30¹/₂ x 25 in)
Private Collection

THE PAINTING Ned Kelly was a notorious nineteenth-century Irish-Australian outlaw of the bush. His fame spread throughout the country until he became something of a folk hero. The iron mask was part of his home-made armour, to protect him in many shoot-outs with the law. Nolan did two series of Ned Kelly paintings, in the 1940s and 1950s, making a narrative of exploits that he had heard first-hand from his policeman grandfather. The slab-like iron mask is a completely flat square, with eye-slits disjointedly highlighted in the cobalt blue of the background. Kelly's wide and staring eyes and slightly opened straight mouth give the impression of an alert animal, ready to dart away to its next hiding place or to pursue its next kill.

THE ARTIST The most internationally acclaimed Australian painter, Nolan is regarded as the most significant painter in the country's history. But he was a controversial figure, criticized for attempting to do too much by some and lauded as one of the century's greatest painters by others. After absorbing the styles of Picasso, Matisse and the Surrealists, Nolan had developed his own mixed style by the time he was conscripted into the army during World War II. While he was posted in the flat farmland of northern Victoria, he painted the Australian landscape in bright simple colours that ignored the threats of war around him. He moved around New York, Greece and London, but always returned to Australia and to his lifelong obsession with Ned Kelly.

Lucio **Fontana**

b. Rosario, Santa Fé 1899; d. Comabbio, nr Varese 1968
Coupure, 1961
Oil on canvas
115.5 x 89 cm (45$^1/_2$ x 35 in)
Private Collection

THE PAINTING Translated as 'cut', the title shows how Fontana went beyond the necessary flatness of pictures to introduce a different kind of space. For the first time in painting, real three-dimensionality was added, bringing into question the nature of the artwork and its place in space. The slashing attack to the canvas is directed against the limiting nature of the old pictorial two-dimensionality, while simultaneously using the traditional format of a stretched canvas to illustrate Fontana's new limitlessness of space. He also intended it to be seen as the action of creating space. It was to 'make conscious the actional process of the spatialisation of the surface through the gaping edges of the slits'. As with the Abstract Expressionist Pollock, it is the action of his creation that is important. Whatever can be seen through the slits becomes part of the painting, changing the nature of a static painting the way Duchamp had done with his *Bride Stripped Bare by Her Bachelors, Even*. Here Fontana has dragged diagonal marks in deeply raised *impasto* across reflective gold paint. This adds further to the questions of space in its reflections, its raised sculpture-like paint and the void of the slash itself.

THE ARTIST Fontana founded Spatialism with his 1946 *White Manifesto*, which aimed to bring together art with new developments in science. Born in Argentina, he moved to Italy when he was six. After being injured in World War I and qualifying as a surveyor, he returned to Argentina, moving between the two countries for the rest of his life. He hoped to combine space, colour, sound, movement and even time in a new type of art where matter could be transformed into energy, like light, to redefine space as art. Fontana rejected the illusory space that had been built up in traditional painting, for a new post-war world of spatial art that would have no boundaries. After putting holes in blank canvases he moved onto physically attacking them with razors, which has become his trademark as an artist. Canvas art was just one area of interest. In 1948 his groundbreaking *Spatial Environment* consisted of a blackened room, with a huge shape hanging from the centre, being flooded by neon light. His physical and metaphysical interest in space and light led to this creation of a three-dimensional space installation well before Environmental art or Performance art were formally developed.

Yves **Klein**

b. Nice 1928; d. Paris 1962
'RE 1', 1958
Pigment on canvas with synthetic resin and sponges
200 x 165 cm (78³/4 x 65 in)
Private Collection

THE PAINTING Klein refused to break his void of colour with any sort of painted detail or line; he said it would be like having a 'tourist walking across the space'. But here he has allowed himself the addition of natural sponges soaked in his patented dusty IKB – International Klein Blue. In these monochrome paintings he wanted to use the same IKB every time to depersonalize colour, to rid it of subjective emotion and 'external impurities'. Absolute purity of colour and space are the essence of what he was doing. He wanted to free the picture of all materiality, to open the way into infinity (blue historically signifying infinity) without giving any prompts or figurative signposts in the painting. The state of mind created within the viewer isn't distracted by anything or even prompted by the artist. It's a personal, metaphysical reaction to the void. The Russian Abstract artist Kazimir Malevich claimed to have brought abstract art to a close with his *White on White* paintings. Klein said that Malevich was only arranging colour blocks, and that he 'painted a still life in the style of one of my pictures. Malevich was standing before the infinite; I am in it.'

THE ARTIST Klein is one of the most charismatic of post-war European artists; he made his life the artwork. The son of painter parents, he attempted to reject their bohemianism by becoming a judo instructor. It wasn't until 1955 that he put his whole energies into art. He produced a little book of his past work (none of which existed), backdated to give himself false art world credentials. It won him some success and soon his one-man show, called 'Void', followed. It was one of the decade's most infamous. The gallery owner invited the glitterati to the opening. The space had blue painted windows and was a totally empty void inside. There was virtually a riot, but it ensured his place as a rising star. He followed it up with his *Anthropométries* – paintings made by covering naked women in IKB and directing them to imprint themselves on paper, all to the accompaniment of an orchestra playing Klein's single-note *Symphonie Monotone*. His frantic life and work were fuelled by amphetamines, which weakened his heart. After a disastrous show to a hostile New York audience in 1961 and a satirical film about his methods, he suffered two heart attacks and died aged thirty-four.

Andy **Warhol**

b. Pittsburgh 1928; d. New York 1987
Shot Red Marilyn, 1964
Polymer paint silk-screened on canvas
101 x 101 cm (39³/₄ x 39³/₄ in)
Private Collection

THE PAINTING Marilyn puckers out at us in glorious Technicolor. Using one of her publicity stills, Warhol was rebranding an already institutionalized image with his now familiar signature of vivid contrasting colours. A purely mechanical process of applying areas of colour to a printed surface, it is not really a painting at all. But Warhol is undeniably the leader of the American Pop art movement, and his 'de-humanized' faces and images have defined a cultural generation. Warhol took Marilyn's image, the American dollar bill and the Campbell's soup can – images so familiar to the American public that they no longer saw them – and stamped them as his 'factory art'. This deliberately impersonal and craft-free process was almost entirely done by a huge studio of hangers-on and helpers, who actually did the manual tasks involved in their production. Warhol cranked out series after series of silk-screens of film stars and Brillo pad boxes. It started as a procedure to shock the public out of its complacency by making them rethink the nature of the artistic process. But it became a vast mass-marketing, branding exercise with Warhol at its centre.

THE ARTIST As the man who said 'everyone will be famous for fifteen minutes', Warhol turned himself into the biggest art star of all. Born into a Czech immigrant family, he started in advertising, drawing shoes for magazines. But in 1962 his colour screenprints of everyday images turned him into an immediate success and one of the country's most famous artists. He set up The Factory in New York and filled it with the 'cultural space debris…of sixties subcultures' – transvestites, drug addicts, prostitutes and artistic drifters who were happy to help in Warhol's production line of art. The image that he was a father figure to his followers was shattered by his anger when one of them threw himself out a fifth-storey window without warning him first, 'so that he could have filmed his death.' One of his disaffected coterie critically shot Warhol in 1968, increasing his reputation as a figure of controversy. Warhol announced that he was giving up painting because it wasn't interesting anymore, and turned his attention instead to the band he had created, The Velvet Underground. But his Factory never really gave up production, and Warhol began making vast amounts doing society portraits from Polaroid photos. When he died after a routine operation, he left an estate valued at $100,000,000.

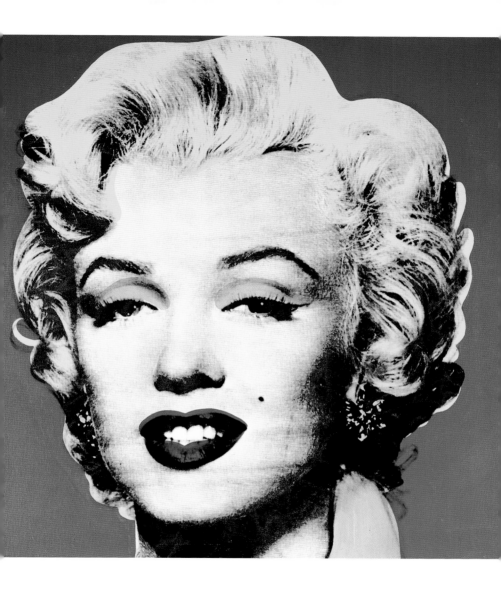

Lucian **Freud**

b. Berlin 1922
Man in a Headscarf (the Procurer), 1954
Oil on canvas
32.5 x 22.3 cm (12³/₄ x 8³/₄ in)
Private Collection

THE PAINTING The strength of this simple composition is the first thing that hits us. It is a life-size head of a man – fleshy, real and human. There is an arresting rawness to his features that gives a sense of the animalistic baseness of man, picked out in strokes and pockmarks of colour. Those lines, pink and grey tones and deep penetrating eyes are not benign. His look of concentration is not so much the one before a moment of speech, as one of cold, considered expectation. The thick knitting of his ochre-coloured woollen headscarf frames his face in a way that is reminiscent of a wise or priestly figure. The woollen top he wears seems to strengthen the sense of wholesomeness. But as the title tells us this man is a procurer, someone who obtains women for prostitution. His fixed gaze is one of confident, unwavering thought but it is coolly locked on the business at hand, on the girls he has come out to find. The rich textures of wool and the creased and aged face belong to a man of unnerving calculation, whose wet, deep but icy eyes stare with carnal thought. The seedy world of streetwalkers and their clients was a familiar one to Freud, who was living and painting around London's Paddington area in the 1950s.

THE ARITIST Freud is considered the best living British painter. The grandson of the Austrian psychotherapist Sigmund Freud, he moved with his architect father from Berlin to London in 1932. After becoming a British citizen in 1939 he went to study painting in East Anglia and at Goldsmiths College, London. The early style he developed there was highly realistic. Using flat, thin oils he built up meticulous detailed paintings, close to the British and German realism of the 1920s and 1930s. His portraits and figurative subjects usually have a mood of alienation, even a sadistically harsh view of his sitters, so for his early detailed paintings he has been called 'the Ingres of existentialism'. But it is this penetrating emotional quality that has made him one of the most powerful figurative painters of the century. From the 1950s his brushwork freed up, and the texture of the oil paint became much more important, like in *The Procurer*. Nudes make up most of his work, with his fluid brushwork suggesting shapes and building up emotional tensions in the flesh tones.

Jasper **Johns**

b. Augusta 1930
Two Flags (in 6 Parts), 1973
Oil on canvas with encaustic
132.7 x 176.5 cm (52¹/₄ x 69¹/₂ in)
Private Collection

THE PAINTING Johns has taken the most well-known American image and redefined it in paint. It is the American flag in repetition, and that's about it. That was Johns' point. He chose the most commonplace, two-dimensional thing so that the viewer wouldn't have to consider what his paint was trying to represent. It is a figurative subject rather than abstract one, yet it has no figurative associations and poses no questions. As Johns said, his flags were 'things the mind already knows. That gave me the room to work on other levels'. The flag is the subject but paradoxically there is nothing there for us to think about except the rich way he has used the paint. The paint is an Ancient Greek mix of hot wax and pigment, a rarely used medium because it is so time-consuming and difficult to make, but its texture is luxurious and strange. The subjectless subject leaves us to think about the nature of art and reality. It is almost a Conceptual art exercise where the image is just a trigger for thoughts. Johns was turning the tide of American art away from the heart-felt emotionalism of Abstract Expressionism and toward the irony of Pop art.

THE ARTIST Johns is one of the leading figures in the American Pop art movement and his flag paintings have made him one of the best-known American artists, as well as the highest paid. His ironic and iconic paintings, almost subjectless, reaffirmed thought rather than emotion as an important force in art. His early life was spent being passed between family members and his divorced parents in South Carolina. After a year in the local university he dropped out to study art in New York. Two terms later he left and found himself drafted into the army and back in Carolina for two years. It was in 1954 that his meteoric career began. He met and became the lover of fellow Pop art leader, the artist Robert Rauschenberg. The year they spent together hammering out ideas led Johns to having a dream about painting the American flag. He painted the first one that year and destroyed all the work he had done up to that point, saying later that he had 'decided to stop *becoming* an artist, and *be* an artist'. The ideas of Duchamp and the 'language picture' linguistic philosophy of Wittgenstein became lasting influences.

Gerhard **Richter**

b. Dresden 1932
Seestuck, 1969
Oil on linen
200 x 200 cm (78³/₄ x 78³/₄ in)
Private Collection

THE PAINTING This huge and expansive ocean horizon is one of Richter's great works of romanticism. It is a painting of simple, natural grandeur, made all the clearer by the limited range of colour. He has only used blues, greys and white, giving the whole picture a feeling of calm clarity. Its simplicity adds to the sense of nature's benevolent peace. But the distance is darkened by the thunderous threat that is ever present in nature. Richter has purged the seascape of any small-scale living elements that might distract from the lofty contemplative feeling. But this isn't exactly a painting of nature. Richter has always been interested in photography and its implications for painting. Here he took one photo of a brilliantly lit sky and another of a similarly lit sea, stuck them together in a photomontage, and painted the result. He felt there was an inherent objectivity in photography that was impossible in building up a painting from life. By imitating the photograph in paint he freed the painting from its traditional associations of landscape art, while also allowing us to appreciate the painterly technique for its own merits. It is a conceptual step not unlike Johns' flag paintings.

THE ARTIST Richter is one of the most sought-after living European painters, despite his reluctance to 'brand' himself by maintaining an artificially consistent style; he shifts between abstraction, realism and photography. Born in the east of Germany in 1932, he studied painting in Dresden in the 1950s and then moved to the West in 1961. In response to the British and American Pop art movements he put on a Performance/Conceptual art installation, in a Düsseldorf department store, called *Demonstration in Support of Capitalist Realism*, where he put furniture as well as himself on pedestals as the artworks. Investigating the possibilities of photography, by the early 1960s he was painting black-and-white photo details in a range of greys. From greys he flipped to his enormous colour-card paintings of 1973 to 1974, like *256 Colours*. He developed his snapshot paintings, transferred from the photo image and so devoid of historical painters' compositions or the associations attached to the painter's thoughts. His 1988 series titled *18 October 1977* depicts three Red Army Faction communists who died in a West German prison. Its highly provocative political nature, together with the detachment of his painting from photos, leaves the viewer with a heavy sense of the pointlessness of ideologies.

Modernism and the Contemporary World

David **Hockney**

b. Bradford 1937
Portrait of Nick Wilder, 1966
Acrylic on canvas
182.9 x 182.9 cm (72 x 72 in)
Private Collection

THE PAINTING The cloudless blue sky is reflected in the translucent water of a Los Angeles swimming pool. The air is clear, the light is crisp and brilliant. The scene is idyllic and carefree. Hockney is rejoicing in his surroundings and his optimism is infectious. Aged only twenty-nine when he painted this, he had already won the Gold Medal at London's Royal College of Art and had spent the five intervening years rising to the top of British Pop art. The year of this painting was his Californian dream year. Tired of grey old England, he moved to California in 1966 and fell in love with an art student. It was with him that he used to visit his friend and neighbour Nick Wilder to swim, talk about painting, and watch the beautiful young men that frequented the house. He had just discovered acrylic paint, in a Los Angeles art shop, and its plastic slickness was perfect for this painting of water and light, both reflecting his new happiness. This portrait of Wilder is one of a series of pool pictures, made in these early American years, that catches a homosexually free world that to Hockney was bathed in perpetual sunshine and happiness.

THE ARTIST Hockney is the most famous and critically acclaimed British artist of his time. His early abstract and experimental work was full of popular references, but he developed this into characteristically sleek figurative paintings like this one. Many of his works at this time included a plain canvas border, looking back to his self-consciously modern early years. His love of California was instant: 'Within a week of arriving there in this strange big city, not knowing a soul, I'd passed the driving test, bought a car, driven to Las Vegas and won some money, got myself a studio, started painting... And I thought, it's just how I imagined it would be'. His success and freedom in the Hollywood Hills were a sharp contrast to his working-class roots in a declining industrial town in the north of England. This new joy is evident in the luminous, sparkling and frank work of his pool paintings. His love affair with Los Angeles, where he still lives and paints, continues to this day.

Gilbert and George
(Gilbert Proesch / George Passmore)

b. Dolomites 1943 / b. Plymouth 1942
Coloured Loves (in 20 Parts), 1982
Gelatin silver print, hand-dyed
241 x 250 cm (95 x 94¹/₂ in)
Private Collection

THE PAINTING Brilliantly lurid Technicolor flowers, magnified photographically with outlined shadows of black, are scattered on a white ground. It seems an irregular arrangement of pure colour formalized by a tough, regular black grid. This kind of regimented pattern became Gilbert and George's frame for their pictures from the 1970s onward. The colours and forms are made as forceful as possible by the huge scale and contrasts of black, white and fluorescent colour. Intense fiery colours are the starting point for all of Gilbert and George's photographic paintings like this. It gives a sense of monumentality as well as an immediacy, helped along by the artificiality and strangeness of the untraditional medium. *Coloured Loves* was made at the same time as a picture called *Coloured Hates*, both signifying simple underlying motivations of human actions and feelings. Like in so many of their pictures, this one highlights, quite literally in its lightbox effect, an essential vivid emotion of life. It expresses Gilbert and George's belief that art is a meaningful instrument for breaking down the divisions between people and cultures. Joy, hatred, nationality, death, sex, fear, politics or almost any other indivisibly aspect of humanity can be isolated and reflected upon in their pictures.

THE ARTIST Gilbert and George are not painters, but they have taken the representational forms of painting and retranslated them into an art form particular to the late twentieth century. The whole blurring of painting, photography and art stems from their beginnings, when they totally rejected traditional methods. They began as 'living sculptures', which according to their own definition they still are – their every action and mode of life is the artwork. Painting themselves gold and wearing their trademark suits they mimed along mechanically to the 1930s music hall song *Underneath the Arches*, which was the also the title of this piece of Performance art. Moving to Video art in 1981 with the film *The World of Gilbert and George*, we see their profiles screaming at each other with their tongues out, wriggling. The existentialist comments these make about the isolation of the individual is much more human that Bacon's painterly swirls of meat, which do the same thing. Their attitudes to the basic important aspects of humanity have led them into graphic representations of all kinds, like *Blood on Spunk* and *Human Shits*. The pair met in St Martin's School of Art in 1967. They have been working together ever since.

Modernism and the Contemporary World

COLOURED
LOVES
1982
Gilbert + George

Jeff **Koons**

b. York, Pennsylvania 1955
Cracked Egg, 1995–97
Oil on canvas
325 x 252 cm (128 x 99³/₈ in)
Private Collection

THE PAINTING *Cracked Egg* is a whopping 10 x 8 feet in size. It is a monumental painting of the everyday, the banal even, and Koons has given it all the glitzy glamour of something spectacular and dreamlike. A white eggshell on crumpled, reflective foil glows with icy brilliance from some blue lighting. This sort of sharp image could be forever burned into the memory of a child who has seen this trivial, but visually stunning, everyday kitchen sight for the first time. Koons painted it as part of a series of hyper-realistic reminiscences of childhood that were intended to instil a juvenile trance of wonder and awe in the sophisticated, modern viewer. The series is called *Celebration* and is full of images of birthday cakes, party hats, Play-Doh and ribbons, all aiming to revisit those foundation emotions, often overlooked, of simplicity and awe. Started in 1995 the series took up to seventy assistants five years to complete, working under Koons' obsessive direction. Paintings of transitory memory flashes were painstakingly re-created to a level of astonishing perfection, to reawaken innocent wonder in the collective consciousness of the over-sophisticated art world.

THE ARTIST Koons is the most notable member of the 1980s American movement neo-Geo (neo-Geometric Conceptualism). He was a successful Wall Street commodities broker who used his wealth to fund his first sculptures. With them he endorsed contemporary commodity culture by elevating its trashy consumer products to the status of artworks. In 1980 he displayed his vacuum cleaners in Perspex – ready-made sculptures to sterility and the modern world that were the heirs to Duchamp and the Dadaist rejection of traditional art materials. For the rest of the decade he celebrated the kitsch and the tasteless with models of toys, puppies and porcelain ornaments, scaled-up to make their sickly tackiness a monument to the consumerism that created them. But he doesn't mock society the way early Pop art did, or react against it cynically like many Dadaists. Koons endorsed the tat that people clearly wanted and gave it back to them as art. Like his *Celebration* series, his sculptures shock the viewer out of their sophistication to deliver certain truths about western civilization. Taste, or even legality, didn't stop his search for glorifying the everyday in art. His infamous life-sized photographs and glass models of himself and his now ex-wife (the porn star La Cicciolina) having graphic sex caused huge controversy.

Damien **Hirst**

b. Bristol 1965
*Gaily Merrily Lovely Happily
Minding My Own Business*, 1998
Gloss household paint and butterflies on canvas
122 x 122 cm (48 x 48 in)
Private Collection

THE PAINTING Against a baby-pink canvas, Hirst has scattered a floating cloud of ascendant butterflies. Their different sizes give the illusion of depth while their directionless fluttering suggests confused flight. But these aren't flying anywhere. They are little, if still beautiful, carcasses fixed in paint. In 1991 Hirst created an installation called *In and Out of Love*. Upstairs was a room filled with flowers, sugared water and canvases with chrysalides attached to them. Each chrysalis would hatch, feed, mate, lay eggs and die, locked in the endless cycle of life and death for the viewer's contemplation. Since the ancient world the butterfly leaving the chrysalis has symbolized the human soul leaving its body, and in Christian iconography life, death and the resurrection is symbolized in the butterfly's life cycle. These historical associations, however, were irrelevant in a room surrounded by the real thing. Butterflies stuck to coloured canvases like this, souvenirs of real life and death, were displayed downstairs at the installation. But this is more than a reminiscence of that exhibit. The lively bright pink gives a feeling of dreamy happiness. The impression is that these beautiful insects are floating upward, though their empty bodies are held fast to the physical canvas.

THE ARTIST Hirst became the acknowledged head of the Young British Artists (YBA) in the 1980s, and has courted more media hype and worldwide success than any artist since Warhol. After studying in Leeds and Goldsmiths College, London, he put on an exhibition called *Freeze* in 1988 featuring himself and his YBA friends. It started the meteoric rise of an artist primarily interested in the big themes of Birth, Life, Love and Death. When the collector Charles Saatchi bought *The Physical Impossibility of Death in the Mind of Someone Living* (1991), a tiger shark preserved in a glass tank of formaldehyde, it set him in the public mind as the *enfant terrible* of contemporary art. It was part of a long period featuring carcasses as the focus of his interest in life and death. His elegant colour spot paintings make some reference to Richter's colour card ones from the 1970s, while his other mechanically spun colour swirl paintings echo Pollock, but without the manual expression that was central to Abstract Expressionism. He won the Turner Prize in 1995 and has diversified into branding a bar and restaurant in London. In the twenty-first century he has incorporated traditional religious imagery to illustrate his themes.

Hirst's beautiful painting of mortality has gone beyond pure paint, through Conceptualism and ready-mades. But his subject is the most eternal in painting, like the Egyptian wall painting of 2,000 BC. Some things will always be painted.

Timeline of Artists and Art Movements

2000 BC 1500 BC 1000 BC 500 BC AD 1

ART MOVEMENTS

———————————————— Egypt - The Middle Kingdom Roman Empire ————————

 ———————————— Egypt - The New Kingdom

 ———————— Egypt - Late Period

 Egypt - Roman Period ——————————————

 Greece - Archaic Period ————

 Greece - Classical Period ————

 Greece - Hellenistic Period ————

ARTISTS / WORKS

● Egyptian Wall Painting

 Vase attributed to The Dinos Painter ●

 Roman Wall Painting ●

 Egyptian School, Roman Period ————

Eastern Roman Empire
(Byzantine Style)

China - Tang Dynasty

China - Sung Dynasty

Yan Liben Xu Xi

French School

Egyptian School, Roman Period

1050	1100	1150	1200	1250

Eastern Roman Empire (Byzantine Style)

China - Sung Dynasty

Gothic

Xu Xi

Emperor Huizong

Cimabue

Giotto

Eastern Roman Empire
(Byzantine Style)

China - Ming Dynasty

China - Yuan Dynasty

China - Sung Dynasty

Gothic

Early Renaissance

Renaissance

Persian School

Byzantine (or Georgian)

Jan van Eyck

Masaccio

Michelangelo

van der Weyden

Fra Angelico

Bronzino

Memling

Uccello

Corregio

Massys

Fra Filippo Lippi

Titian

Fouquet

Piero della Francesca

Parmigianino

Bosch

Gozzoli

Tintoretto

Dürer

Mantegna

Grünewald

Verrocchio

Altdorfer

Ghirlandaio

Cranach

Botticelli

Holbein

Bellini

Clouet

Giorgione

Leonardo da Vinci

Fra Bartolommeo

del Piombo

Raphael

Timeline of Artists and Art Movements

China - Qing Dynasty

China - Ming Dynasty

Mannerism

Baroque

Rococo

Byzantine (or Georgian)

Tiepolo

Caravaggio

Michelangelo

Rembrandt

Blake

Artemesia Gentileschi

Canaletto

Bronzino

Vermeer

Carracci

Panini

Correggio

Teniers

Massys

Reni

Castiglione

Titian

Both

Salvator Rosa

Parmigianino

Ruysch

Guercino

Tintoretto

Dürer

Rubens

Veronese

Grünewald

Frans Hals

Altdorfer

El Greco

Cuyp

Cranach

Bruegel

Claude

van Ruysdael

Holbein

Poussin

Watteau

Clouet

Zurbarán

Chardin

Murillo

Boucher

Velázquez

Hogarth

del Piombo

Mexican School

Ricci

● Basawan and Chatai

Solimena

● Shigehide

van Dyck

Surrealism

neo-Classicism Art Nouveau Dada

Romanticism Symbolism Constructivism

Realism Fauvism Abstract Expressionism

Impressionism Cubism Pop Art

Post Impressionism Futurism

Pre-Raphaelites Bauhaus

Expressionism Photorealism

Whistler Freud

Kirchner

Renoir Degas

Constable Mondrian

Seurat Nolan

Turner Duchamp

Toulouse-Lautrec Hockney

Friedrich De Chirico

Zuccarelli van Gogh Magritte

Ingres Rivera

Guardi Gauguin Johns

Gericault Dalí

Longhi Cézanne Richter

Delacroix Bacon

Gainsborough Munch

Courbet Pollock

Reynolds Klimt

Millet Rothko

West Hassam

Corot Dubuffet

Stubbs Matisse

Church Klein

Robert Chagall

Millais Fontana

Fragonard Picasso

Monet Kandinsky Hirst

David Manet Warhol

Vigee-Lebrun Foujita

Pissarro Koons

Goya Severini

Hokusai Gilbert and George

Timeline of Artists and Art Movements

Further Reading

General Bibliography

James H. Beck, *Italian Renaissance Painting* (Cologne, Könemann, 1999)

Ian Chilvers, *The Concise Dictionary of Art and Artists* (Oxford, Oxford University Press, 1990, 1996, 2003)

Matthew Collings, *Matt's Old Masters* (London, Weidenfeld and Nicolson, 2003)

Matthew Collings, *This is Modern Art* (London, Weidenfeld and Nicolson, 1999, 2000)

E. H. Gombrich, *The Story of Art* (London, Phaidon, first published 1950)

H. Honour and J. Fleming, *A World History of Art* (London, Lawrence King Ltd. 1982, 1984, 1991)

René Huyghe, ed., *Larousse Encyclopedia of Modern Art: from 1800 to the Present Day* (Paris, Hamlyn, 1961, 1975, 1967, 1974, 1980)

E. Langmuir and N. Lynton, *The Yale Dictionary of Art and Artists* (New Haven and London, Yale University Press, 2000)

Michael Levey, *From Giotto to Cézanne* (London, Thames and Hudson, 1962, 1968, 1985)

Edward Lucie-Smith, *Lives of the Great Twentieth Century Artists* (London, Guild Publishing, 1986)

Charles McCorquodale, *The Renaissance: European Painting 1400–1600* (London, Studio Editions, 1994)

B. S. Meyers and T. Copplestone, ed., *Landmarks of Western Art* (London, Hamlyn, 1965, 1966, 1967, 1985)

David Piper, *A–Z of Arts and Artists* (London, Mitchell Beazley, 1984)

A. Smith, ed., *Larousse Dictionary of Painters* (trans. ed. London, Hamlyn, 1981)

Giorgio Vasari, *The Lives of the Artists* (trans. ed. Oxford, Oxford University Press, 1991, 1998)

The Grove Dictionary of Art Online (Oxford, Oxford University Press, 2004) http://www.groveart.com

Bibliography by chapter

The Rise and Fall of the Ancient World

Richard Brilliant, *Roman Art: from the Republic to Constantine* (London, Phaidon, 1974)

Otto Demus, *Byzantine Art in the Making* (London, Phaidon, 1968)

Frank Francis, *Treasures of the British Museum* (London, Thames and Hudson, 1971)

Henri Frankfort, *The Art and Architecture of the Ancient Orient* (London, Pelican History of Art, 1954)

German Hafner, *Art of Rome, Etruria, and Magna Graecia* (New York, Abrams, 1969)

Gisela M. A. Richter, *A Handbook of Greek Art* (London, Phaidon, 1959, ninth edition, 1987)

Carel J. De Ry, *Art of Islam* (New York, Abrams, 1970)

Heinrich Schafer, *Principles of Egyptian Art* (trans. J. Baines, Warminster, Aris & Phillips, 1987)

Meyer Schapiro, *Romanesque Art* (London, George Braziller, 1977, 1993)

David Talbot Rice, *Art of the Byzantine Era* (London, Thames and Hudson, 1963)

Mortimer Wheeler, *Roman Art and Architecture* (London, Thames and Hudson, 1964, 1991)

Ting Sing Wu, *Treasures of China* (Taiwan, The International Culture Press, 1970)

The Italian Renaissance

James H. Beck, *Italian Renaissance Painting* (Cologne, Könemann, 1999)

Marcel Brion, *The Medici: a Great Florentine Family* (London, Paul Elek Productions, 1969, second edition: London, Ferndale, 1980)

Kenneth Clark, *Leonardo da Vinci* (London, Thames and Hudson, 1988)

Karl Ludwig Gallwitz, *The Handbook of Italian Renaissance Painters* (Munich, Prestel, 1999)

Cecil Gould, *The Paintings of Correggio* (London, Faber, 1976)

Michael Jaffé, ed., *Titian* (London, National Gallery, 2003)

R. Jones and N. Penny, *Raphael* (London and New Haven, Yale University Press, 1983)

Michael Levey, *From Giotto to Cézanne: A Concise History of Painting* (London, Thames and Hudson, 1962, 1968, 1985)

Ronald Lightbrown, *Botticelli* (2 vols: London, Paul Elek Productions, 1978)

J. Martineau and C. Hope, ed., *The Genius of Venice: 1500–1600* (London, Royal Academy of Arts / Weidenfeld and Nicolson, 1983)

Charles McCorquodale, *The Renaissance: European Painting 1400–1600* (London, Studio Editions, 1994)

Linda Murray, *Michelangelo* (London, Thames and Hudson, 1980, 1988)

Peter and Linda Murray, *The Art of the Renaissance* (London, Thames and Hudson, 1963, 1971)

Tom Nichols, *Tintoretto: Tradition and Identity* (London, Reaktion Books, 1999)

John Pope-Hennessy, *Fra Angelico* (London, Phaidon, 1952, second edition 1974)

John Pope-Hennessy, *Siennese Quattrocento Painting* (London, Phaidon, 1947)

James H. Stubblebine, *Giotto: the Arena Chapel Frescoes* (New York, W.W. Norton, reissue edition, 1996)

Pietro Zampetti, *A Dictionary of Venetian Painters* (Leigh-on-Sea, F. Lewis, 1969)

The Renaissance in Northern Europe

Ivan Fenyo, *Albrecht Dürer* (Budapest, Corvina, 1956)

Max. J. Friedlander, *Early Netherlandish Painting* (Leyden, A.W. Sijthoff, 1967)

Walter S. Gibson, *Hieronymus Bosch* (London, Thames and Hudson, 1973, 1988)

F. Grossmann, *The Paintings of Bruegel* (London, Phaidon, 1955)

Charles McCorquodale, *The Renaissance: European Painting 1400–1600* (London, Studio Editions, 1994)

John Rowlands, *The Paintings of Hans Holbein the Younger* (London, Phaidon, 1985)

Margaret Whinney, *Early Flemish Painting* (London, Faber, 1968)

The Seventeenth Century

C. Brown, J. Kelch and P. van Theil, *Rembrandt: the Master and his Workshop* (New Haven and London, Yale University Press / London, National Gallery, 1991)

R.H. Fuchs, *Dutch Painting* (London, Thames and Hudson, 1978)

Frank Lewis, *A Dictionary of Dutch and Flemish Flower and Still Life Painters* (Leigh-on-Sea, F. Lewis, 1973)

M. Loer, *The Great Painters of China* (Oxford, Oxford University Press, 1980)

Metropolitan Museum of Art, *The Age of Caravaggio* (New York, Metropolitan Museum of Art, 1985)

Simon Schama, *Rembrandt's Eyes* (London, Penguin, 2000)

Seymour Slive, *Frans Hals* (London, Royal Academy of Arts / Prestel, 1989)

Jacques Thuillier, *Poussin* (Italy, Club del Libro, 1969)

C. Whitfield and J. Martineau, *Painting in Naples 1606–1705: from Caravaggio to Giordano* (London, Royal Academy of Arts / Weidenfeld and Nicolson, 1982)

Rococo to neo-Classicism

J. Martineau and A. Robinson, ed., *The Glory of Venice: Art in the Eighteenth Century* (New Haven and London, Yale University Press, 1995)

Antonio Morassi, *G.B. Tiepolo, His Life and Work* (London, Phaidon, 1955)

R. Rosenblum, *Transformations in Late Eighteenth Century Art* (Princeton, Princeton University Press, 1967, 1970)

Ministere de la Culture, *Chardin: 1699–1779* (Réunion des Musées nationaux, Paris, 1979)

Tate Gallery, *Manners and Morals: Hogarth and British Painting 1700–1760* (London, Tate Gallery, 1987)

W. Vaughan, *British Painting: The Golden Age* (London, Thames and Hudson, 1999)

Pietro Zampetti, *Guardi* (Venice, Alfieri, 1964)

The Birth of the Modern World

M. Butlin, *The Paintings and Drawings of William Blake* (New Haven and London, Yale University Press, 1981)

Robert Fernier, *Gustave Courbet* (Britain, Pall Mall Press, 1969)

A. Malraux, *Saturn: An Essay on Goya* (London, Phaidon, 1957)

B. Novak, *American Painting in the Nineteenth Century* (New York, Prager, 1969, 1971)

V. Pomarede and G. de Wallens, *Corot: The Poetry of Landscape* (France, Gallimard, 1996)

G. Reynolds, *Turner* (London, Thames and Hudson, 1967)

Tate Gallery, *Constable: Paintings, Watercolours and Drawings* (London, Tate Gallery, 1976)

Tate Gallery, *Turner 1775-1851* (London, Tate Gallery, 1974)

W. Vaughan, *British Painting: The Golden Age* (London, Thames and Hudson, 1999)

Impressionism to Post-Impressionism

R.A. Crichton, *The Floating World: Japanese Popular Prints 1700–1900* (London, Victoria and Albert Museum, 1973)

André Fermigier, *Toulouse-Lautrec* (London, Pal Mall Press, 1969)

Ministere de la Culture, *Manet: 1832–1883* (Réunion des Musées nationaux, Paris, 1983)

Phoebe Pool, *Impressionism* (London, Thames and Hudson, 1967, 1970)

Royal Academy of Arts, *Cézanne: The Early Years* (London, Royal Academy of Arts / Weidenfeld and Nicolson, 1988)

John Russell, *Seurat* (London, Thames and Hudson, 1965)

Modernism and the Contemporary World

Arts Council, *Matisse* (London, Arts Council of Great Britain, 1968)

Ulrich Bischoff, *Edvard Munch: 1863–1944* (Cologne, Taschen, 1988)

Raymond Cogniat, *Chagall* (New York, Crown, 1978)

Matthew Collings, *This is Modern Art* (London, Weidenfeld and Nicolson, 1999, 2000)

John Elderfield, *The 'Wild Beasts': Fauvism and its Affinities* (New York, Museum of Modern Art, 1976)

Norbert Lynton, *The Story of Modern Art* (London, Phaidon, 2nd edition, 1994)

I. Sandler, *The Triumph of American Painting: A History of Abstract Expressionism* (New York, Preager, 1970)

Frances Spalding, *British Painting Since 1900* (London, Thames and Hudson, 1986)

C. Tisdall and A. Bozzolla, *Futurism* (London, Thames and Hudson, 1977)

Glossary

Abstract Art Any art form that does not use representational forms.

Abstract Expressionism A term that applies to any expressionistic abstract art form. More particularly it is applied to the American artists Pollock and Rothko who used colour and form to express emotion.

Aerial Perspective Invented by Leonardo to describe the optical effect of short 'blue' light wavelengths on the distant atmosphere. Light wavelengths are scattered as they pass through atmospheric dust and moisture; the shorter, blue wavelengths are scattered most and therefore are more visible when seen over distances. This results in heavier blues being seen, such as the sky.

Art Brut Dubuffet coined this phrase to cover art created by people from outside art culture. 'Outsider art', as it is termed in English, is typically produced by psychiatric patients, prisoners, or maladjusted characters who do not have references to art culture.

Art Informel A loose term referring to European abstract artists of the 1940s and 1950s, who wanted to create a new language of painting. They were roughly equivalent to the Abstract Expressionists in America.

Art Nouveau Also known as Jugendstil in Germany, Sezessionismus in Austria, Modernismo in Spain, and Stile Liberty in Italy. It developed in separate strains throughout western Europe and America between about 1890 and 1915. It was a deliberate rejection of past styles and is characterized by organic elegant flowing lines, often with floral or feminine motifs. Tiffany in America, Mackintosh in Scotland and Klimt in Austria worked in this style.

Arts and Crafts Movement A movement that sprang up across northern Europe and America in the later part of the nineteenth century, vaguely as a reaction to increasing industrialization. It sought for a return to the materials and 'hand-made' techniques of earlier times as well as a harmonizing of craft and fine art.

Barbizon School A group of *plein-air* landscape painters, active *c.*1830 to 1870, who took their name from the French town they settled around.

Baroque The period of art between Mannerism and the Rococo, *c.*1600 to 1750, which is characterized by dynamic movement. It is also associated with the art of the Catholic Counter-Reformation.

Bauhaus School Influential German school of art and design, founded in 1919 and closed by Hitler in 1933. It aimed to break down the hierarchy of fine and applied arts. It re-opened after German re-unification in 1990.

Blaue Reiter Meaning 'blue rider' (named after a painting by Kandinsky), this group of German artists, centered on Kandinsky and Franz Marc, attempted to express spiritualism in painting.

Byzantine Art The art of the eastern Roman Empire, the capital of which was Byzantium (later called Constantinople after the empire split in two in the fourth century). It maintained many of the Greco-Roman traditions in a limited form, through the religious art of icons, until its capitulation to the Turks in the fifteenth century. It is characterized by use of gold and mosaics.

Camera Obscura An ancient device which projects an image through a hole in a darkened box, on to a surface where it can be traced over. It was, quietly, used by artists such as Canaletto and Vermeer.

Capriccio Any fantasy subject combining real or imagined objects, usually in townscapes, such as those painted by Guardi or Panini.

Caravaggesque / Caravaggism In the style of Caravaggio, namely his use of dramatic *chiaroscuro* and realistic earthy subjects.

Caravaggesques Painters who followed the artistic style of Caravaggio.

Chiaroscuro Italian word meaning 'light-dark', which is applied to the heavy shading of painting or drawing. It is associated most with Leonardo and the Caravaggesque painters of the seventeenth century.

Classical Art The sculpture, architecture and painting of the ancient Greeks and Romans.

Colorito See *Disegno* and *Colorito*

Conceptual Art An international movement that began with Duchamp but became widespread by the 1970s, where the concept behind the work becomes the artwork itself. In its strict sense only the ideas thought by the viewer are the artwork. However the artifacts that artists sometimes produce to induce these thoughts are often referred to as such.

Constructivism A movement that started in post-revolutionary Russia, and carried on in Europe with fewer Soviet implications. It embraced industrial materials, seeing them as a liberating force for the people's art. It began as a state-useful art, the antithesis of fine art, but became a term for all angular, industrial-feeling design.

Contrapposto Originally a classical Greek technique in sculpture which asymmetrically balanced a figure. It was revived in the Renaissance, especially by Michelangelo, and is characterized by movement and counter movement in figures.

Cubism Developed by Picasso and Braque by 1907, this method of constructing pictorial forms breaks down the three-dimensional object into its constituent angles and represents them as two-dimensional forms. It broke the Renaissance tradition of creating the illusion of a real object in space.

Cubists Exponents of Cubism.

Dada / Dadaism An anarchic movement that rose up in reaction to the carnage of World War I. It rallied against traditional values, which it saw as morally bankrupt, and used irony, cynicism and nihilism to shock the bourgeoisie out of cultural complacency.

Dadaists Exponents of Dadaism.

Danube School German landscape painters of the sixteenth century, who often made the native landscape the focus of the painting.

Degenerate art Term applied to avant-garde art suppressed under Nazi rule in Germany between 1933 and 1945.

De Stijl Dutch for 'the style', referring to a group of Dutch artists such as Mondrian who, through the journal of the same name, intended to further their ideas of a universal, underlying equilibrium.

Die Brücke German for 'the bridge', to indicate a connection between old and future art. This group of German Expressionists formed in 1905, the same year as the Fauves, and used similar expressive colour and un-naturalistic forms. However, they expressed a modern life full of anxiety and energy rather than pure beauty.

Disegno* and *Colorito Italian for 'design' and 'colour'. *Disegno* in Renaissance art theory was the underlying artistic force that unified all the arts. By the sixteenth century the term gained currency as draughtmanship. It was viewed in opposition to the Venetian use of *colorito*, by which was meant colour-melting brushwork to create form. The French termed the opposing forces of *disegno* and *colorito* as the battle of *Poussinistes* against *Rubénistes*.

Dutch Italianates A group of Netherlandish artists who travelled to Italy where they were influenced by its warm lighting.

École de Paris A disparate group of foreign artists working in Paris after World War I, who worked in a poetically expressive figurative style, including Chagall and Foujita.

En Grisaille A technique of painting only in tones of grey.

Environmental Art Closely related to Performance art, it involves the viewer entering and interacting with an environment defined by the artist, such as Fontana's *Black Spatial Environment* (1947), a darkened room with an amebic lit form hanging at its centre.

Expressionism Movement based mainly in Germany during the first half of the twentieth century that was concerned with emotional subjective experience. Its art often uses vibrant non-realistic colour and two-dimensional space.

Expressionists Exponents of Expressionism.

Fauves / Fauvism Translated as 'wild animals', this applies to a group of early twentieth-century French artists, like Matisse, who used vivid, unrealistic colour for emotional and decorative effect.

Foreshortening Type of representation whereby the objects depicted recede in space according to the laws of perspective.

Futurism Founded in Italy in 1909, this movement praised the dynamism of the modern world and called for a break with the past. In painting it is characterized by pointillist use of colour and cubist forms.

Futurists Exponents of Futurism.

Genre A category of painting that depicts scenes from daily life. Often comic, it was seen as a low form of painting and had its climax in seventeenth-century Dutch art.

Gothic The art of post-Romanesque Europe that spanned the mid-twelfth century to the sixteenth century. In architecture, pointed arches characterize the style. In painting it is characterized by elegant but primitive naturalism where perspective is unrealistic. During its last centuries minute detail became a feature.

Gouache A thick type of watercolour, bound by glue, with added white pigments to give it an opaque quality.

High Renaissance The last years of the Renaissance, between 1500 and 1520, when Leonardo, Raphael and Michelangelo were all active.

Hudson River School A loose group of American painters of the mid-nineteenth century who, inspired by Turner, painted the American landscape in a heroic and patriotic way.

Icon From the Greek, meaning 'likeness', this term is particularly applied to Byzantine holy paintings from the ninth century, which are partly regarded as sacred objects in their own right.

Impasto Ridges of thickly applied paint, usually oils.

Impressionism A loosely organized movement of French artists in the 1860s, which focused on the effects of light and colour. They painted scenes of everyday life or landscapes with a brevity of brushwork that was intended to re-create momentary visual perceptions. Their name, which was originally used derisively, came from Monet's painting *Impression: Sunrise* (1872).

Impressionists Exponents of Impressionism.

Installation Art An artwork that might consist of multiple objects, usually distributed in a large space and often transitory in nature. One of the few examples currently on permanent display is Richard Wilson's *20:50*, a room seemingly filled with oil that has to be viewed from a footbridge, in the Royal Scottish Academy.

International Gothic See Gothic.

Jugendstil See Art Nouveau.

Kinetic Art An art form whereby movement is either physically enacted in mobile sculptures or suggested in painting.

Linear Perspective A method of representing three-dimensional space on a two-dimensional surface, by creating the illusion of 'distantly receding' parallel lines at right angles to the picture plane which meet at the same distant vanishing point. Objects along the lines are represented at an increasingly smaller scale. Masaccio was the first to use this fully in painting.

Mannerism A loosely defined term for a style of art that is characterized by elongated elegance of forms in a non-naturalistic way. It was mainly used after the High Renaissance and before the Baroque period, from about 1520 to 1600.

Mannerists Exponents of Mannerism.

Metaphysical Painting A movement that strove to excite thought about the nature of objects by placing them in unusual contexts. It was founded by de Chirico in 1917 and is the predecessor of Surrealism.

Mexican Muralism A form of outdoor public art, begun in Mexico but influential in America, that combined the styles of Cubism and Expressionism with the native Indian culture and popular imagery.

Mexican Muralists Exponents of Mexican Muralism.

Minimal Art An abstract art form developed mainly in America since the 1960s. Free of decoration, symbolism or expressionism, it often uses repetitive geometric structures.

Modernism A vague and much disputed term that in its broadest art sense refers to anything seen as associated with contemporary life and thoughts. Its beginnings are variously ascribed to: Romanticism's clash of the individual with the authority of the classical world; Manet's challenges to art historical references with up-to-date meanings; or the passing of naturalistic representation in favour of individual expression, through Symbolists like van Gogh, Gauguin and Munch (who all struggled with the modern industrial world). It can be seen as the entirety of artistic movements from any of these starting points up to the present.

Modernismo See Art Nouveau.

neo-Classicism The dominant style in Europe and America from the late eighteenth to the early nineteenth centuries. It was concerned with re-creating the motifs and spirit of the classical world.

neo-Classicists Exponents of neo-Classicism.

neo-Geo (neo-Geometric Conceptualism) A group of New York artists of the 1980s, led by Koons, who used pastiches of commercially kitsch objects in a reaction against neo-Expressionism.

neo-Impressionism A term for the movement begun by Seurat, which developed from Impressionist compositions as well as its interest in colour but did not follow its interest in fleeting impressions. Instead it broke down colours into separate areas, such as in Pointillism.

Performance Art A staged live artwork that can combine theatre, music and visual arts together, such as Gilbert and George's living sculpture art *Underneath the Arches*, or Klein's *Anthropométries*. It is distinguishable from a 'Happening', which is similar but without choreography.

Persian School A broad term generally applying to the arts of the Middle-East, or more specifically referring to the area around modern Iran.

Plein air French term, meaning 'open air', which refers to painting (mainly landscape), that has been painted from life.

Pointillism A movement started by Seurat (who called it 'Divisionism'), where pure unmixed colours are applied in dots of paint, without lines. The effect on a viewer standing at the appropriate distance is to create a more vibrating and luminous range of colours.

Pointillists Exponents of Pointillism.

Pop Art An American and British movement beginning in the 1950s, that took its imagery from popular culture, comic strips and consumer goods. With its use of existing iconic imagery it echoed Duchamp, and in its disregard of traditional art methods it is a descendant of Dadaism. It is sometimes referred to as neo-Dada.

Post-Impressionism This was the movement that followed Impressionism's use of colour and informal subject matter, but was not pre-occupied with its momentary effects of lighting. Through artists like Gauguin and van Gogh, Post-Impressionism forms a bridge between Impressionism and Expressionism.

Post Impressionists Exponents of Post-Impressionsim.

Pre-Raphaelite Brotherhood A group of mid-nineteenth century British artists, who wanted to return to the sincerity of the Italian primitives before the slick academism of the High Renaissance, specifically of Raphael and his followers.

Ready-made Industrially or pre-made objects that, by virtue of being chosen by the artist, become a work of art by that artist. Duchamp invented the art form with his first pure, ready-made *Bottle Rack* in 1914.

Realism A broad term applying to naturalism in painting, more specifically to the movement in late nineteenth-century French art that centred around Courbet. He denounced allegorical painting in preference to scenes from everyday life, often with socialistic overtones.

Realists Exponents of Realism.

Renaissance Meaning 'rebirth', this period of intellectual and artistic development in Italy and later in other parts of Europe strove to replicate the intellectual ideals of the classical world. In painting its earliest exponents included Giotto, but it is taken to have begun fully with Masaccio's investigations into lighting and perspective.

Rococo An artistic style that dominated in the eighteenth century and developed from the heavier Baroque period. It is characterized by frivolity of subject, by 'S' and 'C' curves in decorative details, and a colour palette of pastels, gold and silver.

Romantic Movement / Romanticism A varied movement in Northern Europe and America that focused on the emotions and imagination of the individual. Love, loss and heroism are common themes.

Romantics Exponents of Romanticism.

Salon The exhibition of art from the official French Academy, the *Académie Royale*, begun in 1667. Artists who failed to be included in the exhibitions, like Manet, initiated their own counter-academies, such as the *Salon des Refusés* in 1863.

Sezessionismus See Art Nouveau

Sfumato A term, from the Italian meaning 'smokey', to describe the technique of subtly blending tones and colours together, melting harsh outlines.

Spatialism A movement founded by Fontana in 1947 aiming to combine space, colour, sound, movement and time in art. His paintings often include holes in the canvas, opening up the two-dimensional space and transforming it into a three-dimensional one.

Stile Liberty See Art Nouveau

Surrealism This was defined in 1924 by its creator, André Breton, as a movement 'to resolve the previously contradictory conditions of dream and reality into an absolute reality'. Using a high degree of realistic naturalism, artists juxtaposed the real and the imaginary in an attempt to express the subconscious.

Surrealists Exponents of Surrealism.

Symbolism A late nineteenth-century movement that rejected naturalistic representation in favour of any forms that could express ideas and emotions.

Symbolists Exponents of Symbolism.

Trompe l'œil A French term meaning to 'deceive the eye', this is an illusionist form of painting that intends to deceive the viewer into believing a painting is a three-dimensional space.

Ukiyo-e Meaning 'pictures of the floating world', this school of Japanese art was dominant between the seventeenth and nineteenth centuries. Its subject matter is typically informal.

Video Art Any art that makes use of video technology, often similar to Performance Art but arranged for the purposes of recording.

Young British Artists (YBA's) A group of British artists that came together in Hirst's *Freeze* exhibition in 1989, including the Chapman brothers, Rachel Whiteread, Tracey Emin, Sarah Lucas, Chris Ofili and Marc Quinn. The diverse group use non-traditional mediums like human blood, elephant dung, food, insects and carcasses to explore issues such as death, sex and the individual.

Index

Acknowledgements

A big thank you to Nicola Chalton for asking me to write this book in the first place, and to all her colleagues at Constable & Robinson who have helped see its production through to the end. Also thank you to Matthew for a great introduction that sets the heritage of painting perfectly in its contemporary place. Many thanks go to Lucinda Duckworth for all the support through the long winter months. A particularly big thank you must also go to my tireless editor Miranda Harrison who has given over many a Sunday night patiently going over every aspect of the book, and to Pascal Thivillon for his design work. Grateful thanks too to Emma Strouts of Christie's Images for pulling so much out of the bag and to Louise Bythell of Bridgeman Art Library. Also thanks must go to my family for being at the end of the phone, and to my friends.

Photographic Acknowledgements

Christie's Images for the illustrations on pages: 5, 9, 13, 18, 19, 43, 47, 49, 69, 91, 95, 99, 112, 113, 121, 124/125, 129, 132, 133, 135, 137, 148, 149, 155, 156, 157, 159, 165, 167, 168, 169, 181, 183, 191, 195, 199, 203, 205, 207, 211, 212, 215, 217, 218, 219, 223, 225, 227, 229, 231, 233, 235, 237, 239, 241, 244, 245, 247, 249, 251, 253, 255, 257, 258, 259, 261, 262, 265, 267, 269, 271, 273, 275, 277, 279

Bridgeman Art Library for the illustrations on pages: 4, 7, 10, 11, 14/15, 17, 23, 25, 27, 28, 29, 31, 33, 35, 37, 39, 41, 45, 47, 50, 51, 53, 55, 57, 59, 61, 63, 65, 67, 68, 73, 75, 77, 78, 79, 81, 83, 85, 87, 89, 93, 94, 101, 103, 105, 106, 107, 109, 111, 115, 116, 117, 119, 123, 127, 131, 136, 141, 143, 145, 147, 151, 153, 161, 163, 166, 171, 172, 173, 177, 179, 182, 185, 186, 187, 189, 190, 193, 194, 201, 209, 213, 243

The author and publishers also wish to make acknowledgement to the following copyright holders for permission to reproduce pictures where copyright permission was needed:

Dali: © Salvador Dali, Gala-Salvador Dali Foundation, DACS, London 2004; Duchamp: © Succession Marcel Duchamp/ADAGP, Paris and DACS, London 2004; Matisse: © Succession H. Matisse/DACS 2004; Munch: © Munch Museum/Munch-Ellingsen Group, BONO, Oslo, DACS, London 2004; Picasso: © Succession Picasso/DACS 2004; Rothko: © 1998 Kate Rothko Prizel & Christopher Rothko/DACS 2004; Warhol: © The Andy Warhol Foundation for the Visual Arts, Inc./ARS, NY and DACS, London 2004; Chirico: © DACS 2004; Bacon: © Estate of Francis Bacon 2004. All Rights Reserved, DACS; Johns: © Jasper Johns/VAGA, New York/DACS, London 2004; Pollock: © ARS, NY and DACS, London 2004; Severini, Kandinsky, Magritte, Klein, Foujita, Dubuffet, Chagall: © ADAGP, Paris and DACS, London 2004; Piet Mondrian, Composition in White, Blue and Yellow: C, 1936 © 2004 Mondrian/Holtzman Trust c/o hcr@international.com; Diego Rivera, The Flower Seller, 1942 © 2004 Banco de México Diego Rivera & Frida Kahlo Museums trust, Av. Cinco de Mayo No 2, Col. Centro, Del. Cuauhtémoc 06059, México, D.F.; Frederick Childe Hassam, Flags, Afternoon on the Avenue, 1917 © Frederick Childe Hassam; Ernst Ludwig Kirchner, Strassenszene, 1913 © by Dr Wolfgang & Ingeborg Henze-Ketterer, Wichtrach/Bern; Sir Sidney Nolan, Ned Kelly, 1955 © Sidney Nolan; Lucio Fontana, Coupure, 1961 © Lucio Fontana; Lucian Freud, Man in a Headscarf (the Procurer), 1954 © Lucian Freud; Gerhard Richter, Seestuck, 1969 © Gerhard Richter; David Hockney, Portrait of Nick Wilder, 1966 © David Hockney; Gilbert & George, Coloured Loves (in 20 Parts), 1982 © Gilbert & George; Jeff Koons, Cracked Egg, 1995-97 © Jeff Koons; Damien Hirst, Gaily Merrily Lovely Happily Minding My Own Business, 1998 © Damien Hirst.